Hayward Gallery, London 10 February–17 April 1983
Bristol City Museum and Art Gallery 30 April–4 June 1983
Stoke-on-Trent City Museum and Art Gallery 11 June–16 July 1983
Mappin Art Gallery, Sheffield 23 July–28 August 1983

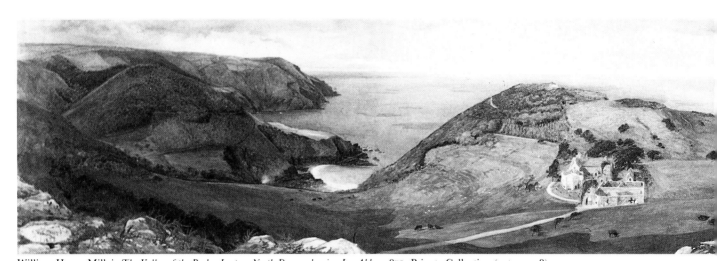

William Henry Millais *The Valley of the Rocks, Lynton, North Devon, showing Lee Abbey* 1875. Private Collection (cat. no. 28)

Landscape in Britain
1850-1950

Arts Council
OF GREAT BRITAIN

ISBN 0 7287 0344 0

Exhibition organized by Nicola Bennett,
assisted by Lise Connellan

Catalogue edited by Judy Collins and Nicola Bennett

Catalogue designed by Graham Johnson
and printed by The Hillingdon Press

Contents

List of Lenders

Public

Aberdeen Art Gallery and Museums

Bath City Council, Victoria Art Gallery

Birkenhead, Wirral, Williamson Art Gallery and Museum

Birmingham Museum and Art Gallery

Bradford Art Galleries and Museums

Brighton, Royal Pavilion, Art Gallery and Museum

The City of Bristol Museum and Art Gallery

Broughty Ferry, The Trustees of the Orchar Art Gallery

Calderdale Museums Service

Cambridge:
Fitzwilliam Museum
Kettle's Yard, University of Cambridge

Cardiff, National Museum of Wales

Cheltenham Art Gallery and Museum

Compton, The Watts Gallery

Coniston, The Ruskin Museum

Dublin, The Hugh Lane Municipal Gallery of Modern Art

Dundee Museums and Art Galleries

Eastbourne, Towner Art Gallery

Edinburgh, National Gallery of Scotland

Edinburgh, Scottish National Gallery of Modern Art

Egham, Royal Holloway College, University of London

Glasgow, University of, Hunterian Art Gallery

Glasgow Art Gallery and Museum

Glasgow School of Art

Harrogate Art Gallery, Harrogate Borough Council

Harrow, The Kodak Museum

Hastings Museum and Art Gallery

Hereford City Museums and Art Galleries

Hove Museum of Art

Kirklees Metropolitan Council, Huddersfield Art Gallery

City of Kingston upon Hull Museums and Art Galleries, Ferens Art Gallery

Ipswich Museum and Galleries

Kettering Borough Council

Kirkcaldy Museums and Art Gallery

Leeds, Temple Newsam House

Leicestershire Museums and Art Galleries

Lincoln, Usher Gallery

Liverpool, Walker Art Gallery

London:
Bethnal Green Museum
Goldsmiths' College Gallery, University of London
Guildhall Art Gallery, Corporation of London
The Trustees of the Imperial War Museum
The Tate Gallery
Victoria and Albert Museum

Manchester:
City Art Galleries
Whitworth Art Gallery, University of Manchester

Newcastle upon Tyne, Laing Art Gallery, Tyne and Wear County Council Museums

Norfolk Contemporary Art Society

Norwich Castle Museum, Norfolk Museums Service

Nottingham, Castle Museum

Oldham Art Gallery

Oxford, Ashmolean Museum of Art and Archaeology

Penzance Town Council

Perth Museum and Art Gallery

Portsmouth City Museum and Art Gallery

Sheffield City Art Galleries
Sheffield, Guild of St. George

Southampton Art Gallery

Street, Somerset, The Trustees of the Sarah and Roger Clark Trust

Swansea, Glynn Vivian Art Gallery and Museum

Swindon Permanent Art Collection, Borough of Thamesdown

Wakefield Art Gallery and Museums

Warrington Museum and Art Gallery

Whitby, The Sutcliffe Gallery

Worthing Museum and Art Gallery

York:
City Art Gallery
National Railway Museum

Private

Sir Brian Batsford

Douglas Percy Bliss

Clifford and Rosemary Ellis

The Fine Art Society

Robin Garton Gallery

J. A. Gere

Government Art Collection

Mrs Rosemary Gwynne-Jones

Adrian Heath

Robert Hershkowitz Ltd

John Hewett

Rowland Hilder

Guy Howard

Andrew Lanyon

London Transport Executive

Maas Gallery, London

Meredith Monnington

Christopher Newall

Anthony d'Offay Limited

Michael Parkin Fine Art Ltd

Howard and Jane Ricketts

The Roland Collection

The Trustees of the Royal Society of Painters in Water-Colours

William Scott

Shell U.K. Ltd

Sotheby's, London

Sir Peter Wakefield

Private Collections

Preface

In 1973 the Tate Gallery mounted an exhibition of British landscape painting from 1750-1850. Ten years later, our exhibition carries the theme forward into the twentieth century. The dividing point between these two exhibitions is marked by the deaths of Wordsworth in 1850 and Turner in 1851. The period covered in the present exhibition was characterized by swift and radical change of a kind which was only beginning to threaten the traditional order celebrated by landscape artists of the previous century. The spread of railways, roads, factories and cities, and the large-scale movement of the population away from the countryside, contributed to an awareness of increasing separation from the natural environment.

Included in the exhibition are works by over two hundred artists; mostly paintings with some photographs, posters, books and prints. As a touring exhibition, however, its size is limited and it cannot claim to be a full survey of the period. The selection concentrates on rural landscape but also features urban and industrial scenes. It acknowledges the travels of British artists abroad and the role of artists in recording the First World War.

Many of the artists represented are leading figures in British art movements of the period. However, a feature of the exhibition is the inclusion of many lesser known artists, a result of the extensive researches of our selectors, Frances Spalding and Ian Jeffrey, who visited collections all over the country. We are most grateful to them for the enormous amount of thought and time they have put into both the selection and the preparation of the catalogue which includes some two hundred artists' biographies in addition to their essays. We are also fortunate to have a contribution from the poet Donald Davie on aspects of landscape in the literature of the period.

We would like to extend our warmest thanks to the lenders who have responded so generously to our requests to borrow works, and we join our selectors in thanking all those whose names are recorded in the acknowledgements on the last page.

Joanna Drew
Director of Art

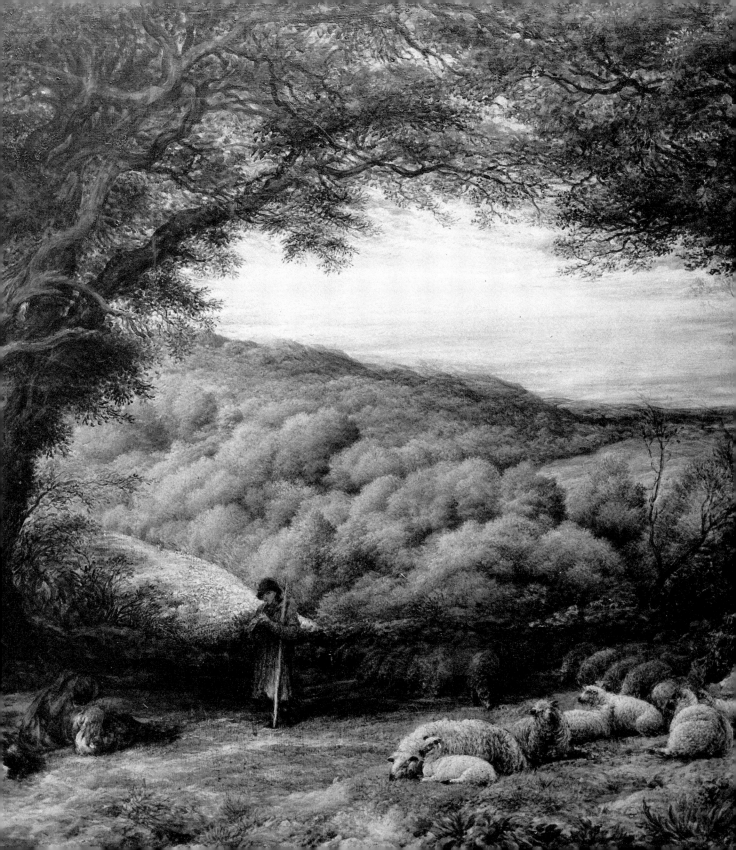

Changing Nature:
British Landscape Painting 1850-1950

by Frances Spalding

John Linnell
Under the Hawthorn (detail) 1853
Aberdeen Art Gallery and Museums
(cat. no. 2)

In 1851, the year that Turner died, John Linnell retired to Redhill, where he built Redstone Wood on top of a hill overlooking fine views of the Surrey landscape. Over the years he acquired eighty of the surrounding acres, much of it woodland which he kept intact, rarely felling a tree. Redstone Wood proved the making of Linnell's career. Previously he had painted portraits and copied Old Masters in order to provide for his large family, admitting sadly that no great progress could be made 'in poetic landscape unless the whole heart and mind can be devoted to it'.[1] For the next thirty years after his move to Redhill (he died in 1882 at the age of ninety) he became one of England's most prolific and popular landscape artists. Drawing upon various resources – memory, earlier sketches, photographs and the views from his house, he ignored the agricultural depression of the 1870s and painted scenes of a happier rural past, in which carts laden with hay lumber through a benevolent landscape, often under a radiant sunset sky.

Much Victorian landscape painting is either the result of intense looking or myopic nostalgia. The latter was encouraged by the taste of the urban middle classes who wished to be reminded of the countryside which many of them had left within a generation or less. Landscape pictures also helped salve the blight caused by the Industrial Revolution by offering a reassuring contrast with the hideous town. In that mythology which Raymond Williams has exhaustively analysed,[2] rural life became associated with the past and tradition; it suggested an innocent, peaceful alternative to the ambition, disturbance, corruption and squalor often associated with the city. This mythology was made still more precious during the period dealt with in this exhibition because the countryside itself was fast changing due to modern agricultural methods and the spread of suburbia: John Linnell's late, pantheistic landscapes gain in urgency from the fact that in all the places where he had lived, Hampstead, Bayswater and finally Redhill, he had witnessed the steady erosion of the countryside. By the mid-nineteenth century, landscape in the hands of lesser artists, such as the highly skilled and immensely popular Birket Foster, had become an unashamedly sentimental confluence of associations drawn from the literature and art of the past.

In *Pictures of English Landscape* (1863), published in collaboration with the Dalziel Brothers, Birket Foster presents a charming, conservative vision of rural delight. It would be wrong to accuse him of pure escapism because, as Donald Davie argues, the idyll, in that it looks back to a better past, carries within it, by implication, a criticism of the present. This criticism is made explicit in one of the poems which Tom Taylor wrote to accompany Birket

[1] Quoted in Katherine Crouan, *John Linnell: A Centennial Exhibition*, catalogue to an exhibition held at the Fitzwilliam Museum, Cambridge, 1982, p. xiv.
[2] See *The City and the Country*, 1973.

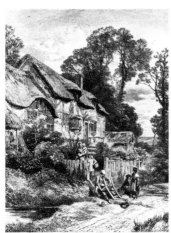

Fig 1 Myles Birket Foster. Illustration no. 6 in *Pictures of an English Landscape (engraved by the Brothers Dalziel) with Pictures in Words by Tom Taylor.* Published by George Routledge and Sons, London 1863

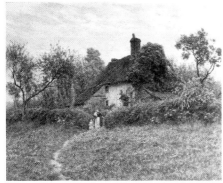

Fig 2 Helen Allingham *Old Cottage at Pinner.* Birmingham Museum and Art Gallery

Foster's illustrations. The poem, entitled 'Old Cottages', praises their picturesqueness but admits the 'foul miasma of their crowded rooms'. Taylor ends by welcoming 'the utilitarian hand' which will result in cottages 'By sketchers shunned, but shunned by fevers too'. Helen Allingham, a follower of Birket Foster, furthered her reputation by specializing in cottage scenes which, though they uphold the cottage as a symbol of English virtues, of repose and continuity, also underline, by contrast, the sorry state into which many had fallen, either because of uncaring landlords or as a result of the huge shift of population away from the country into the cities. She entitled one of her watercolours *The Condemned Cottage* and in the preface to her 1886 exhibition of Surrey cottages at the Fine Art Society took the opportunity to upbraid the insensitive restoration of such buildings.

Popular Victorian landscape painting, therefore, in its suggestion of timelessness, is often a protest against change. Artists were noticeably less willing than novelists to come to terms with the effects of industrialization; there is no painter concerned with the urban landscape equal in stature to Arnold Bennett or D. H. Lawrence. Most artists born within sight of a mill or a mine left the area at the first opportunity. Because the art world centred on London, artists, in order to advance their careers, were obliged to head for the metropolis. Moreover the general revulsion from urban life left scant market for industrial subjects. Even the young Lawrence painted, not the streets of Eastwood or Nottingham, but copies of Benjamin Leader, Peter de Wint, Girtin and Maurice Greiffenhagen's *Idyll* (Walker Art Gallery, Liverpool), and in 1909 wrote ecstatic praise of Bastien-Lepage's *Pauvre Fauvette* (Glasgow Art Gallery and Museum). Lowry, Sir Charles Holmes, Edward Wadsworth, Bertram Priestman and Alan Lowndes apart, most twentieth-century artists who have painted industrial landscapes have enjoyed local and not national reputations. Birmingham, which by 1850 contained some of the worst industrial slums in Britain, spawned not realists but naturalists and dreamers – David Cox, Thomas Creswick and Burne-Jones; its only significant school has been the tempera painters like Charles Gere and Joseph Southall who looked back to the art and technique of fifteenth-century Italy.

The selective vision employed by landscape artists affirms this rejection of progress. When painting *The Plough* (Tate Gallery, London) in the winter of 1869–70, Frederick Walker, working outdoors in conditions of severe physical discomfort, concerned himself with exactitude, catching the low light of evening and the precise colour of the ploughed field. But he chose not to see the Minehead Branch of the Great Western Railway and the road that ran between the scene and his hut. Moreover, when portraying the labourers, he gave them a style of dress that did not suggest the present. Paradoxically Burne-Jones, who once declared that the more materialistic science became the more angels he would paint, was one of the few nineteenth-century artists to paint or draw telegraph poles (39). It has been jokingly

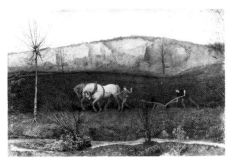

Fig 3 Frederick Walker *The Plough* 1870. Tate Gallery, London

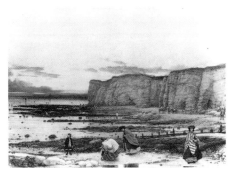

Fig 4 William Dyce *Pegwell Bay, Kent – a Recollection of October 5th, 1858*. Tate Gallery, London

remarked that J. McIntosh Patrick has been gifted with an inability to see either telegraph poles or electricity pylons, for his twentieth-century paintings of the Angus countryside present it as it was a hundred or more years ago. Nor did the primitive artist Alfred Wallis paint St Ives as he saw it but as it was when the Cornish fishing industry was at its zenith: 'i do most what used to Be what we shall see no more avery Thing is altered.'[3] This desire to preserve, to celebrate 'what used to be', lingers on today, vitiated by time, in Rowland Hilder's paintings, prints and calendar illustrations, in which oast-houses and half-timbered buildings, hedges and quiet country lanes evoke a pre-juggernaut Britain.

If urban sprawl makes us nostalgic about the countryside it also drives people out in search of it. Even before the development of the railways towns-people made a habit of riding out to the country at weekends. Moreover large areas of Britain, particularly the moorlands in North England and North Wales, remained untouched by industrialization and urban sprawl. Previously tourists visiting these parts had looked at the countryside through the eyes of painters, enjoying likenesses to the classical and picturesque landscapes that were popular in their day. After 1850 the increased accessibility of the countryside because of the advent of the railways, combined with the fact that the family summer holiday had now become an institution, created a more domesticated view of nature. This change was furthered by the rising bourgeoisie whose practical taste encouraged the Pre-Raphaelites. Millais' claim – 'The Pre-Raphaelites had but one idea – to present on canvas what they saw in nature'[4] – though an inadequate definition of Pre-Raphaelitism, emphasizes this desire for facts, the accumulation of which also satisfied the intellectual climate. Pre-Raphaelite landscapes suggest that nature, though illimitable, can be possessed; each leaf, flower, fern or pebble is docketed with the same attentiveness that Victorians brought to their natural history collections.

William Dyce's *Pegwell Bay* – sadly unavailable for this exhibition – is a key work within the history of Victorian landscape painting. The appearance of Donati's comet in the sky and the emphasis given to rocks and cliff bring together Astrology and Geology – Tennyson's 'Terrible Muses'. Set against these two immensities, the foreground figures are, by inference, dwarfed by the new conceptions of time attendant upon recent scientific discoveries.[5] At Oxford Ruskin had been obliged to try to reconcile his evangelical upbringing with the discoveries of the eminent geologist Sir Charles Lyell. He had listened to his tutor Dr Buckland, Professor of Mineralogy and Geology, argue that the discoveries of the geologists need not trouble those who interpreted the Bible literally if one took its first words, 'In the beginning', to refer to an indefinite period of time prior to the present state of earth and its inhabitants. Moreover when Ruskin began writing *Modern Painters* he was living in a pre-Darwinian period and could still believe that nature revealed the infinite goodness and wonder of God's creation. What began as a defence

[3] Quoted in Edwin Mullins, *Alfred Wallis: Cornish Primitive Painter*, 1967, p. 20.

[4] Quoted in John Guille Millais, *The Life and Letters of Sir John Everett Millais*, Vol. 1, 1899, p. 55.

[5] See Marcia Poynton, 'The Representation of Time in Painting: A Study of William Dyce's "Pegwell Bay: A Recollection of October 5th, 1858"', *Art History*, Vol. 1, No. 1, March 1978, p. 99ff. Also her book on Dyce, published in 1979.

of J. M. W. Turner developed into a treatise on landscape art. With an extraordinary attention to detail and impassioned eloquence Ruskin swept away outdated attitudes and standards and helped to inculcate an approach to landscape painting which valued a mossy river bank as much as a dramatic or picturesque view.

Ruskin believed that landscape art should do more than divert the eye. He argued that it was an instrument for moral power, a vehicle for profound truth. In the preface to the second edition of *Modern Painters* he condemned

> the utter inutility of all that has been hitherto accomplished by the painters of landscape. No moral end has been answered, no permanent good effected, by any of their work. They may have aroused the intellect, or exercised the ingenuity, but they have never spoken to the heart. Landscape art has never taught us one deep or holy lesson . . . it has not prompted to devotion, nor touched with awe; its power to move or exalt the heart has been fatally abused, and perished in the abusing. That which ought to have been a witness to the omnipotence of God, has become an exhibition of the destiny of man . . .[6]

The chief purpose of the first volume of *Modern Painters* was to prove the excellence of the landscapes by Turner and his contemporaries, in comparison with the 'unimportant and feeble truths' discovered by certain Old Masters, many of whom had helped direct the earlier taste in England for the sublime, the beautiful and the picturesque. These artists, Ruskin argued, had defied the laws of nature.

> A man accustomed to the broad wild sea-shore, with its bright breakers, and free winds, and sounding rocks, and eternal sensation of tameless power, can scarcely but be angered when Claude bids him stand still on some paltry chipped and chiselled quay, with porters and wheelbarrows running against him, to watch a weak, rippling, bound and barriered water, that has not strength enough in one of its waves to upset the flowerpots on the wall, or even to fling one jet of spray over the confining stone. A man accustomed to the strength and glory of God's mountains, with their soaring and radiant pinnacles, and surging sweeps of measureless distance, kingdoms in their valleys, and climates upon their crests, can scarcely but be angered when Salvator bids him stand still under some contemptible fragment of splintery crag, which an Alpine snow-wreath would smother in its first swell, with a stunted bush or two growing out of it, and a volume of manufactory smoke for sky. A man accustomed to the grace and infinity of nature's foliage, with every vista a cathedral, and every bough a revelation, can scarcely but be angered when Poussin mocks him with a black round mass of impenetrable paint, diverging into feathers instead of leaves, and supported on a stick instead of a trunk. The fact is, there is one thing wanting in all the doing of these men, and that is the very virtue by which the work of human mind chiefly rises above that of the daguerreotype or calotype, or any other mechanical means that ever have been or may be invented, Love. There is no evidence of their ever having gone to nature with any thirst, or received

[6] *The Works of John Ruskin*, Vol. III, ed. E. T. Cook and Alexander Wedderburn, 1903, pp. 21-2.

PLATE I Alfred William Hunt *Rock Study: Capel Curig – The Oak Bough* 1857. Christopher Newall (cat. no. 32)

PLATE II Charles Napier Hemy *Among the Shingle at Clovelly* 1864. Laing Art Gallery, Newcastle upon Tyne (cat. no. 52)

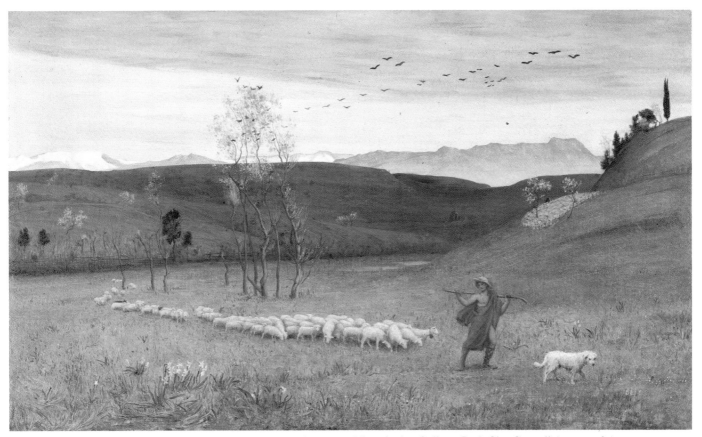

PLATE III Matthew Ridley Corbet *Arcadian Shepherd and his flock* 1883. Victoria Art Gallery, Bath City Council (cat. no. 62)

PLATE IV John Everett Millais *Chill October* 1870. Private Collection (cat. no. 30)

from her such emotion as could make them, even for an instant, lose sight of themselves; there is in them neither earnestness nor humility; there is no simple or honest record of any single truth; none of the plain words or straight effects that men speak and make when they once feel.[7]

With such passages Ruskin dispelled academic subterfuge and the tendency to rely on conventionalized, second-hand perceptions of landscape. He was by no means the first to encourage a close study of nature: the tradition of 'plein-air' painting dated back to the seventeenth century, while in the first half of the nineteenth century Constable had demonstrated the validity of 'natural' painting and John Varley had taught his pupils 'Go to Nature for everything'. But Ruskin's scientific examination of natural phenomena, his moral fervour and magnificent prose, combined with the Pre-Raphaelite Brotherhood's revulsion against the 'slosh' of academic practice as well as a more widespread desire for facts, resulted in a radical revision in the art of landscape painting. Those often small, intense paintings produced during the 1850s and early 1860s still astonish and enthral; the multiplicity of pictorial incident, the crowded detail invokes a similar devotional attitude to that found in fifteenth-century Flemish art and which has scarcely been equalled in any other period.

Yet it has to be admitted that the style which Ruskin did so much to encourage was incapable of development. The passionate, detailed looking that he advocated required a tenaciousness that only Brett, Inchbold, Atkinson Grimshaw and Holman Hunt were able to sustain. For the most part this earnest, elaborate but naive style ended almost as suddenly as it had begun. While it lasted it attracted a number of minor figures who briefly excelled in the Pre-Raphaelite vein and then faded from sight. Tight, linear detail was gradually replaced by a softness of touch, capable of expressing those atmospheric conditions which the Pre-Raphaelite technique could not encompass. In 1859 Millais observed that Ruskin

does not understand my work which is now too broad for him to appreciate, and I think his eye is only fit to judge the portraits of insects.[8]

Eleven years later Millais painted *Chill October* (30) in a backwater of the Tay, storing his large canvas in a nearby stationmaster's hut and claiming that he 'chose the subject for the sentiment it always conveyed to my mind.'[9]

Humphry House has argued that the exaggerated sentiment in late Victorian painting arose from a desire to restore man's self-esteem, shattered by recent scientific discoveries.[10] In practical terms it meant that allusiveness began to take precedent over fact. J. W. North observed that Frederick Walker's ideal was

to have suggestiveness in his work; not leaving out, but by putting in, detail, and then partly erasing it. This was especially noticeable in his water-colour landscape work, which frequently passed through a stage of extreme elaboration of drawing, to be afterwards carefully worn away, so that a suggestiveness and softness resulted—not emptiness, but veiled detail . . .[11]

[7] ibid. pp. 168-9.

[8] *The Life and Letters of Sir John Everett Millais*, Vol. 1, p. 342.

[9] ibid. Vol. II, p. 29.

[10] Humphry House, 'Man and Nature: Some Artists' Views', *The Listener*, 15 April 1948.

[11] Quoted in John George Marks, *Life & Letters of Frederick Walker*, 1896, p. 168.

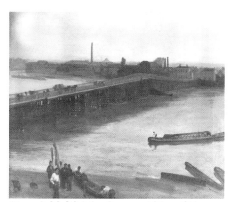

Fig 5 J. M. Whistler *Brown and Silver – Old Battersea Bridge*. Addison Gallery of American Art, Andover, Mass.

This veiling of detail helped create an elegiac mood. It is found not only in Walker's art but also in North's *Gypsy Encampment* (53), and in the work of the Etruscans, a loose association of English artists all of whom had come under the influence of the Italian landscape painter Giovanni Costa (nicknamed 'The Etruscan'). Though the term the Etruscan School did not come into existence until 1883, these artists had earlier exhibited together and most had painted in the Roman Campagna in Costa's company. Their landscapes achieve sentiment through a process of abstraction based on direct experience of nature. There was a noticeable tendency to idealize, and in the art of Sir William Blake Richmond and Matthew Ridley Corbet landscape became associated with a dream of Arcadia.

This increasing desire for sentiment had a noticeable effect on the career of George Heming Mason. In the early 1850s he had made expeditions into the Campagna with Costa and Leighton and there painted the landscape crisply illuminated by strong sunlight. In 1857 he returned to England, married and settled into his family home in Staffordshire. There, beset by ill health, financial difficulties, a growing family and intellectual isolation, he had despaired and given up painting. In 1863 Costa paid him a visit and encouraged him to paint in the surrounding countryside. Mason, his eyes formerly blinded by his love of Italy, woke to the qualities of the English landscape. In *A Derbyshire Farm* (13) he catches the moist atmosphere, evanescent light and lush greens of the Peak District. Thereafter his career revived, but, in keeping with the taste of the day, his wakefulness slowly shaded into dream. His farm landscapes became romanticized and his colours sank into one hue as sunsets and twilight became a recurrent aspect of his work.

At the same time Whistler, looking at an industrial eyesore, observed that tall chimneys and warehouses became campanili and palaces when transformed by an evening mist. He claimed that his paintings were primarily an arrangement of line, form and colour, and though he made studies of the river landscape at night, his Nocturnes were painted from memory and reflect more on the artist's idea of the scene than on the scene itself. Only when painting the sea did he seek a realistic effect, achieved nevertheless with broad and simple means. 'He will give you', his pupil Sickert observed, 'in a space of nine inches by four an angry sea, piled up, and running in, as no painter ever did before.'[12] But for the most part Whistler regarded nature with distrust; he argued that in order to create harmony the artist must pick and choose: total subservience to nature produced only cacophonous results.

Between the two extremes represented by Whistler and Pre-Raphaelitism exist various approaches to landscape art. Often the painter's attitude was determined by his relationship to the countryside. Victorian landscape artists who were also town-dwellers tended to regard the countryside as something to be raided. The London-based William Dyce once boasted:

[12] *A Free House! or the Artist as Craftsman. Being the writings of Walter Richard Sickert*, ed. Osbert Sitwell, 1947, p. 19.

14

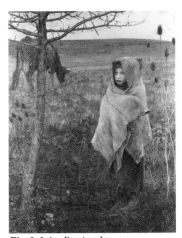

Fig 6 Jules Bastien-Lepage
Pauvre Fauvette. Glasgow Art Gallery
and Museum

I made £400 by my trip to Ramsgate two years ago and £260 by my last year's trip to Arran and I hope to make an equally good thing out of my Welsh excursions.[13]

These town-dwellers, particularly those who sought wide success, tended to look for spectacular effects and remarkable views. The popular Scottish landscapist Peter Graham first took the Royal Academy by storm in 1866 with *A Spate in the Highlands* (Manchester City Art Gallery), in which a river has burst its banks and pours in a torrent towards the spectator. He went on to excel at storm-lashed cliffs and Highland cattle marooned on mist-filled moors. Horatio McCulloch, based in Edinburgh, toured the Highlands each summer in order to paint that wildness and solitude which Queen Victoria admired. Like the stag leading the King into the unknown country of the Trossachs in Scott's *Lady of the Lake*, we enter into an undefiled landscape of great scenic beauty in McCulloch's *Loch Katrine* (4) and see it and Ellen's isle as if through the King's eyes. Paintings like this increased the number of tourists flocking to Scott's countryside so that the myth of its inviolateness, as has been remarked, grew less true with every year that passed.[14]

Very different are the scenes portrayed by those artists who actually lived in the countryside, sharing in village life and observing the daily toil of farm labourers. Instead of the breathtaking and spectacular, these artists dwelt on the diurnal and commonplace. They had moved to the country in the 1880s, inspired by the example of the French artist Bastien-Lepage who drew many of his subjects from the life of Damvilliers, the village where he had been born. He also painted his canvases out of doors, favouring the steady grey light created by an overcast sky. Nowadays his peasant subjects seem sentimental, his technique somewhat mannered, his *plein-air* style far less adventurous than the work of the true Impressionists. Nevertheless in Britain during the 1880s he exercised an enormous influence, upon the Newlyn and Staithes Schools, the Glasgow School, William Stott, Frank O'Meara and others. To George Clausen, his chief apologist in Britain, Lepage represented 'a new view of nature'.

> His attitude towards nature is one of studied impartiality.(...)
> His people stand before you and you feel that they must be true to the very life. He loves to place them in an even, open, light, and simply accepting the ordinary conditions of his sitters, produces a surprisingly original result.(...)
> He found his ideal in the ordinary realities of his own experience.[15]

Clausen, it seems, was merely praising another form of truth to nature, but it was felt that this 'studied impartiality' could only be achieved if the artist lived among his or her subjects. Most artists who imitated Lepage had trained in Paris and were aware of, or had visited, artists' painting colonies in France, at Pont-Aven, Barbizon or Grès-sur-Loing. It was in imitation of the French example that the Newlyn and Staithes Schools were formed, that certain members of the Glasgow School painted at Brig O'Turk or Cock-

[13] Quoted in Marcia Poynton, *William Dyce 1806-1864*, 1979, p. 156.

[14] See James Holloway and Lindsay Errington, *The Discovery of Scotland: The Appreciation of Scottish Scenery through Two Centuries of Painting*, National Gallery of Scotland, 1978, p. 112.

[15] George Clausen, 'Bastien-Lepage as Artist', in André Theuriet's *Jules Bastien-Lepage*, 1894, pp. 115, 118 and 122.

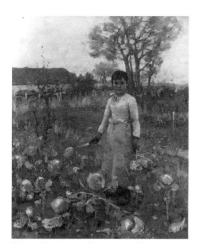

Fig 7 Sir James Guthrie *A Hind's Daughter* 1883. National Gallery of Scotland

burnspath, where James Guthrie took up residence, and that Clausen moved to Childwick Green and began portraying Essex labourers.

Many of these artists concentrated on peasant types, as Lepage had done, often giving more prominence to the figures than the landscape. Precisely because Lepage combined literary with aesthetic qualities (a fact that Clausen praised), his mild Impressionism slipped easily into the anecdotal vocabulary of late Victorian art. It was, moreover, 'an Impressionism from which the colour had been removed and to which a high moral tone had been added'.[16]

One characteristic that often accompanied this style was the use of the square brushstroke. It is found in Guthrie's *A Hind's Daughter* (National Gallery of Scotland, Edinburgh) and was often used in paintings of cabbage patches ('kail' having been the staple diet of the cottager since the eighteenth century). Here it is particularly apt as its choppy effect is suggestive of earth sliced with the spade and it therefore acts as 'a metaphor for honesty and a sense of reality'.[17] It also encouraged the artist to paint across forms, with a breadth of touch that chased away any lingering influence of Pre-Raphael-itism and which, in its evident flatness, emphasized the decorative aspect of the picture. By the late 1880s, however, many of these realist painters had begun to soften their images and were painting more ambiguous evocations of landscape. Some became more concerned with pattern and arabesque. Sense perception was now subject to the mood which the scene aroused in the artist and which, as in George Henry's *River Landscape* of 1887 (87), helped to shape and order the final image.

Contemporaneously Wilson Steer, under the impact of Monet, was employing broken brushwork and prismatic colour. 'Midsummer madness', the *Daily Telegraph* termed it. By the early 1890s Steer was experimenting with a *pointilliste* style and exhibiting among other Neo-Impressionists with Les XX in Brussels. Bruce Laughton's analysis of Steer's development stresses his attraction to styles that resulted from a clear conception of method; he had earlier learnt much from Whistler: now he studied the work of Seurat.

Steer remains an isolated figure within the history of British landscape painting. On the whole the influence of Monet and his colleagues produced in England only a milk-and-water Impressionism, as found in the work of Mark Fisher, James Charles (64), Edward Stott and late Clausen, all of whom Steer outstripped. When in 1905 the dealer Durand-Ruel brought a large exhibition of French Impressionism to London it did not appeal to the general public and few paintings sold. The still dominant influence of Whistler, and his concern with tone, militated against what he called the 'screaming blues and violets and greens' of the French Impressionists.

French Post-Impressionism, however, as shown in London at the two famous exhibitions of 1910 and 1912, had an immediate and far-reaching impact on landscape painting. Though the Scottish Colourists had already become familiar with the work of Matisse in Paris, in London the work

[16] Quentin Bell, *A New and Noble School – The Pre-Raphaelites*, 1982, p. 175.

[17] Holloway and Errington, *The Discovery of Scotland*, p. 141.

Fig 8 James Dickson Innes *Welsh Mountain Landscape*. City of Manchester Art Galleries

of the Fauves, of Gauguin, Van Gogh and Cézanne came as a shock to artists and public alike and presented a challenge to the etiolated traditions and insularity then feeding much English art. Compared with the tired mimetic skills that many English artists brought to their work, the Post-Impressionists spurned the comfort provided by habitual ways of seeing. They left behind a desire, not only to catch the shifting pattern of appearances, but to make the image more durable, by emphasizing either structure, as in Vanessa Bell's *The Haystack, Asheham* (134), or by stressing an expressive response to the scene and therefore selecting and to some extent rearranging visual facts to create the desired effect. Camden Town artists, whose garden scenes had previously been informed by a vaguely impressionistic style, now began to use patches of colour in such a way that they defined spatial recession *and* created an articulate surface pattern. We find this tauter sense of design in the clipped angularity of Bevan's Sussex landscapes (99) and in the rhythmic ordering that Ratcliffe imposes on an unremarkable view (108).

Though it injected fresh vitality into English art, Post-Impressionism also tended to encourage a detached view of landscape, objectifying its forms into a mere still-life. This fact makes the landscapes painted by Innes, Augustus John and Derwent Lees in North Wales between 1910 and 1913 all the more exceptional, for they combine the high-key palette and free brushwork of Post-Impressionism with native traditions, with a feeling for place and a charged romanticism. Though John's interest in the Romany gypsies had earlier attracted him to the area, it was Innes' enthusiasm for the landscape that largely inspired this sudden, brief flowering of small, intense oils in which colour can take on the luminosity of stained glass. Wandering footloose over the moors, living and sleeping out of doors in emulation of the nomadic lifestyle, Innes discovered the Arenig mountain which became associated in his mind with his mistress Euphemia Lamb. He painted this mountain repeatedly, under various light effects, employing a swift, direct method, registering stratified clouds with crude streaks of the brush, dotting in foliage in a manner that Lees was to imitate. All compositional tricks are shorn away in this simultaneous exposure of means and feeling. Not surprisingly, critics have often found in these urgent paintings a reflection of Innes' consumptive state which caused his early death in 1914 at the age of twenty-seven.

Apart from the pre-war Welsh paintings of these three artists, Post-Impressionism chiefly developed a more structural approach to landscape. It is often difficult in Camden Town landscapes to know the precise weather conditions, the time of day or even the nature of the artist's response, for the emphasis is more on the timeless element of design. This disinterested approach, however, broke down in the trenches where the splintered imagery of Cubism proved to be a powerful vehicle for the representation of war and its exploded and ravaged terrain. Here artists were confronted with a landscape that aroused conflicting emotions. On the one hand there was a

Fig 9 Paul Nash *We are making a New World* 1918. Imperial War Museum

countryside obliterated by destruction, the trees blasted and torn, the ground pitted with shell holes and debris of war, and over it all a thick, white mud. Then, some months later, the same landscape, dried by the sun, gave off a dazzling whiteness in which wild flowers grew beside skulls and helmets. 'Ridiculous mad incongruity!' wrote Paul Nash. 'One can't think which is the more absurd, the War or Nature; the former has become a habit so confirmed, inevitable, it has the grip on the world just as surely as spring or summer.'[18] Both Nash and William Orpen registered in their war paintings the inscrutable nature of death and earth's promise of renewal.

After World War 1 there was a revival of interest in landscape and a return to the traditional values of representational painting. But though painters hurried to isolated spots in search of the spirit of the place, none went so far as to represent the British countryside as an idyll: no longer was it offered as a repository of traditional virtues, a potent alternative to the city. The complexity of the situation that now confronts the historian can be suggested by listing this exodus to the land. Since 1912 William Rothenstein had lived at Far Oakridge in the Cotswolds; in 1916 Vanessa Bell and Duncan Grant had established a rural haven at Charleston beneath the Sussex downs; in the early 1920s Matthew Smith recuperated in Cornwall from his experience of war; Nash was at Dymchurch where he was visited by Ben Nicholson; Ben and Winifred Nicholson wintered abroad during the early 1920s at Castagnola and afterwards divided their time between London and Cumberland eventually establishing St Ives as an artistic centre, attracting to this small fishing town, among others, Christopher Wood; in 1924 David Jones, having joined Eric Gill's Ditchling community, moved with him to Capel-y-ffin and painted landscapes at Capel and on Caldy Island, as well as in the suburban environment of Brockley where his parents lived; in 1929 John Nash settled at Wormingford in Essex; Bawden and Ravilious at this time looked for a weekend cottage, found Brick House at Great Bardfield and settled there permanently in 1932, Ravilious moving out to Castle Hedingham in 1935; in the 1920s Peploe and Cadell made regular visits to Iona; in 1923 Bomberg visited Palestine where he began to develop the technique characteristic of his mature and late years; other landscape artists made regular pilgrimages to France, Roger Fry buying a house at St Rémy-de-Provence, Matthew Smith settling at Aix and Vanessa Bell and Grant establishing a second Charleston just outside Cassis.

In most cases association with the countryside was beneficial but perhaps not wholly absorbing. These artists looked to nature for fresh stimulus but used it as a vehicle for their own concerns, landscape often becoming merely a tool in the making of art. Bomberg apart, the general result was a greater sense of detachment. Unlike much Victorian landscape painting which embraces the spectator, drawing us into the scene portrayed, there is no longer any ease of relationship with nature. Bawden's and Ravilious' watercolours with their bleak winter light are often severely beautiful but they retain a

[18] Paul Nash, *Outline. An Autobiography and other writings*, 1949, p. 187.

PLATE V Augustus John *The Blue Pool* 1911. Aberdeen Art Gallery and Museums (cat. no. 129)

PLATE VI Cedric Morris *Corner in Treboul, Brittany* 1927. Sir Peter Wakefield (cat. no. 152)

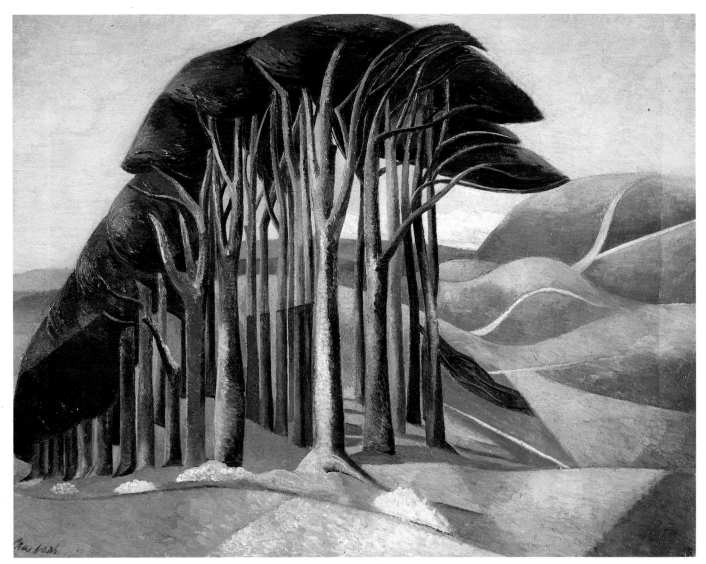

PLATE VII Paul Nash *Wood on the Downs* 1929. Aberdeen Art Gallery and Museums (cat. no. 155)

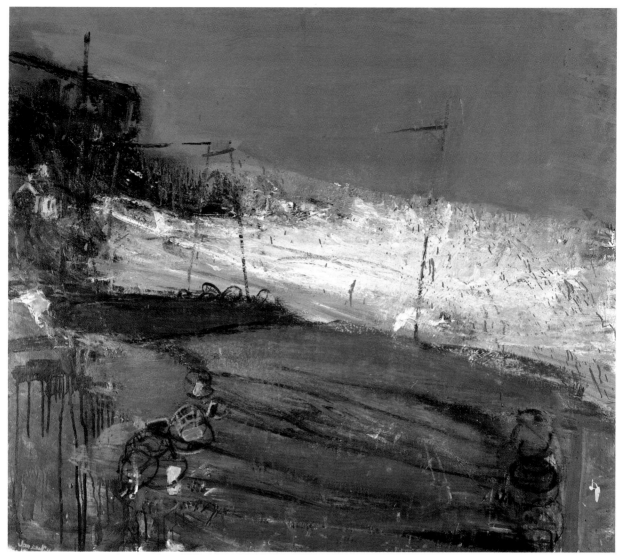

PLATE VIII Joan Eardley *Breaking Wave*. Kirkcaldy Museums and Art Gallery (cat. no. 261)

Fig 10 Graham Sutherland *Dark Hills – Landscape with Hedges and Fields*. Borough of Thamesdown, Swindon Permanent Art Collection

clinical distance: the scene excludes not only the viewer but also the artist. The attempt to extract permanence from impermanent conditions results in a predominantly mental grasp of landscape. Only rarely is there an attempt to discover in the countryside an harmonious sense of being at one with nature.

The most lyrical landscapes produced during this period were those by Seven & Five Society artists, among them Ben and Winifred Nicholson, Frances Hodgkins, David Jones and Christopher Wood. Ben Nicholson and Wood were stimulated by their discovery in 1928 of the primitive Cornish artist, Alfred Wallis; his symbolic treatment of land and seascapes, town and harbour scenes appears to have released in them greater freedom in their interpretation of appearances. In Wood, Wallis's example seems also to have liberated an element of fantasy. The naivety of Seven & Five landscapes, with their childlike drawing and minimum modelling, hides their aesthetic sophistication; their poetry springs from a knowledge of art rather than an attitude to nature. As H. S. Ede remarked, in his preface to the seventh exhibition of the Seven & Five Society in January 1927, 'They are not so much pictures as ideas settled for a moment on canvas, but ever ready to take flight into some new life.' A painting was no longer a representation of nature, but an equivalent to nature. 'Can you imagine the excitement which a line gives you when you draw it across a surface?' Ben Nicholson once asked. 'It is like walking through the country from St Ives to Zennor.'[19]

A similar degree of abstraction, in the hands of Paul Nash, becomes a means of mediating between the transient and the eternal. The beeches in his *Wood on the Downs* (155), though apparently windswept, are stilled by Nash's structural logic into an image, authoritative, majestic and yet entirely devoid of rhetoric. For Nash, nature was the keeper of a mystical geometry. His landscapes are usually unpopulated and when figures do appear they waft through like ghosts. He uncovers relationships between forms that echo strangely in the mind, which, though they may not exist in nature, are nevertheless poetically convincing. His landscapes give the impression that they represent appearances in a more profound way than would be achieved by direct evocation.

Graham Sutherland also realized the expressive potential of abstraction when he took up painting and in 1934 discovered the Pembrokeshire district. Previously, in his etchings of the 1920s, he had been one of the few artists who had attempted to revive the English country idyll. The model that he chose, however, was not the sweet fancies of Birket Foster but the passionate, mystical visions of the recently rediscovered Samuel Palmer. In Sutherland's Welsh paintings, and often in the landscapes of those artists he inspired, Minton, Ayrton, Craxton and Vaughan, the concern is less with the countryside itself than with the emotive landscape in the mind of the artist. This explains why Sutherland, though he made repeated visits to Wales and soaked himself in the landscape, was wary of over-exposure to his subject.

[19] Quoted in Denys Val Baker, *The Timeless Land*, 1973, p. 18.

Fig 11 Photograph of Joan Eardley

He only made notes and sketches while there, working up oil paintings from these on his return to the more placid environs of Kent. Pembrokeshire gave him 'an emotional feeling of being on the brink of some drama'[20], an elusive experience that had to be swiftly registered but recreated in tranquillity.

> I like to take a thing on the wing, as it were. I go for walks with no particular preconceived ideas. I have a very small note-book and I look right and left as I am walking, and suddenly I see something that interests me and make a note of it. These notes are extremely important as they are the basis of the final painting, and in addition, they have the virtue of speed; the moment of seeing is often fleeting . . . it may be useless to return, as the object which I have seen will have disappeared and mean nothing to me. It must be there, of course, but the flash of recognition has passed.[21]

Sutherland, therefore, looked only for those forms which corresponded with certain states of mind. Like John Minton, he seems originally to have sought in nature solace for the twentieth-century sense of displacement. Hence his fascination with a landscape that could create 'a mysterious space-limit, a womb-like enclosure'.[22] But in their return to nature the neo-romantic landscape artists did not discover an idyll but a feeling of unease. Palmer's influence, reinvigorated by Surrealism, resurfaced in valleys of vision that are no longer cosy, but strange and disquieting. With hindsight, the apprehensive mood of these paintings can be seen to express a foreboding caused by the approach and onset of war.

Once again war returned artists to the land. To Peter Lanyon the Cornish landscape where he was born and grew up, offered permanence and familiarity after his service with the Royal Air Force during 1940–45. The picture he associated with his homecoming was *The Yellow Runner* of 1946 (255). He used this work to celebrate his marriage and the onset of family life; in the centre of the canvas is a womb-like shape to which the yellow horse on the far hill is returning and inside which the form of the horse is echoed. In his later work Lanyon grew increasingly concerned with the intangible aspects of nature, finding that his creativity was quickened by disequilibrium:

> Without this urgency of the cliff-face or of the air which I meet alone, I am impotent. I think this is why I paint the weather and high places and the places where solids and fluids meet. The junction of sea and cliff, wind and cliff, the human body and places all contribute to this concern.[23]

At the same time Joan Eardley, her canvas clamped to an easel held in position by boulders, was painting stormy seas under leaden skies at the fishing hamlet, Catterline, on the north-east coast of Scotland. Both Eardley and Lanyon developed an expressionistic style that verges on pure abstraction. Their attempts to lose themselves in landscape, to reunite with nature, resulted in images that engulf rather than embrace the spectator. Nothing

[20] Graham Sutherland, 'Welsh Sketch Book', first published in *Horizon*, April 1942, pp. 225–35, and reprinted in *Sutherland in Wales* (catalogue of collection at the Graham Sutherland Gallery at Picton Castle), 1974, pp. 11–15.

[21] Interview with Graham Sutherland, in Noel Barber, *Conversations with Painters*, 1964, p. 44.

[22] See note 20.

[23] Peter Lanyon, 'A Sense of Place', *The Painter and Sculptor*, Vol. 5, no. 2, Autumn 1962.

Fig 12 Peter Lanyon *The Yellow Runner* 1946. Guy Howard, London

could be further from the cottage gardens of Helen Allingham, the tame pastures of Birket Foster or the Etruscans' dream of Arcadia. Nature, no longer a fount of goodness, has become at best a refuge from uncertainty. Like much twentieth-century art, the paintings of Eardley and Lanyon carry an undertow of desperation.

Public Problems and Private Experience in British Art and Literature

by Ian Jeffrey

Painters in the Romantic era were landscape adepts, but even so the practice was not without its problems. Some of these problems emerged in the summer of 1813 when a writer, Richard Ayton, and an artist, William Daniell, sailed north from Land's End. Their story is told in *A Voyage Around Great Britain*, published between 1814 and 1825, and now famous mainly for Daniell's beautiful engravings. Ayton, in a full account which was quite in keeping with the contemporary taste for the sublime, refers often to frightful rocks, bleak mountains and majestic headlands. He is supported, rather elegantly, by Daniell, whose harbours are still as mill-ponds.

But from time to time Ayton's commentaries are excessive, more brutal than sublime. He finds 'reservoirs of rottenness' at Newport, 'accumulated filth' at Barmouth, 'dunghills by every door' at Port Isaac, cheating 'at its highest pitch of extravagance' in Aberystwyth, and 'bestial debaucheries' in the mines of Whitehaven. It is as though landscape conventions of the sublime are not enough, and that for harsh and notable experience he has to turn to society and to 'hideous scenes of desolation' made by man.

He introduced his text with a complaint, that 'the inland counties of England' had been 'so hackneyed by travellers and quartos'. He jibed too at the 'ladies' and 'gentlemen' who frequented the tame landscapes of the sea-bathing resorts. He was conscious that pictorial and literary conventions stood in the way of genuine experience, and that one of these conventions was that of ultimate experiences: the sublime itself.

By 1836 tourists were treating the sublime with courteous indifference. Thomas Roscoe, in *Wanderings and Excursions in North Wales*, remarked on this while discussing Mount Snowdon: 'I had noticed a succession of visitors who arrived, as if making a morning call, and, like "shadows that come and go", seemed quite as eager to depart'. The times were failing, in need of renewal. In 1838 William Howitt, in *The Rural Life of Britain*—a thoroughly prepared survey—commented on 'the ambitious and frippery taste of the age', and thought that the remedy lay, in art terms at least, in a return to Nature, 'the true, the beautiful, the unambitious'. He had Thomas Bewick in mind as an example of an artist who had successfully turned to Nature.

Renewal was needed because of a growing sense of disproportion in British life. In the same book Howitt included a diary entry: 'May 8. E. wind, with a blue haze; called here blight; but which is in reality the smoke from London, visible with this wind forty miles down the country'. The blight was more than atmospheric; he also remarked that the countryside around London was bereft of churches and of spirituality.

Elsewhere, on northern farms, he found grim evidence bearing on Britain's future, both scenically and culturally: 'Let us suppose. . . . almost all our working population cooped up in large towns in shops and factories, and all the country thrown into large farms to provide them with corn—what an England would it then be! The poetry and the picturesque of rural life would be annihilated; the delicious cottages and gardens, the open common, and the shouting of children would vanish; the scores of sweet, old-fashioned hamlets, where an humble sociality and primitive simplicity yet remain, would no more be found. . . . all that series of gradations of rank and character, from the plough-boy and the milk-maid, the free-labourer, the yeoman, the small farmer, the substantial farmer, up to the gentleman, would have gone too, "And a bold peasantry, its country's pride" would be replaced by a race of stupid and sequacious slaves, tilling the solitary fields of vast land-holders, who must become selfish and hardened in their natures, from the want of all those claims upon their better sympathies which the more varied state of society at present represents'. Village-centred landscape symbolized a healthy integrated society with a chain of command and a chain of responsibility.

Tomorrow, with its promised excess, looked likely to upset an ideal order of rural life. The complaint was based on aesthetic as well as political grounds. The old England made a complete picture, but modern life brought with it traces of a discordant Elsewhere. In 1850 Sylvanus, author of *The Bye-Lanes and Downs of England with Turf Scenes and Characters*—and a connoisseur of village England, described himself as searching for an ideal spot 'where neither Terminus nor Telegraph is to be seen'. Both elements stood for disruptive, intrusive forces, of a kind which made it difficult ever to feel integrated or at ease. Henceforth most places were simply transit stations on the way elsewhere, or parts of an uncentred network.

There were several ways out. That is what they were: ways out into imagined or secluded England. Sylvanus, a great expert on horse racing and a fund of information of English social life in mid-century, appreciated a tidy countryside, varied but at the same time balanced. This is his admiring picture of Langton Wold on the outskirts of Malton in Yorkshire: 'Highly cultivated lands, fox coverts, wooded heights, fair meadows, mansions, and village spires, lie in sweet mêlée at your feet'. This well-tended countryside recurs in his book ('hedges trimmed to a *twig*'). It is a more fulsome version of the England often described by William Cobbett in his *Rural Rides* of 1830.

Regard for this sort of England often went along with a hankering after the great, bad days of Fielding and Smollett, the 'high-fed, rollicking days of *Tom Jones* and *Count Fathom*', as Sylvanus described them for his own 'era of Turf and Pace'. The painter who catered most completely for this taste of 'the old squire' was Thomas Creswick, whose large-scale landscapes represent a village-centred England, a nice mixture of mills, pasture-lands and river traffic.

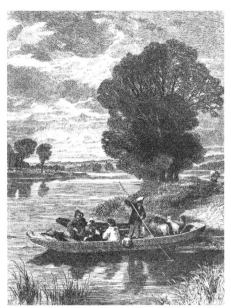

Fig 13 Myles Birket Foster. Illustration no. 28 in *Pictures of an English Landscape (engraved by the Brothers Dalziel) with Pictures in Words by Tom Taylor.* Published by George Routledge and Sons, London 1863

A more popular way out was Birket Foster's, which led into the nooks and crannies of mossy villages, where swallows fluttered over summer duckponds in the shade of elms, urchins lurked by the fence and locals gathered by the country inn. Foster and Tom Taylor, a dramatist, grieved for the old days in their much-loved *Pictures of English Landscape* of 1863. Taylor, in rudimentary verse, referred to the sort of estranging modern experience which gave their idyllic memories a special significance. Like Sylvanus he blamed the railways, but rather for by-passing the villages than destroying the scenery. Like Howitt he looked askance at modern rationalization, especially at 'the trim right-angled pattern/That Science fits her farms to nowadays'. A third disruptive element was Abroad. Opposite a picture of a country ford and watering place he outlined a dismal picture of overseas: 'Under skies of tropic heat,/Over sands that scorch the feet,/By dry beds of parched-up streams,/How many an Englishman may be/Wrapped even now in pleasant dreams/Of English coolth and greenery!'. Abroad made such a forceful showing because it was arduous, remote and disproportionate, as disproportionate as death – if Taylor's *Night Thoughts in an Australian Stockman's Hut* (with illustration no. 28) are reliable: 'But now there lies between us – my early love and me–/Six feet of churchyard loam, and four thousand miles of sea'. Modern life was excessive, to be thought of in terms of vast mileages, vast masses and disintegration.

For whatever reasons traditional ideas of landscape were, decidedly, not shared by a new generation of artists and poets. They neither could nor would subscribe to the deft listing and mapping of the old way, in which a comfortable balance was struck between the cultural and the natural. Composition meant access to, and confidence in, organizing principles, and in 1850 this confidence was conspicuously lacking. In 1843, in *Modern Painters*, John Ruskin spoke up for coherency when he insisted that God's shaping influence could be seen in the many forms of Nature, but the evidence of his writings points the other way, to an individual's intermittent, impulsive apprehensions of a shifting scene. For Matthew Arnold, the most anxious poet of mid-century, the beauties of Nature came unendorsed by God, and intermixed with banalities. Arnold was the poet of unamalgamated fragments. In his most famous poem, *Dover Beach* (1848), 'the light/Gleams, and is gone'. In *Thyrsis*, written on the death of his friend Arthur Hugh Clough in 1861, documentary details simply crop up: 'Fields where soft sheep from cages pull the hay,/Woods with anemonies in flower till May.'

Such unincorporated details are both less ridiculous and more obvious in British painting of that time. Prosaic matter crops up again and again in paintings by Ford Madox Brown, William Holman Hunt and John Everett Millais, in views and close-ups seemingly cut at random from Nature. Frequently shadows cover the entire foreground in Brown's smaller landscapes, and the main, and only, event occurs in a far corner. The question arises: Why this rather than some other more or less insignificant sample of earth?

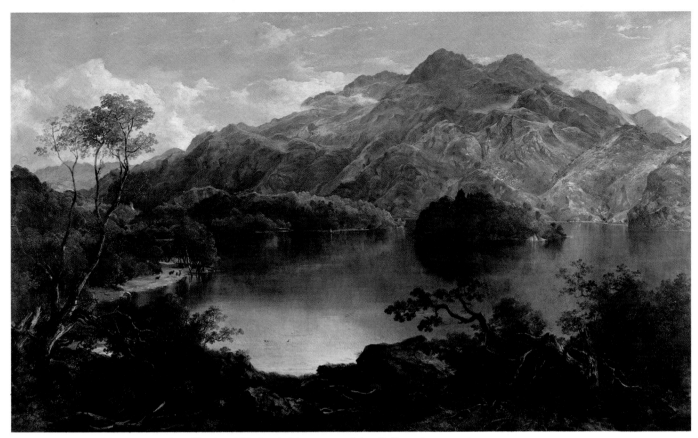

PLATE IX Horatio MacCulloch *Loch Katrine* 1866. Perth Museum and Art Gallery (cat. no. 4)

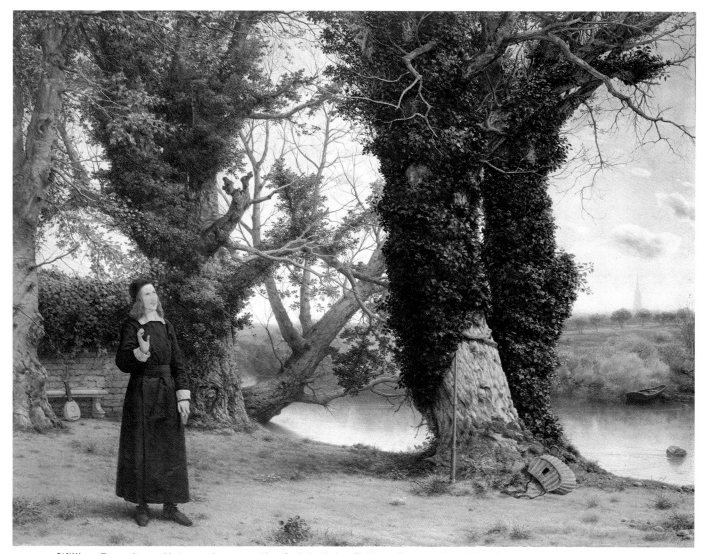

PLATE X William Dyce *George Herbert at Bemerton* 1860. Guildhall Art Gallery, Corporation of London (cat. no. 6)

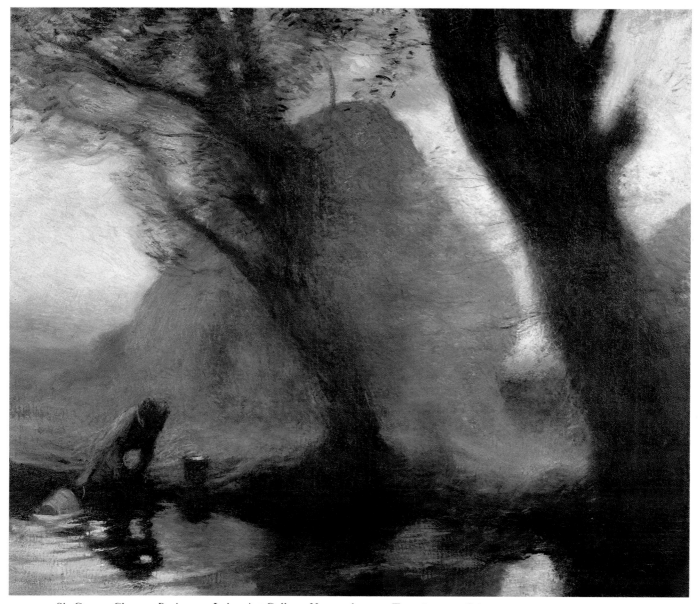

PLATE XI Sir George Clausen *Dusk* 1903. Laing Art Gallery, Newcastle upon Tyne (cat. no. 67)

PLATE XII Sir Alfred Munnings *The Poppyfield* 1905/6. Dundee Museums and Art Galleries (cat. no. 131)

All that can be concluded is that such places existed and were seen from certain standpoints at particular times. Brown especially included much evidence of the moment: flags, sails and plumes of smoke moved by the breeze. He bore witness to a moment, or more specifically to his perception of that moment.

The Pre-Raphaelites were artists engrossed by the idea of sentience and of the sheer materiality of the world. Composition meant mediation or loss of immediacy, and thus it was avoided in favour of vivid presentations of things themselves, seen in states where they impinged on consciousness with peculiar intensity. Brown, for instance, paints scenes of harvesting which have more to do with memories of the abrasiveness of stubble under foot and of straw ropes rough to the touch than with the myth of harvest home. Elsewhere Pre-Raphaelite painting is rich in meticulous evidence of the hardness of stone offset by the caress and splash of water. Or intensity might be won by extremes of irony: Millais' dead *Ophelia* 1851-2 (Tate Gallery, London) floats Lady of Shalott-like through dense undergrowth exquisite to the eye; Hunt's Christian priest sheltered by a family of converted Britons (Ashmolean Museum, Oxford) has also been saved to enjoy the gem-like beauties of the natural world which fringe his Ancient British shelter; Arthur Hughes' weeping sailor *Home from the Sea* 1856-63 (Ashmolean Museum, Oxford) mourns in the sensuous aura of the most idyllic of English churchyards and if the dead of Bettws-y-Coed could rise from under their sundials and stone slabs paradise would meet their eyes in Benjamin Leader's most opulent view of a leafy Welsh hillside, *The Churchyard, Bettws-y-Coed*, 1863 (36).

It is as though a whole generation was moved, for a time, by a horror of abstraction. The world was to be tasted raw, touched and smelled. The Pre-Raphaelites were never quite as extreme in this respect as Courbet, their exact contemporary in France, but they were thorough nonetheless. Courbet invited his audience to live through, or at least to recognize, a variety of states of being: his subjects concentrate with their bodies or with their eyes and fingers or they listen, they wait, they loll, they doze, they die. His landscapes, likewise, allow no escape from material experience. Hillsides, woods and cliffs rise like walls and allow little hope of an escape into pure, objectless vision. British versions of Courbet's confrontational landscapes were painted in watercolour by George Price Boyce in the 1860s. In these beautifully observed and realized pictures, hedges, fences and walls barricade and obscure idyllic corners of the countryside, for example his *Landscape: Wootton, Autumn* (24), and suggest, literally as well as metaphorically, the hardships of seeing. They are pictorial correlatives for Ruskin's idea of the necessary effort involved if the beauties of Nature are ever to be recognized.

They are matched, these surprising paintings, by some of the photographs of Benjamin Brecknell Turner. These too look like sections taken more or less randomly from country waysides. Under previous rules landscape elements were arranged around a far prospect and amounted to no more

than subordinate parts in a vision as deep and distant as the mind of the seer. In B. B. Turner's friezes of pollarded willows, by contrast, the transcendental Beyond is obscured and personal vision reduced to a matter of checking from one particular to another.

But perhaps the most astute of these mid-century naturalists was Roger Fenton, another photographer. Fenton, a reporter in the Crimea, a portraitist and a landscapist, was more used than any of his contemporaries to dealing with ready-made material, images for which the texts were already written: the contents of the British Museum (where he was an official photographer), Crimean war sites already the subject of reports, and beauty spots 'hackneyed by travellers'. In 1858 he toured in Wales, and photographed *Miner's Bridge, Llugwy* (14). The bridge with its regular rungs lies like a yardstick over the rocky bed of the stream, and looks like one of those scales which set a standard in the industrial and documentary pictures of that era. In this respect it represents Nature seen in terms of Culture's units of account. On the other hand a striding man pacing the bridge's rungs reinvests the whole with body and actuality. Fenton had no firmly stated aesthetic programme, but he always seems to have been fascinated by interactions between sign and matter, and between cross-section and deep space. At the same time other view photographers, such as Francis Bedford, turned often to landscapes in process of becoming: timber and cut stones litter their wharves, en route, usually, for another of Brunel's constructions. Photographers worked as though compelled to acknowledge that element of arbitrariness which was inherent in their medium anyway.

Although estranged from traditional organizing principles, the Pre-Raphaelites and their contemporaries still assumed that their work was consequential, and that it could matter to a large audience. Hunt, Brown and the others mingled their intensely observed particular with portentous moments from history and religion. The mingling was sometimes awkward: visions, for instance, were hard to situate in the vivid immediacy of a Pre-Raphaelite landscape–the enraptured poet, George Herbert, in William Dyce's painting of 1860 makes an unconvincing showing (6). History was re-imagined as constituted of vivid instances: Dyce's *Man of Sorrows* (National Gallery of Scotland, Edinburgh) alone in a wilderness, Hunt's *Scapegoat* (Lady Lever Art Gallery, Port Sunlight) perishing on a desiccated shore, Millais' *Jephthah* (National Museum of Wales, Cardiff) aghast at the promised death of his daughter. But not even such fierce and lonely moments from history could blind artists to the meaning of those unincorporated details which so attracted them. Life, these said, was made up of no more than arbitrary moments, unfathomable.

However, one last great, public effort was made to ward off the threat of insignificance which was inherent in the new sensibility. Artists and writers turned, in their quest for the portentous, from history to a more extreme and

demanding sort of landscape. Thomas Hardy described the move most fully, in an account of Egdon Heath, near the opening of *The Return of the Native* (1878). He thought that the taste for orthodox beauty had run its course, and that the new Arcady might be a wasteland: '. . . human souls may find themselves in closer and closer harmony with external things wearing a sombreness distasteful to our race when it was young. The time seems near, if it has not actually arrived, when the chastened sublimity of a moor, a sea, or a mountain will be all of nature that is absolutely in keeping with the moods of the more thinking among mankind. And ultimately, to the commonest tourist, spots like Iceland may become what the vineyards and myrtle-gardens of South Europe are to him now; and Heidelberg and Baden be passed unheeded as he hastens from the Alps to the sand-dunes of Scheveningen'. Millais had already sensed as much in 1870 when he painted *Chill October* (30), one of his most successful pictures which both he and other commentators praised rather evasively on account of its 'sentiment'.

Benjamin Leader, in his late career, expressed the new dour aesthetic most successfully, especially in his glum *February Fill Dyke* (Birmingham Museum and Art Gallery) of 1881. It also continued to work in Thomas Hardy's imagination, and some of the most striking scenes in *Tess of the D'Urbervilles* (1891) are of Tess on remote downland tracks or at work in chilled fields. He referred to 'valour' in the context of turnip cutters labouring in a 'yelling wind' under a 'leaden light'. He wrote as though grandeur could only emerge from hardship and discomfort, or as though there were some natural association between the terms. That idea certainly held for those many artists who painted pictures at that time of solitary tillers, reapers, shepherds and poachers. Tess is as well remembered for what she had to endure as for the exact story of her misfortunes in society.

Hardy dealt in compensatory extremes of bleakness and summertime bliss. There is an aura of the 1860s, and of Pre-Raphaelite evocations of death in paradise, about his work. Younger artists and writers were less resolute for grandeur. In their work things, beautiful or bleak, simply occur and are presented, as it were, indifferently. Richard Jefferies' country folk are as likely to die unremarked in their beautiful habitat. This is the end of a country tale from 1887, *The Acorn Gatherer*: 'When his feet slipped and he fell in, his fishing line somehow became twisted about his arms and legs, else most likely he would have scrambled out, as it was not very deep. This was the end; nor was he even remembered'.

All that can be relied on among these ugly and arbitrary happenings is personal experience of beauty as it is disclosed. Jefferies described himself, again in 1887, as desperate for the experience of beauty: 'The hours when the mind is absorbed by beauty are the only hours when we really live, so that the longer we can stay among these things so much the more is snatched from inevitable Time. Let the shadow advance upon the dial – I can watch it with equanimity while it is there to be watched. It is only when the shadow is *not*

Fig 14 Joseph Pennell. Illustration from
The Stream of Pleasure, Being a Month on the Thames
by Joseph and Elizabeth Robins Pennell,
published by T. Fisher Unwin, London, 1891

there, when the clouds of winter cover it, that the dial is terrible. The invisible shadow goes on and steals from us'. In story after story Jefferies described himself noticing the earth's beauties. His private experience is what matters, and to an unprecedented degree. Sometimes brutal news from outside breaks in, but it only makes his attention the more acute.

Experience of landscape became private experience. Artists became solitaries and wanderers, and the self which had been a martyr became a hermit. Nuances of weather and light constituted the new content of landscape art. Transience became a central concern, and the artist became an observer like Peter Henry Emerson, a photographer and writer who was a distinguished contemporary of Jefferies. Emerson was just as engrossed by Nature, and spent years on the Norfolk Broads learning about its folk and animal life (sometimes indistinguishable). He came away with brutal tales to tell, in, for example, *English Idyls* of 1889 and in the photographically illustrated *Marsh Leaves* of 1895. He is a fund of good advice, on the best time to eat bream (in the spring), and on how to cook pike, but he can also write nauseatingly of a marshman killing a ferret with a spade. His local dialect is convincing, and is used more and more as he withdraws his own voice from his texts. His very precise observations are sometimes ponderous: 'As I stepped from the quaking bog to my boat, a speckled owl flew *heavily* – so fairy-like and stilly was the wintry night, – shrieking over the reed-tops'. Interleaved with the coarseness and the accuracy come photogravures delicate enough to have been taken from the shadows of dead leaves.

Emerson's concern for the *mot juste* was matched by such younger painters as Arnesby Brown and Alfred Munnings, both of whom worked in East Anglia. Neither had anything of Emerson's brutal and nihilistic extremism. Both caught the magic of certain Spring, Summer and Autumn days. They painted animals not entirely for their own sakes but because in certain weathers animals behave in certain ways. Thus it is possible to be especially precise, and to make that drowsy atmosphere under the summer trees incontrovertibly real. The self is assimilated into a Nature which is shown to be as beautiful as anything ever desired by Richard Jefferies.

This aesthetic of intensely felt private encounters with Nature developed in conjunction with a mounting distaste, even hatred, for a corrupted city life. Emerson's bitterest feelings were reserved for the cockneys and charabanc parties who polluted his rural paradise.

London took the brunt of the attack. This is a fragment by Arthur Symons, Britain's main promoter of Symbolism, from *London: A book of aspects*, published in 1909: 'London that was vast and smoky and loud, now stinks and reverberates; to live in it is to live in the hollow of a clanging bell, to breathe its air is to breathe the foulness of modern progress'. He added that it had become 'the wreck and moral' of civilization. By comparison the countryside was presented as entirely restorative, and described thus, with reference to

a view from a Cornish village: '... further on towards the sky, the blue glitter of the sea, shining under sunlight, with great hills and palaces of white clouds, rising up from the water as from a solid foundation'.

Symons' idea, explained in *The Symbolist Movement in Literature* of 1899, was that 'as we brush aside the accidents of daily life, in which men and women imagine that they are alone touching reality, we come closer to humanity, to everything in humanity that may have begun before the world and may outlast it'. In other words the abraded and fouled surface of modern life could somehow be seen through, and beauty uncovered. At least that was his view in 1899; on the evidence of London in 1909, however, the 'foulness of modern progress' could not be overlooked, and indeed caught the imagination more fiercely than evocations of beauty. It was only in railway and transport advertising after the Great War that symbolist prescriptions made much headway in landscape art. By then such purified versions of British scenery were the sheerest fantasy, if contemporary reports are to be believed.

The writing which was on the wall in 1850, Howitt's 'blight', was all over the wall by 1900. The anger of those who cared was great, as was their helplessness. In other cultures artists might have managed some sort of expressive response to what was described in England as destruction of the land. But in England they hardly needed to for the job was taken on early by writers, for whom it quickly became a major theme. It was also a subject which lent itself to writing, a fundamentally more expressive medium in which anger could be given a voice and immediately assuaged, as in Symons' writing, by an oceanic cadence.

Until 1940 the idea of England was indissolubly connected with the idea of England's despoliation. (Britain was a far more robust figure, whose scenery of crags and earthworks coped better with modern blight). Ahead of Symons even, the greatest composer of laments for the brutalized land was G. F. Masterman, who was in charge of British propaganda in the Great War. Masterman wrote regularly for such influential periodicals as *The Contemporary Review*, and in 1905 a set of his essays 'written in time of tranquillity' was put together under the heading *In Peril of Change*. In an essay on *June in England* he described the main danger: 'The Motor is indeed the keynote of the newer changes. All these June Sundays a procession of wandering locomotives hustles along the roads and avenues. The air is vocal with their hooting and shrill cries, the ritual of the New Religion, as they clank and crash through the village, leaving behind the moment's impression of the be-goggled occupants, an evil smell, a cloud of grey dust'. Mr Toad at large. The masses out hop-picking are trolls, 'lured out for a season from the slums of the cities, blinking in dull wonder at the strange world of sunshine and silences to which they have been conveyed'. They are people of the night, 'the litter of their encampments manifest in the day and the lights of their revelry shine far into the night. The old inhabitants, secure in the pride of

Fig 15 Thomas Derrick. *Oread – nymph of the mountain*, illustration in *The Untutored Townsman's Invasion of the Country* by C. E. M. Joad published by Faber and Faber, London, 1946

ancient heritage, gaze dismally at the pandemonium'. They come from a 'labyrinth of lamplit streets . . . crowded thoroughfares . . . warrens and tenements'.

Masterman's bleakest triumph was *In Dejection near Tooting*, another essay of 1905, which reads like a journey to the end of civilization past 'a moving show of shadow shapes of mean houses, in which airy nothing has taken a local habitation and a name'. Tooting reached, it turned out to be London's dumping ground: 'Down below in the valley, conveniently adjacent to the cemetery, was the immense fever hospital, a huddle of buildings of corrugated iron. In front was a gigantic workhouse; behind, a gigantic lunatic asylum; to the right, a gigantic barrack school; to the left, a gigantic prison. Other shadowy and enormous buildings rose dimly in the background. Yet even the presence of these monuments of ruin could not arrest the eruption of mean streets, driven forward by the pressure behind them of unthinkable numbers'. In his survey, *The Condition of England*, published in 1911, his lamentation was for 'a land of radiant beauty' inhabited by a people living 'under the visible shadow of the end'.

But what was deplored was also, and quite clearly, fascinating. Masterman and his contemporaries re-discovered a form of the sublime as they composed their jeremiads. Witnesses to a crime they were unable to prevent they responded with a chanted prose poetry in which detail after detail of the foul new world is listed. Kenneth Grahame, author of *The Wind in the Willows*, watched the vulgarizing of England in the years when Masterman was in full voice and his essays of that time are published in *Pagan Papers*. This is from an *April Essay*, dedicated to *The Rural Pan* but best on the befoulers: 'Who is this that flieth up the reaches of the Thames in steam-launch hired for the day? Mercury is out – some dozen or fifteen strong. The flower-gemmed banks crumble and slide down under the wash of his rampant screw; his wake is marked by a line of lobster claws, gold-necked bottles, and fragments of veal pie. Resplendent in blazer, he may even be seen to embrace the slim-waisted nymph, haunter of green (room) shades, in the full gaze of the shocked and scandalized sun. Apollo meantime reposeth, passively beautiful, on the lawn of the Guards' Club at Maidenhead'.

In the 1930s, and after, C. E. M. Joad sustained and even developed the genre. Joad, a philosopher and eventually a celebrity broadcaster, was alert to every outrageous detail of ribbon development (a term coined by Professor H. J. Fleure and enshrined in the Restriction of Ribbon Development Planning Act of 1935). In 1931 his *Horrors of the Countryside* was published as a pamphlet by Leonard and Virginia Woolf at the Hogarth Press. Joad's material is new and the build-up more inventive and varied than Masterman's: 'Country number two is the country which surrounds the towns and adjoins the main roads. Its characteristic features are petrol pumps and garages, tea places, usually "Old English", shanties, bungalows and innumerable notice boards. It has few native inhabitants, but it is a dormitory

PLATE XIII Joseph Southall *The Botanists* 1928. Hereford City Museums and Art Galleries (cat. no. 95)

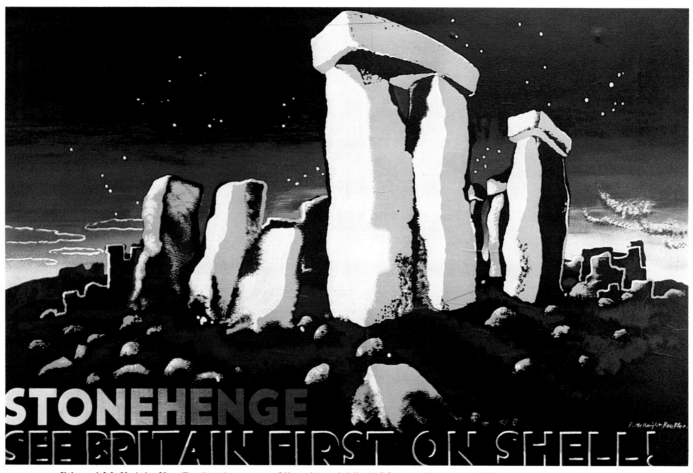

PLATE XIV Edward McKnight Kauffer *Stonehenge* 1931. Victoria and Albert Museum (cat. no. 162)

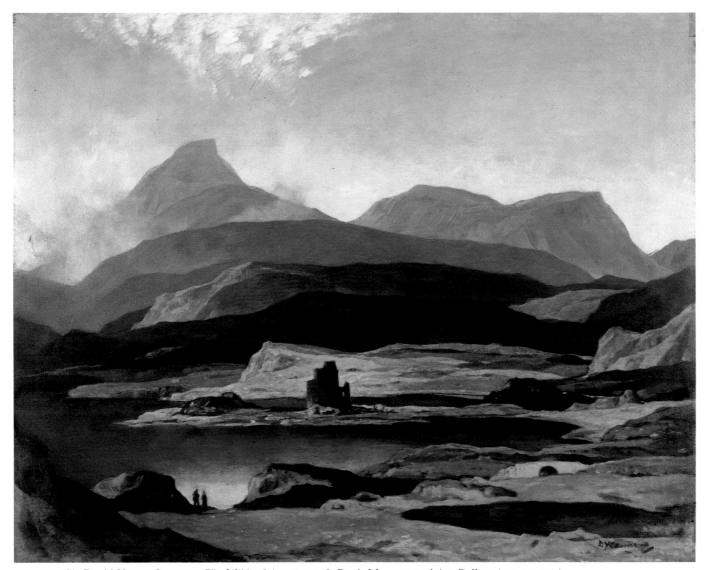

PLATE XV Sir David Young Cameron *The Wilds of Assynt c.*1936. Perth Museum and Art Gallery (cat. no. 100)

PLATE XVI Eric Ravilious *Train Landscape* 1940. Aberdeen Art Gallery and Museums (cat. no. 213)

for town dwellers and a corridor for motorists. Maiden ladies retire into it and keep poultry farms. Those of the original working folk who remain in it abandon their traditional occupations and become parasites on the motorists and suburbanites; they keep wireless sets, buy gramophones and tea cakes in frilled papers, batten on the Sunday press and become basely rich. Their country pubs are replaced by motoring hotels in the hinder parts of which they drink in dingy obscurity'. And so on, year after year through to the 1950s – by which time Joad noted that television had come on the scene as a supplementary aid to alienation.

Joad's denunciations, which took the form of inventories, established a pattern. J. B. Priestley, in the last chapter of his *English Journey* of 1933, gave a similarly itemizing account of what he called 'the third England' – the other two being 'Old' and 'Nineteenth Century'. The third England was made up 'of arterial and by-pass roads, of filling stations and factories that look like exhibition buildings, of giant cinemas and dance-halls and cafés, bungalows with tiny garages, cocktail bars, Woolworths, motor-coaches, wireless, hiking, factory girls looking like actresses, greyhound racing and dirt tracks, swimming pools, and everything given away for cigarette coupons'.

Earlier in his summing-up Priestley had subjected the nineteenth century to the same sort of analysis, but with a difference: he ended on a sombre note, an antique, even romantic, note, with references to 'a cynically devastated countryside' and to 'grim fortress-like cities'. Despite its connections with trade and manufacture an aura of the sublime still clung to the image of the old century. Its crimes had been magnificent. The new age, by contrast, was far more bland than splendid. Above all it was an age of indifference and heedlessness. Grahame's careless befoulers of the Thames were pioneers to be followed, lower down the social scale, by any number of motorized vandals. It was an age which could only be lampooned and shaken into life by paradoxical representations of the stock exchange as Mount Olympus or shop girls as film stars.

The change from Masterman's era to the 1930s was a change from serious, Tennysonian gloom to the collagist shop-window aesthetics of a new age. Joad and Priestley, despite their misgivings, were among the first connoisseurs of the new ribbon-developed English countryside. Glowering or sparkling, they, and many other contemporary writers, had the means to cope with the mobilized masses moving aimlessly between filling stations on the arterial roads. By virtue of the vigour of their prose they could assert themselves in the face of modern plainness.

But painters, watercolourists and etchers did not respond as writers responded. As a rule they held back from satire and parody and pandemonium. In the first place the more established among them were professionals, enrolled in well-regulated organizations: the Royal Academy, the Royal Watercolour Society, the Royal Society of British Artists, the Royal Institute

Fig 16 Ellis Martin. Map cover for The Ordnance Survey 1920s

of Oil Painters, the Royal Society of Painter-Etchers, and so on. These organizations, which mounted regular exhibitions, were powerful upholders of tradition. Younger artists either joined the newer and more radical organizations such as the New English Art Club (1885) and the London Group (1913), or they pulled out altogether, and chose to live, if not in hiding, in relative isolation in the country.

On his English journey J. B. Priestley, after time spent in the Cotswolds, described a visit to an artist friend: 'He is a Catholic, a medievalist, a craftsman who would have all men craftsmen, a thorough hater of everything modern. . . . He has lived in the Cotswolds for thirty years, ever since he ceased to be an art student. . . .' Whoever Priestley's friend was (F. L. M. Griggs?–an engraver and Cotswold Catholic), he was not unlike the engraver Eric Gill, who settled in Ditchling in Sussex in 1907 and moved to Capel-y-ffin on the Welsh borders in 1924–where he was joined in the same year by the painter and poet David Jones. In Northumberland, Helen Sutherland's Rock Hall was another artists' refuge from 1928. David Jones, in particular, was a regular visitor and painted from the windows.

'A scene painted from the window at. . . .', is a phrase of the greatest significance in this context. It recurs in catalogue raisonnés of the art of these years. Windows were noticed; they were important, as signs both of privacy and of access. Helen Sutherland, in a diary entry of 1928, noted of the Nicholson's place near Lanercost in Cumberland, 'it's a lovely white farm full of great windows'. Not all windows opened on to such delightful landscapes as those at Rock Hall and Bankshead, the Nicholson's house. T. S. Eliot's 'lonely men in shirt-sleeves leaning out of windows' mused over 'narrow streets' in 1917 when *Prufrock* was published. David Jones at his parents' house in Howson Road, Brockley, looked out on a series of suburban enclosures in the late 1920s (183). Paul Nash, painting in the same years from a room opposite St Pancras Station saw mysterious evidence of a modernistic Elsewhere. But most contemporary artists were watchers who looked out from their windows on to scenes of far greater beauty: ancient villages and wholesome vales of the kind outlined by Rex Whistler, in his deft book illustrations of the 1930s, and by Ellis Martin in his map covers for the Ordnance Survey.

The early Romantics represented windows and solitary watchers, and the idea of isolated apprehension of a world was sustained by Samuel Palmer in his images of walled gardens and shadowing trees. Some of the Pre-Raphaelites painted as though from terraces, but in isolation rather than seclusion. From the 1860s onwards the Impressionists often painted from high windows, but their idea was to be inclusive, to take a bird's eye view. Solitary, secret watchers only declared themselves in any numbers around the turn of the century. Sickert was one of these, observing from the shadows in London theatres.

The new watchers of the 1920s were of a different order again. Sickert had

Fig 17 Rex Whistler. Frontispiece to *A Village in a Valley* by Beverley Nichols, published by Jonathan Cape, London, October 1934

reached out to the glitter and liveliness of streets and theatres. His secretive successors, by contrast, moved back as though seeking refuge. The majority of David Jones's landscapes, for example, feature windows as thresholds secured by vases and domestic oddments, which create a larger and more personal landscape inside the room than any to be seen out there. Frances Hodgkins did much the same in window pictures, filled by flower arrangements. Ben Nicholson, in the late 1920s, could paint landscapes where window frames have the strength of embrasures, and give only guardedly on to the outside world. Other, more modern, forms of withdrawal are suggested by Gertrude Hermes looking out from the warm security of a car down the beam of her headlights (197), and by Eric Ravilious considering ancient Britain from the relative comfort of a third-class compartment (213).

The twentieth-century landscapist lived in a rural retreat – in Cumberland, Cornwall, Wales, East Anglia, the Cotswolds. If unable to find a permanent hideaway the artist roamed far afield in holidays, and in comprehensive biographies of the period these interludes are always stressed as formative. Secondly, the same landscapist sought seclusion, and often acknowledged as much in window pictures which simultaneously signify separation and access. Thirdly, the twentieth-century landscapist was as likely to be a draughtsman as a painter. Some Victorian artists had matched grandiose landscapes in grandiose paintings. The new landscapist was, by contrast, a private person who made notations for other private people. In fact much of the landscape art of the twentieth century takes the form of book illustration and etching, both of which emphasize private consumption: both are scanned in solitude by their readers and connoisseurs.

The pioneers, etching in the days of Richard Jefferies, were virtuosi, acutely attentive to shorelines and tidelines and to atmospheric effects. Frank Short and David Young Cameron had the eyes of sportsmen or of expert shots. Their successors, especially the Goldsmiths' landscapists of the 1920s, made their scenes small and intimate. They (Graham Sutherland and Robin Tanner especially) were deeply moved by their discovery of Samuel Palmer. Graham Sutherland, recalling his time at Goldsmiths' School of Art, accounted for the change thus: 'The day on which one of our band, William Larkins, brought a small Palmer etching (*The Herdsman's Cottage*) which he had found in Charing Cross Road was a turning point'. It was a turning point confirmed by what Robin Tanner remembers as an 'astonishing' exhibition of late 1926 at the Victoria and Albert Museum, *Drawings, Etchings, and Woodcuts by Samuel Palmer and other disciples of William Blake*. The times were right for Samuel Palmer, and the welcome given to him was uninhibited; Graham Sutherland and his companions set off, cloaked, for Palmer's 'Valley of Vision' at Shoreham. The etchings which resulted were deeply-bitten, full of intricate shadows and sudden highlights. Palmer's influence was permanent; in particular he helped establish the type of the refuge image which was to last in painting and in the graphic arts well into the 1940s.

Fig 18 John Minton. Dustjacket for *New Writing and Daylight*, a book of essays, stories and reviews published by The Hogarth Press, London, 1944

Although in hiding for the most part landscapists were still drawn to the sublime. Turner and the romantics could not be competed with as regards mountains and wilderness, and nothing sublime was to be found along the North Circular Road. But Ancient Britain still gave scope for dreaming. Civilized Romans, homesteading Saxons, wild Danes and brutal Normans had walked through the art of the nineteenth century, as had some pious Britons. Few of these reappeared, but British sites automatically, it seems, induced far-reaching reveries. Thus J. Ramsay MacDonald in 1918 dreaming (of the Great War?) in the West Country: 'Up on the hill-tops was the ridge way worn by the feet of our British predecessors, dotted with the grey stones and burial mounds of which Ossian sings with a sad heart, for even in his day the dead who lay there had lost their names. The mists came down, and the hills hid themselves in grey mantles. A great gloom was upon us, and the wind souched round us and supplied the magic which raises the dead'. Vaughan Cornish, closely associated with the Council for the Preservation of Rural England, was as easily set dreaming in *The Scenery of England* (1932) where he imagined 'worship in the courts of Stonehenge'. Bill Brandt made similar invitations in dark pictures of Avebury and Maiden Castle (224), as did Edwin Smith through into the 1950s. Such sites, on which there appeared to have been a fusion of original landscape and human building, pointed back to a time when human activity had the look of something justified by nature, far from the 'bungaloid scurf' which C. E. M. Joad thought of as characteristic of the modern age.

The court of Stonehenge, however, was a court of last resort for seekers after the sublime. Britain, even in the 1930s, was well on the way to rationalization, and to a future in which many inspirational irregularities would be smoothed away. Town and Country planning was evolving and the influential R. G. Stapledon (a prolific author and Professor of Agricultural Botany at the University College of Wales) was asking, in *The Land: Now and Tomorrow* (1935), for an 'All-embracing Survey and Enquiry' which entailed detailed land-utilization maps and aerial photography. In 1942 Lord Justice Scott's Committee on Land Utilization in Rural Areas carried out something of the sort and gave rise to one of Joad's greatest diatribes on the 'England of leisure-users'. Sir Stephen Tallents, who was to be head of the Empire Marketing Board and a major British propagandist before the Second World War, wrote on *The Projection of England* in 1932 and envisaged a culture in which research institutes set the pace whilst picked workers in the arts were busy with the propagandist task of 'national projection': *The English countryside*, *English villages*, the *English home* and *English servants* prominent on the list of selling features. Tallents, impressed by what he had seen of national projection at the great international exhibition in Barcelona in 1929, was persuasive and under his guidance and in the corporatist ethos of

the 1930s a strong element of 'rural projection' entered into landscape art. Individual identities were to a certain extent subsumed into the house style of Great Britain Inc., as represented by its ministries and manufacturers; and it was thus enrolled that British artists found themselves when confronted by the unbuttoned exuberance of American 'national projectionists' in the late 1950s.

Selected Bibliography

Ayton, Richard
A Voyage round Great Britain undertaken in the summer of the year 1813. With a series of views illustrative of the character and prominent features of the coast, drawn and engraved by William Daniell. Eight vols. London: Longman, 1814–25

Brandt, Bill
Literary Britain. Photographed by B. Brandt. With an introduction by John Hayward. London: Cassell and Co., 1951

Bell, Adrian
The Open Air. An anthology of English country life. London: Faber and Faber, 1936

Chapman, Guy Patterson
Culture and Survival. London: Jonathan Cape, 1940

Cobbett, William
Rural Rides in the Counties of Surrey, Kent, Sussex . . . with economical and political observations relative to matters applicable to, and illustrated by, the state of those counties respectively. London: William Cobbett, 1830

Cornish, Vaughan
The Scenery of England. A study of harmonious grouping in town and country. London: Council for the Preservation of Rural England, 1932

Emerson, Peter Henry
English Idyls. London: Sampson Low and Co., 1889
Marsh Leaves. With sixteen photo-etchings from plates taken by the author. London: David Nutt, 1895

Grahame, Kenneth
Pagan Papers. London: E. Mathews and J. Lane, 1894

Howitt, William
The Rural Life of England. Two vols. London, 1838

Jefferies, Richard
A collection of articles by Richard Jefferies extracted from Longman's Magazine. London, 1883–87

Joad, Cyril Edwin Mitchinson
The Horrors of the Countryside. London: Leonard and Virginia Woolf, 1931 (Day to Day Pamphlets)
The Untutored Townsman's Invasion of the Country . . . With Drawings by Thomas Derrick. London: Faber and Faber, 1946

Foster, Birket and Taylor, Tom
Birket Foster's Pictures of English Landscape. London, 1863

MacDonald, James Ramsay
Wanderings and Excursions. London: Jonathan Cape, 1925

Masterman, Charles Frederick Gurney
The Condition of England. London: Methuen and Co., 1909
In Peril of Change: essays written in time of tranquillity. London: T. Fisher Unwin, 1905

Powys, Llewelyn
Dorset Essays. With forty photographs by Wyndham Goodden. London: John Lane, 1935

Priestley, John Boynton
English Journey. Being a rambling but truthful account of what one man saw and heard and felt and thought during a journey through England during the autumn of the year 1933. London: W. Heinemann; Victor Gollancz, 1934

Rinder, Frank
D. Y. Cameron: An Illustrated Catalogue of his Etched Work with Introductory Essay. Glasgow: James Maclehose and Sons, 1912

Roscoe, Thomas
Wanderings and Excursions in North Wales, with 51 engravings by Radclyffe, from drawings by Cox, Harding, and others. London, 1837

Stapledon, Sir Reginald George
The Land, Now and Tomorrow. London: Faber and Faber, 1935

Sylvanus [Robert Cotton]
The Bye-Lanes and Downs of England, with Turf Scenes and Characters. London, 1850

Symons, Arthur William
The Symbolist Movement in Literature. London: W. Heinemann, 1899
London: a book of aspects. London: privately printed, 1909

Tallents, Sir Stephen George
The Projection of England. London: Faber and Faber, 1921

The Industrial Landscape in British Literature

by Donald Davie

By 1850 in Britain, as in other countries, what historians of all the arts recognize as 'the Romantic Movement' had overcome early opposition and derision and had established itself as a reigning orthodoxy. There would be still, through many decades to come, pockets of resistance; and in those pockets there would be articulate people of real distinction. But their anti-Romanticism, whether well or ill conceived, would be a minority opinion.

When we consider how any of the arts treated landscape, one feature of the Romantic Movement must surely bulk larger than any other: the displacement of the aesthetic category of 'the beautiful' by that of 'the sublime'. Edmund Burke's *Philosophical Inquiry into the Origin of Our Ideas of the Sublime and Beautiful* had appeared as long ago as 1756; but its coming so soon, and anticipating so much, only shows Burke's genius. Already in this seminal treatise 'the beautiful' is continually in danger of being demoted to the merely pretty, and it is plain that Burke was far more excited by 'the sublime', alike in nature and in art. Of the sublime, as Burke expounded it, two related characteristics are particularly important for students of the way in which modern art has rendered landscape: first, the sublime has to do characteristically with objects and scenes of a physical magnitude beyond that which the beautiful could sustain; secondly, and largely as a result, sublime art and sublime nature make us *frightened* – with a fright that, oddly enough, we take pleasure in.

In *The Old Curiosity Shop* (1840–41) Charles Dickens described a landscape which, both in magnitude and frightfulness, answered to Burke's criteria for the sublime, though it was landscape of a kind that Burke could not have known. It was the recently but comprehensively industrialized landscape between Birmingham and Wolverhampton:

> a long, flat, straggling suburb passed, they came by slow degrees upon a cheerless region, where not a blade of grass was seen to grow; where not a bud put forth its promise in the spring; where nothing green could live but on the surface of the stagnant pools, which here and there lay idly sweltering by the black roadside.

This passage is quoted by Margaret Drabble, to whose *A Writer's Britain, Landscape in Literature* (1979) we must be indebted for a demonstration of how, consistently and from early on, industrialized landscapes satisfied the criteria of sublimity as well as, or better than, any non-industrialized landscapes could.

This put the Victorian artist in a quandary. For the passage from *The Old Curiosity Shop* makes it quite clear that for Dickens the blasted sublimity of

Walter Bell
Derbyshire Quarry (detail) 1937
Sheffield City Art Galleries
(cat. no. 220)

37

the Birmingham/Wolverhampton landscape was bought at an altogether exorbitant cost, humanly, socially, even aesthetically. Accordingly the entire category of the sublime, as equal or superior to the beautiful, was called into question. Ian Jeffrey for one has noticed how frequently in the 1850s (Dickens himself as a prime example) there is a nostalgic appeal back to the eighteenth-century England of 'the old Squire' – that is to say, to an English landscape where the modest scale of 'the beautiful' (cornfields and spinneys, dells and dingles) is preferred to the more vaunting scale of 'the sublime'. Moreover it is not a simple matter of preferring agrarian to industrial scenes; for agrarian landscapes had themselves been industrialized, in the sense that in some areas, particularly in the North of England, agriculture had been rationalized by landowners intent on maximum profits, who had therefore merged many small holdings into one vast sweep of cornfields, of which the extent, the sheer magnitude, dismayed many visitors from the south, as once again Ian Jeffrey has noticed. Accordingly, when Victorian sages like Thomas Carlyle (*Past and Present*, 1843), George Eliot (*Felix Holt*, 1866), Matthew Arnold (*Culture and Anarchy*, 1869) or John Ruskin (*Unto This Last*, 1860) regarded the growth of industry with at least dismay and apprehension, and often enough with anger and indignation, their protests cannot be set aside as the ultimately frivolous petulance of privileged aesthetes. Their horror at what industry was doing to the landscapes of Britain came not from the eradication of many scenic prospects that they could have taken pleasure in, nor did any of them for long imagine that they could put the clock back. They were concerned with landscapes as arenas in which lives are lived, even as images of how private and communal life could be conducted either satisfyingly and with decency or else brutally. The point was that people lived, and would continue to live, between Birmingham and Wolverhampton; that the landscape there, precisely by its sublimity (for the sublime was by definition on a more than human scale), seemed to threaten that the lives lived there could not be satisyingly human. Thus the sense of affront, of outrage, conveyed by Ruskin in particular is, it may well be thought, something we cannot afford to leave behind; for it derives from considerations that are humane and civic rather than, in any narrow sense, aesthetic.

All the same, by 1870, if what you wanted of English landscapes was 'the sublime', there seemed no doubt that industrial landscapes supplied it, or would soon supply it, better than agrarian or pastoral landscapes. Though the mountains of Wales and Scotland, not to speak of Ireland, were still grander and more awesome than any industrialized areas of those countries, in England that was not the case. For the man-made or man-devastated landscapes of Manchester and Salford already rivalled in sublimity the nature-made landscapes of Wordsworth's (or Ruskin's) Lake District. Very curious in this perspective is R. D. Blackmore's description of the Doone valley in chapter 4 of his *Lorna Doone* (1869):

> . . . she stood at the head of a deep green valley, carved from out the mountains in a perfect oval, with a fence of sheer rock standing round it, eighty feet or a hundred high; from whose brink black wooded hills swept up to the sky-line. By her side a little river glided out from underground with a soft dark babble, unawares of daylight; then growing brighter, lapsed away, and fell into the valley. There, as it ran down the meadow, alders stood on either marge, and grass was blading out upon it, and yellow tufts of rushes gathered, looking at the hurry. But further down, on either bank, were covered houses, built of stone, square and roughly cornered, set as if the brook were meant to be the street between them. Only one room high they were, and not placed opposite each other, but in and out as skittles are; only that the first of all, which proved to be the captain's, was a sort of double house, or rather two houses joined together by a plank-bridge over the river.
>
> Fourteen cots my mother counted, all very much of a pattern, and nothing to choose between them, unless it were the captain's. Deep in the quiet valley there, away from noise, and violence, and brawl, save that of the rivulet, any man would have deemed them homes of simple mind and innocence. Yet not a single house stood there but was the home of murder.

This is composed with admirable craft, particularly in the ways the sublimity of the moor around ('fence of sheer rock' . . . 'black wooded hills swept up to the skyline') is evoked to surround 'the beautiful' in the isolated settlement, with its 'cots' and 'rivulets'. There is no wonder that *Lorna Doone* reads as seductively now as it did a hundred years ago. Yet now, when we can visit the Doone valley by motor-coach, the gestures towards the sublime seem unconvincing, almost comically so. In the age of the motor-car Exmoor itself has shrunk for the imagination; it is hard to attach such words as 'wild' or 'remote' to a terrain that one may cross in a half-hour at most. This drastic contraction of distances, the consequence of rapid transport, stands between us and the landscapes of many late Victorian writers. Richard Jefferies for instance often tries to convey a sense of remoteness and loneliness in describing landscapes of southern England that we have good reason to think of, from our own experience, as thoroughly cosy and densely peopled. And although in Jefferies' case Jeremey Hooker may be right to see this as the projection on to landscape of psychological loneliness and alienation in Jefferies himself, the same cannot be said of Thomas Hardy, though there are occasions in *Jude the Obscure* or *The Return of the Native* when Hardy attributes to various Wiltshire or Dorsetshire uplands qualities of sublimity which, if we have motored thereabouts, we may find it hard to accord to them. Hardy himself was aware of this change of scale in our perception of landscape, and there is a very astute passage in *Jude the Obscure* about the coming of the railway which, at the same time as it made accessible places previously remote, made *more* remote other places that had been on the stage-coach routes but were now bypassed by the railway. For that matter Blackmore was already writing in the Railway Age, and he was able to endow

Exmoor with sublimity chiefly by telling his story through the eyes of the seventeenth-century yeoman John Tidd. His style, in the passage quoted and throughout the story, moves very adroitly and with marvellous resourcefulness between normal Victorian English and a pastiche of what we can imagine as provincial seventeenth-century speech. Some Edwardian authors who wrote about what was by then called 'the countryside' fabricated and used, much more heavy-handedly and with far less logic, a self-consciously archaic English which is sometimes used even now, for instance in brochures for the tourist trade. Meanwhile other originally Edwardian writers, as different as Arnold Bennett and D. H. Lawrence, were attempting the surely more honourable task of showing that in thoroughly industrialized landscapes, despite the privations that they imposed on their inhabitants, lives of decency and crippled dignity could be lived.

We may set beside Dickens in the 1840s between Birmingham and Wolverhampton George Orwell in the 1930s outside Wigan:

> I remember a winter afternoon in the dreadful environs of Wigan. All round was the lunar landscape of slag heaps, and to the north, through the passes, as it were, between the mountains of slag, you could see factory chimneys sending out their plumes of smoke. The canal path was a mixture of cinders and frozen mud, criss-crossed by the imprints of innumerable clogs, and all around, as far as the slag heaps in the distances, stretched the 'flashes' – pools of stagnant water that had seeped into the hollows caused by the subsidence of ancient pits. It was horribly cold. The 'flashes' were covered with ice the colour of raw umber, the bargemen were muffled to the eyes in sacks, the lock gates wore tears of ice. It seemed a world from which vegetation had been banished: nothing existed except smoke, shale, ice, mud, ashes, and foul water.

The coincidence over more than a century between Dickens and Orwell is surely extraordinary; not only the tone but many of the images – the stagnant water, for instance – are identical. The English imagination, one is tempted to say, had over a century made no progress in accommodating, in *humanizing*, industrial landscapes. John Berger, in an essay on the painter L. S. Lowry ('Lowry and the Industrial North', 1966, in *About Looking*, 1980) has harshly but justly complained of 'the submerged patronage found in nearly all critical comment on Lowry's work'. Lowry's landscapes of industrial Lancashire are treated, says Berger, 'as though they dealt with the view out of the window of a Pullman train on its non-stop journey to London, where everything is believed to be different'. It would be intolerable to call Orwell's appalled compassion for the unemployed of Wigan 'submerged patronage', but it is true that his description of the environs of Wigan, if it is not quite the view through the window of a Pullman train, is still, like Dickens's view of Wolverhampton, the view of an outsider, a tourist. Lowry's view on the other hand, like Arnold Bennett's view of the Potteries or Lawrence's of industrial Nottinghamshire, is the view of an insider, for whom the landscape that

Orwell describes is the landscape of the native habitat. 'Dreadful', Orwell's epithet, is not what would come to the lips of one who had grown up in such scenes. And the point is important. Berger, quoting this Orwell passage (from *The Road to Wigan Pier*) declares that it 'is virtually describing a painting by Lowry'. We need not quarrel with that. But to give a virtual description of a painting is different from giving an *equivalent* of that painting in the alternative medium of words. It is not in Orwell's prose but only in Lowry's paint that we find what Berger finely identifies as the content of Lowry's paintings: 'The notion of progress—however it is applied—is foreign to them. Their virtues are stoic; their logic is one of decline.' About progress or decline, as about stoicism, Orwell's honourably shocked prose has nothing to say, one way or the other.

It is worth noticing two points at which Orwell's English could have risen above itself, to something artistic, more than documentary. One is at the expression 'to the north through the passes', where a more artistic writer would have exploited the possibility of an allusion, melancholy or sardonic, to those romantically sublime landscapes which the Wigan landscape parodies—if only, it may be thought, by carrying them to their historically logical conclusion. And the other comes with the word 'flashes'. Does this local usage derive from something like the American expression, 'flash-floods'? Or does it not, more affectingly, register how the sheets of standing water take the light, the sky, and render it back to the observer as an illumination, an enlightenment? Orwell passes over the word without dwelling on it—he is using language as an instrument, not as an artistic medium.

Those pools of standing water in industrially ravaged scenes, which moved Dickens and Orwell to the aversion registered by 'stagnant' and 'foul', can appear quite differently to the eye of an insider like Lowry or the poet Charles Tomlinson, native of industrial Staffordshire:

> It was a language of water, light and air
> I sought—to speak myself free of a world
> Whose stoic lethargy seemed the one reply
> To horizons and to streets that blocked them back
> In a monotone fume, a bloom of grey.
> I found my speech. The years return me
> To tell of all that seasoned and imprisoned:
> I breathe familiar, sedimented air
> From a landscape of disembowellings, underworlds
> Unearthed among the clay. Digging
> The marl, they dug a second nature
> And water, seeping up to fill their pits,
> Sheeted them to lakes that wink and shine
> Between tips and steeples, streets and waste
> In slow reclaimings, shimmers, balancings,
> As if kindling Eden rescinded its own loss ('The Marl Pits', from
> And words and water came of the same source. *The Way In*, 1974)

Berger's perception of stoicism as the implicit moral content of Lowry's pictures is endorsed by Tomlinson in the phrase 'stoic lethargy'. But by Tomlinson this condition is named only so as to be transcended. And it is transcended not by moving away, in fact or in imagination, to a place where water is purer, air cleaner, but on the contrary by dwelling ever more intently on the local fact to the point where water, however fouled, can still be identified as the element, water, and air, however smoky, can still be welcomed as the element, air – to the point indeed where Burslem or Hanley can be retrieved as 'Eden'. To achieve this, or to prove the achievement, all the energies of words must be released, down to what is as raw material no more than a rhyming jingle – of 'kindling' for instance with 'rescinded'.

To those with a strong humanitarian and/or political concern about injustice, anxious to ameliorate the privations of the labouring or unemployed poor imprisoned in the blighted landscapes of old and declining industry, such a transcendence as Tomlinson's poem proclaims and proves is far from welcome. For they will argue, from their standpoint quite justly, that every testimony to how a deprived lot can be transcended saps the will of the deprived to change their lot by political, perhaps revolutionary, action. And this, we may suspect, is John Berger's way of thinking. For he says of Lowry's art: 'It does not belong in the mainstream of twentieth-century art, which is concerned in one way or another with interpreting new relationships between man and nature.' And in another essay in *About Looking* ('Romaine Lorquet', 1974), he explains what he has in mind:

> All art, which is based on a close observation of nature, eventually changes the way nature is seen. Either it confirms more strongly an already established way of seeing nature or it proposes a new way. Until recently a whole cultural process was involved; the artist observed nature: his work had a place in the culture of his time and that culture mediated between man and nature. In post-industrial societies this no longer happens. Their culture runs parallel to nature and is completely insulated from it. Anything which enters that culture has to sever its connections with nature. Even natural sights (views) have been reduced in consumption to commodities.

> The sense of continuity once supplied by nature is now supplied by the means of communication and exchange – publicity, TV, newspapers, records, shop-windows, auto-routes, package holidays, currencies, etc. These, barring catastrophes – either personal or global – form a mindless stream in which any material can be transmitted and made homogeneous – including art.

Those of us who, while recognizing in Berger's account some of the indeed dismal features of our present situation, yet feel that his condemnation is too sweeping, may take heart by looking again at Tomlinson's poem. For does Tomlinson's art there propose 'a new way' of seeing nature? Clearly it does not; it applies itself strenuously to recovering an old way, long lost – which is, of course, quite different from confirming 'an already established way'.

PLATE XVII Spencer Frederick Gore *The Garden*. Kirkcaldy Museums and Art Gallery (cat. no. 127)

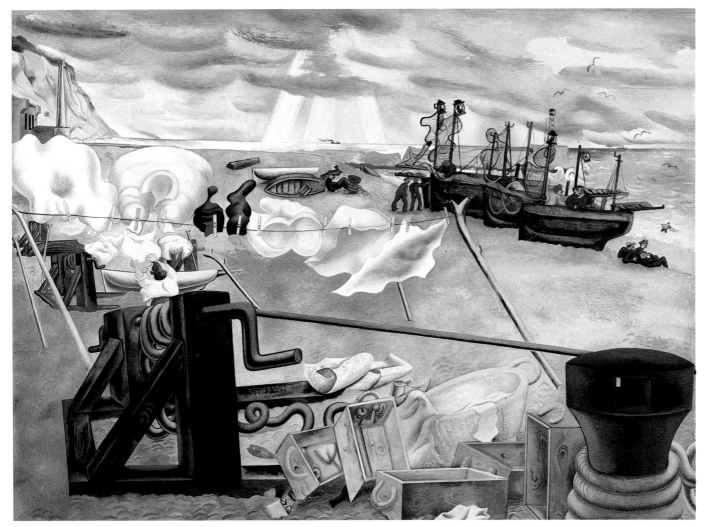

PLATE XVIII Edward Burra *South West Wind* 1932. City Museum and Art Gallery, Portsmouth (cat. no. 226)

PLATE XIX Mary Potter *Rising Moon*. Ferens Art Gallery, Kingston upon Hull (cat. no. 193)

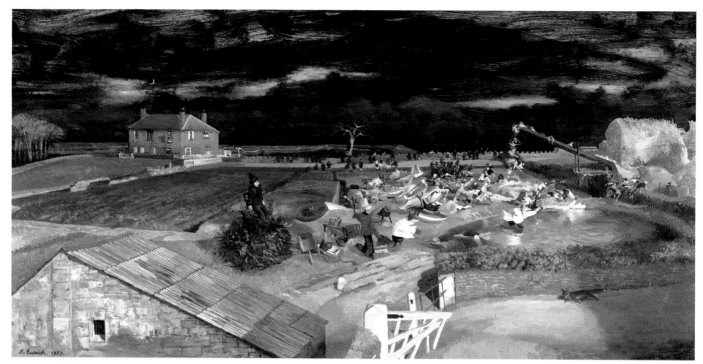

PLATE XX Richard Eurich *Men of Straw* 1957. Castle Museum, Nottingham (cat. no. 206)

Thus John Berger's either/or – *either* change the way nature is seen *or else* confirm an already established way – is false. These are false alternatives. For it may be argued that the best British writing through the past hundred years and for longer has concerned itself, as Charles Tomlinson's poem does, with a third way that John Berger either fails to see or refuses to acknowledge. This third way is a way of recovery – recovery of ways of seeing long lost but still available to us if we will take the trouble to look for them. To find them we need to look in ourselves as well as in landscapes; for they are to be found, in fact, in the transaction between ourselves and the landscapes that we inhabit and move among and (too seldom) pause to contemplate.

Meanwhile, however, we may suspect, taking note of the poems as well as the paintings most popular among us, that 'landscape' as most of us understand it tacitly excludes the industrial landscapes we have been talking of. How do we explain this persistently greater popularity of pastoral and rural landscapes? Margaret Drabble's explanation seems to be, very gently and obliquely, that this is infantile; that in reverting from the sublime to the beautiful, we have demoted the beautiful not to the pretty but to the *cosy*; that in opting for the smaller scale of the beautiful we have in fact sought, if not the womb, at least the cradle. Undoubtedly for the most industrialized and urban of nations to seek so persistently in its art for the pastoral, the pre-industrial, can hardly be a sign of health. If so, there is still point to the gibe at the self-styled 'Georgian' poets of the time of the First World War that the rural landscapes in their poems were word-painted by week-enders from London or some other city. (It is perhaps significant that this gibe was more commonly heard forty years ago than today.) Undoubtedly, however, this charge can be levelled too unthinkingly. On the one hand, the idyll has been from ancient times, in painting and in literature alike, an art-form which, by presenting what ideally ought to be and perhaps once was, by implication criticizes caustically what has in fact come to pass – in landscapes and in the societies that those landscapes image or imply. Thus, a work of art which paints a picture of a Britain that once was, or once may have been, may be commenting sharply on the very different Britain that we inhabit. And on the other hand, Richard Jefferies was not the first or the last English artist to practise what the French call *paysage intérieur* – that is to say, while offering to present a landscape exterior to himself, in fact he expressed and communicated a landscape in his head or in his heart. The loneliness of Edward Thomas, like the loneliness of Jefferies, is projected on to the outside world but is really a psychological state which cannot find expression in any other way. The clue to this is that both Jefferies and Thomas see something deadly in the non-human Nature that they celebrate. And if this seems a devious way of expressing one's self, it is borne out by common usage. For how strange it is, after all, that we can and do speak of 'a lonely place' as of 'a lonely

person'. Indeed if it should be true, as some psychologists tell us, that loneliness (alienation) is the besetting malady of the industrially urbanized man and woman, then – paradoxically – we can expect to meet more lonely and unpeopled landscapes in poems and paintings, even as such landscapes become harder to find in actuality.

Finally, we may pause on a word that John Berger uses: 'post industrial'. In trying to understand what this might mean, we may perhaps think first of electronic or 'clean' industries. Certainly the industrial presence in our lives is no longer, for most of us, signalled by reeking smoke or by burning flares in the night from chemical factories or from foundries. A new sort of industrialized landscape was heralded by the development, fifty or more years ago, of the Great West Road's approach to London: 'glittering white factories with green lawns and beds of tulips'. Interestingly, Orwell objected to this vehemently, declaring, 'A dark Satanic mill should be like a dark satanic mill.' Margaret Drabble sees Orwell here as 'tempted by the "sublimity" argument'. Of course we see what she means. But by now we have 'industrial archaeology'; probably as many coaches visit the long abandoned factories in Coalbrookdale as cruise into the Doone valley. John Betjeman's poem 'A Shropshire Lad' (in *Old Lights for New Chancels*, 1940) was already wringing pathos out of once-industrial Shropshire, since reverted to pastoralism; as at the same time was W. H. Auden out of the abandoned mine-workings of his native Craven in Yorkshire. It is from a standpoint of sympathy with industry in its pioneering and massively grim Victorian embodiment that we can dislike hygienic factories among beds of tulips as, in John Berger's words, part of the 'mindless stream' constituted by 'the means of communication and exchange'. Certainly, if we see industry in the image of the credit-card and the TV set, we image it quite differently from Dickens and Orwell and Tomlinson, with their pools of standing water among spoiled earth. From this point of view, we might maintain that the great achievement of English landscape art over the past 130 years has been the assimilation and humanizing of the First Industrial Revolution; and the challenge which confronts it now is the assimilation of the Second (Computerized) Industrial Revolution, so much more suave and twinkling, with no longer any visible claim to sublimity. And doubtless, in the hands of a few earnest and dedicated masters the rural idyll will stand as stern a reproach to the Second Industrial Revolution as to the First.

Chronology

Social

1850–1860

The 1851 census revealed that, for the first time, the size of the urban population of England exceeded that of the rural; it showed too that over 20% of the national income still derived from agriculture. The 1850s, coming after the 'Hungry '40s' which had still suffered from the effects of the Napoleonic Wars, were years of great agricultural prosperity. High inputs of capital and labour led to high returns; aided by improved transport facilities and improved soil conditions, mixed farming prospered. Mechanical reapers and threshers became far more widely used after mid-century: mechanization, however, continued to be a slow and gradual process. The number of agricultural organizations grew apace, as did the number of agricultural journals. The Royal Scottish Forestry Society was founded in 1854; 1857 saw the founding of the Alpine Society. Darwin's *Origin of Species* appeared in 1859. Darwin had in fact originally been more interested in geology, a relatively new science, than in biology. At first the work of a few isolated individuals, the classification and gathering of material became increasingly systematic after 1830. 1858 saw the founding of the Geologists' Association, open to both professionals and amateurs. By 1850 the main trunk of the railway system had been built (the first railway, the Stockton to Darlington line, had opened in 1825). To begin with development of the railways was piecemeal and uneven; the 1840s and '50s, however, saw the amalgamation of smaller, local companies into large corporations. The road network, much improved by 1830, was virtually eclipsed by the coming of the railways, and remained so for nearly one hundred years. In 1851 Thomas Cook brought thousands by rail to London for the Great Exhibition. His first publicly advertised rail excursion had already taken place in 1841; he issued special handbooks for tourists, and a magazine called *The Excursionist*. Ruskin was one of those who frowned on the new developments: 'Going by railway I do not consider as travel at all; it is merely being "sent" to a place, and very little different from becoming a parcel'.

John Everett Millais *John Ruskin at Glenfinlas* 1853–4. Private Collection

Artistic

1850–1860

William Wordsworth died in 1850, and J. M. W. Turner in 1851. 1851 was also the year of the Great Exhibition, and the year in which John Ruskin began to champion the Pre-Raphaelites. In 1853, John Everett Millais and the Ruskins took a holiday together at Brig O'Turk in the Trossachs. Since 1844, David Cox had been spending some months every year at Bettws-y-Coed: large numbers of artists followed, even after his death in 1856; among them Benjamin Leader and Thomas Creswick. The Aran Islands attracted artistic attention for the first time in 1857, when Sir Frederick William Burton paid a visit there. By mid-century, a change in the background of both artists and patrons was taking place. Up to *c*.1850, the artists were men who lived in or were in close contact with the countryside (Stark, Constable, Ward, Garrard, Weaver, Hills). By 1850, attitudes were changing: patrons were increasingly to be found among the new industrialists, not, as before, among the landed gentry; and brief visits to the country by city- or town-based artists began to replace the earlier intimacy. Although founded in 1826, it was only in the 1850s that the Royal Scottish Academy began to exert a dominant influence on painting in Scotland. Volumes 3 and 4 of Ruskin's *Modern Painters* were published in 1856, and Volume 5 in 1860 (Volumes 1 and 2 had already appeared in 1843 and 1846–47 respectively). 1854 saw the publication of Dickens's *Hard Times*, which attacked the spiritual poverty of mercantile philosophy.

1860–1870

The 'golden age' of British farming continued well into the 1860s. Advances in farming were no longer the province only of the rich landlords: enterprising tenant farmers prospered, encouraged by the growth of agricultural societies and journals, which provided both

1860–1870

Birket Foster moved to Witley in Surrey in 1863, building a house for himself known as 'The Hill'. In the course of his thirty years' residence there, the house became a social centre for a large number of artists, including Frederick Walker. Queen Victoria visited Glen Feshie in the

Social

moral and practical support. Not surprisingly, emigration figures in 1860 were far lower than in 1850: in the period 1861–65 the proportion of emigration to population was 0.48%, compared with 0.84% in 1853–55. 1852 had seen the publication of *The Emigrant's Handbook, being a guide to the various fields of emigration, in all parts of the globe* by J. Cassall; in the 1870s the number of emigrants from the United Kingdom was to increase again. Yet even in the times of greatest hardship, the growth of emigration failed to keep pace with the growth of population. The railway network continued to grow: by 1870 there were *c*.15,500 miles of track. The Agricultural Gangs Act of 1867 forbade the employment of women and young children in gangs, part of a general trend towards more humanitarian working conditions. Only severe cattle plague in the late 1860s seemed to hint of the lean years' to come.

William Morris. A page from *News from Nowhere*. Courtesy Victoria and Albert Museum

1870–1880

These were years of severe agricultural depression, leading to serious rural de-population that lasted until the end of the century. A series of bad harvests, local taxation, increasing financial competition from industry, a series of Education Acts passed between 1870 and 1876 which put an end to the plentiful supply of cheap child labour, and above all the import of cheap grain from the United States–all these took their toll. The latter was the delayed result of the repeal of the Corn Laws in 1846, which had protected the price of British-grown wheat. In 1846 the European nations had little food to spare, and American wheat production was still in its infancy; but with the opening up of the prairies through transcontinental railways, and a steamer service to British ports–and later (in the 1880s), the introduction of refrigerated cargo, the British market was flooded. The increasingly large urban population may have clamoured for cheap food, but for the farmers the result of Free Trade was disastrous. The import of wool and mutton from Australia and New Zealand, beef from South America, bacon and dairy products from Denmark and fruit and vegetables from the continent aggravated the situation still further. In 1871/2, workers in the South and Midlands turned to trade unionism, but with only short-term success. The corn-growing disasters of the '70s did, however, lead to increased specialization in other fields: horticulture, poultry, pedigree livestock, and particularly dairy farming. In 1873 the word 'ecology' made its first appearance in English scientific literature, in a version of the German zoologist Ernst Haeckel's *History of Creation*. 1870 saw the publication of *Wild Garden* by William Robinson, leading opponent of the

Artistic

Highlands in 1860, and described it in her diary as 'a most lovely spot–the scene of all Landseer's glory'. (Her regular visits to Balmoral since 1848 did much to popularize the area as, earlier, did the novels of Sir Walter Scott.) 1862 saw the publication of P. G. Hamerton's *A Painter's Camp in the Highlands*, which proved an immediate best-seller. The Glasgow Institute of Fine Arts was established in 1862, and the Dudley Gallery, London, in 1865. The initial exhibitions held at the latter were devoted to watercolours by painters who were not members of recognized societies; in later years, the New English Art Club was to hold many of its exhibitions here. In this decade the Liverpool and Manchester Academies enjoyed great prestige; many artists associated with them were highly sought after even though most enjoyed local and not national reputations.

1870–1880

This decade saw the flourishing of the 'Manchester School' under the leadership of Joshua Anderson Hague. Its artists were conspicuously indebted to the Barbizon example, and the later work of men such as Frederick William Jackson and James Charles showed the impact of Impressionism. The School did much of its work in North Wales; even when it did tackle local subjects, any hint of the presence of heavy industry was avoided. It was in the 1870s that Irish artists began to settle permanently in their native country, and that the Irish landscape began to acquire a new importance. National feeling revealed the attractions of the West Coast of Ireland and the continued presence of a Celtic tradition. From 1871 until his death in 1900, Ruskin was to spend most of his time at Brantwood House, on Coniston Water; and in 1871 Morris and Rossetti moved to Kelmscott Manor. Millais paid frequent visits in the 1870s to the Perth area, where he painted some of his best-known works, notably *Chill October*. The Slade School of Fine Art was founded in 1871, and adopted the teaching methods of the French. Also several London exhibitions of French art held in this decade helped to introduce French art and ideas. Many British artists now began to train abroad, either in Paris or Holland. Despite this tendency to go abroad, most British artists remained suspicious of Impressionism and tended to prefer the *plein-air* effects achieved by Bastien-Lepage who enjoyed widespread fame after the success of his *The Hayfield* of 1878. In 1877 William Morris founded the Society for the Protection of Ancient Buildings and the Grosvenor Gallery opened in Bond Street. This new gallery became the focal point for the

Social

taste for the exotic and exponent of the wild, or natural garden.

Artistic

Etruscan School, a group of English artists all of whom had at one time come under the influence of Giovanni Costa, nicknamed 'The Etruscan'. In 1878 the Royal Scottish Society of Painters in Watercolours was founded. Thomas Hardy's first 'novel of character and environment', *Under the Greenwood Tree*, appeared in 1872.

1880-1890

The agricultural depression of the '70s lasted well into the 1880s: the worst-hit years were those from 1875 to 1884. Emigration figures continued to rise, due, at least in part, to the continued depressed state of the countryside. In 1884, however, the Third Reform Bill extended the franchise to the working classes in rural districts, and in 1889 a government Board of Agriculture was set up, marking the beginning of increased state interest and intervention in the land. The decade also bears witness to the beginnings of a greater environmental awareness, with the founding of the Royal Forestry Society of England, Wales and Northern Ireland in 1882, and the Environmental Health Officers Association in 1883. 1885 saw the establishment of the Selborne Society for the preservation of birds, plants etc., founded to perpetuate the memory of Rev. Gilbert White, author of *The Natural History and Antiquities of Selborne* (Hampshire), originally published in 1789.

George Clausen *Artist Painting out of Doors* 1882 (cat. no. 66). City of Bristol Museum & Art Gallery

1880-1890

The most prominent feature of these years was the growth of the artists' colony, inspired by French examples (Grès-sur-Loing, Pont-Aven and others, mainly in 'primitive' Brittany). Painting styles, too, derived from French Impressionism or the more conservative tradition represented by Bastien-Lepage. Stanhope Forbes was working in the Cornish village of Newlyn from 1884, becoming the leader of the 'Newlyn School'. Other members included Frank Bramley, Thomas Cooper Gotch, Norman Garstin and Henry Scott Tuke. The North Yorkshire fishing village of Staithes became another favoured location. Notable members of the 'Staithes Group', which comprised 25-30 artists and flourished until c.1910, included Gilbert Foster, Frederick Jackson, James Booth, Charles Mackie, Fred Mayor and, later, Harold and Laura Knight. The 1880s also saw the coming together of the 'Glasgow Boys': members of the group included W. Y. Macgregor (who took on the initial leadership), James Guthrie, E. A. Walton, Arthur Melville, George Henry, E. A. Hornel, Joseph Crawhall, Alexander Roche and John Lavery. In the early '80s, the 'Boys' congregated at Brig O'Turk for the summer; it was here, in 1882, that Guthrie found the subject for his *Highland Funeral*, which established the group's reputation. In 1883, they 'discovered' Cockburnspath; Guthrie remained here for the next three years, painting, among other things, *A Hind's Daughter*. Kircudbright became another important centre for the Glasgow School (from 1883 onwards). In 1888, many of the group congregated at Cambuskenneth. Hubert von Herkomer inaugurated a school of painting at his home in Bushey, Hertfordshire, in 1883, which turned Bushey into a flourishing art centre. The most notable of the painters trained here was William Nicholson; Arnesby Brown was another pupil. Whistler and Sickert spent a few weeks at St Ives in 1883-84; Wilson Steer first visited Walberswick, a thriving artistic colony in Suffolk, in 1884. The watercolourist Helen Allingham moved to Witley in Surrey in 1881; and Edward Stott, 'the English Millet', settled in Amberley, West Sussex, in 1889. 1880 saw the founding of the Royal Society of Painter-Etchers and Engravers, and 1881, the founding

Social

Peter Henry Emerson *During the Reed Harvest*. Illustration from *Life and Landscape in the Norfolk Broads*, London, 1886. Norfolk County Library

Artistic

of the Royal Cambrian Academy. The Royal Institute of Painters in Oils was set up in 1883, and the New English Art Club came into being in 1886. The New Gallery opened in 1888, providing an alternative venue for the Etruscan School (officially founded in 1883). The photographer George Christopher Davies' *Norfolk Broads and Rivers* or *The Waterways, Lagoons, and Decoys of East Anglia* was published in 1883; and the first of Peter Henry Emerson's photographic essays, *Life and Landscape in the Norfolk Broads* appeared in 1886. Based on the Yorkshire coast, the photographer Frank Meadow Sutcliffe was also seeking to record a vanishing world.

Myles Birket Foster *Girl with an Orange*. City of Bristol Museum & Art Gallery

1890-1900

Agriculturally speaking, this decade saw little improvement on the preceding two. Except for 1891 and 1894, each year was stricken by drought; between 1891 and 1899 agricultural depression was again severe. This does not, however, seem to be reflected in the emigration figures for those years, which remained proportionally constant. The Board of Agriculture, although it made noble attempts, remained more or less helpless in the face of adverse conditions. 1895 saw the production of the first original, full-size British petrol motor; the first commercial motor company was set up in 1896 (at Coventry, producing the continental Daimler). Motor buses were introduced in about 1898, but until about 1910 were neither commercially very successful nor technically very reliable. Some of the earliest bus services were started by rail companies, as feeders to their rail services. Public awareness of environmental issues seems to have been on the increase, as witnessed by the establishment of 'The National Trust for Places of Historical Interest and Natural Beauty' in 1895, and the National Society for Clean Air in 1899. Also in 1899, the Town and Country Planning Association came into being, with the aim of promoting a 'national policy of land-use planning to improve living and working conditions, advance industrial and business efficiency, safeguard green belts and best farmland and enhance natural, architectural and cultural amenities'. In 1898, Ebenezer Howard published his *Tomorrow: A Peaceful Path to Social Reform*, which contained the first socio-economic outline for a non-specific new town, combining the advantages of both city and country.

1890-1900

John (later Lamorna) Birch visited Lamorna Cove, Cornwall, for the first time in 1890; Arnesby Brown moved to Norfolk in this decade. The Impressionist Alfred Sisley was in Wales in 1897, and painted many landscapes in the South Glamorgan area. 1899 saw the founding by Stanhope Forbes of the Newlyn School of Art, which attracted students from all over the world; the Women's International Art Society was set up in the same year. The Grosvenor Gallery put on a major show of the Glasgow School in 1890, further establishing their reputation. Dorothy Wordsworth's *Journals* were published in 1896, over forty years after her death. (Another volume appeared in 1904.) The early '90s marked the beginning of Ralph Vaughan Williams's interest in the collection and study of English folk songs (particularly those from Norfolk, Essex and Sussex); the English Folk Song Society was founded in 1898. Gustav Holst's symphony *The Cotswolds* appeared in 1899-1900.

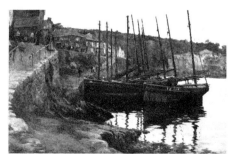

Stanhope A. Forbes *At their moorings*. Ferens Art Gallery Kingston upon Hull

Social

1900-1910

Agricultural conditions took a turn for the better in this decade, largely through the intervention of the Board of Agriculture (which in 1903 took Fisheries under its wing). Much was done to protect the tenant farmer from the worst abuses of unsatisfactory leases, to safeguard him against misfortunes outside his control and to encourage him to carry out improvements. The development of motor transport had up to now been hampered by restrictive legislation: the Motor Car Act of 1903 for the first time gave the motorist substantial freedom. The number of motor vehicles increased steadily between 1903 and 1914, although they remained an expensive luxury. The motor bus was introduced to London in 1905; bus services in the provinces came rather later. 1909 saw the establishment of a national Road Board, authorized to construct and maintain new roads and to urge highway authorities to build new roads or improve old ones. Letchworth, thirty miles north of London, in Hertfordshire, the first garden city, was begun in 1903. The Camping Club of Great Britain and Ireland came into being in 1901; the Federation of Rambling Clubs in 1905, uniting the activities of the many individual clubs that had sprung up over the previous twenty-five years. The Boy Scouts Association was founded in 1908; the Girl Guides in 1910. From 1899 Gertrude Jekyll, advocate of simplicity and naturalness in garden design, had been publishing numerous volumes on the subject.

Artistic

1900-1910

The Wye Valley became a favoured painting ground for artists associated with the New English Art Club in this decade, notably Wilson Steer, but also Henry Tonks and Fred Brown. John Birch settled permanently in Lamorna in 1902, and Laura and Harold Knight lived in Cornwall from 1908. Paul Nash's family moved to Iver Heath, Buckinghamshire, in 1901; and Charles Gere moved to Painswick, Gloucestershire, in 1904. Rudyard Kipling's *Puck of Pook Hill*, a vivid evocation of the magical spirits of the Sussex countryside, appeared in 1906; and Kenneth Grahame's *The Wind in the Willows*, set in Cookham Dene, Berkshire, a loved place in a childhood of uprooting and loss, was published in 1908, although not at first well received. 1907 saw the publication of J. M. Synge's *The Aran Islands*, illustrated by Jack Yeats. Vaughan Williams's *Linden Lea*, a setting of words by the Dorset dialect poet William Barnes, appeared in 1901; in these years, he also composed works such as *In the Fen Country* (1904), *Norfolk Rhapsodies* (1907) and *On Wenlock Edge* (1908-09), a song cycle with words by A. E. Housman. Holst published his *Somerset Rhapsody* in 1906-07; between 1905 and 1910, Percy Grainger was busy collecting British folk songs, which he drew on, slightly later, for his cycle of *British Folk Song Settings*. Arnold Bax, an Englishman who strongly identified with Ireland after encountering W. B. Yeats's *The Wanderings of Usheen* in 1902, was writing works such as *A Celtic Song Cycle* of 1904 and *In the Faery Hills* of 1909; Cecil Sharp, the English folk music collector whose avowed aim was to restore 'their song and dance to the English people', published a compilation of *Folk Songs from Somerset* (1904), *The Morris Book* (1907-13) and his own *English Folk Song: Some Conclusions* (1907).

1910-1920

Although the situation was now much improved, the outbreak of war found British agriculture singularly unprepared. The total agricultural area in Britain had fallen by half a million acres since the 1870s, while the population had risen from 33.33 to 45.25 million: in other words, the country was capable of producing enough food for only one third of its population. The Food Production Campaign came into being in 1917, in an urgent attempt to save the country from starvation. Free Trade was temporarily abandoned and financial incentives provided to increase the amount of land cultivated (and hence production generally), with the result that by 1918 an extra three million acres had been brought under the plough. By 1914 there were

1910-1920

J. D. Innes discovered the Rhyd-y-Fen inn near Arenig Fawr in 1910; he returned in 1911, joined by Augustus John, who described it as 'the most wonderful place I've seen . . . the air is superb and the mountains wonderful'. From 1911, John was living in Alderney Manor, in Dorset. He visited Doolin, County Clare in 1912, and in 1915 lived for a while in Galway. Derwent Lees and Innes visited the South of France in the winter of 1912-13; in 1913 Lees took a cottage at Ffestiniog. Charles Rennie Mackintosh spent part of 1914-15 in Walberswick, for the first time able to concentrate entirely on watercolours. Between 1911 and 1915, Alfred Munnings was making annual visits to Lamorna; Laura and Harold Knight were at Newlyn between 1910

Social

23,000 miles of railway line; private car registrations numbered 132,000, and motor cycle registrations 124,000; there were 51,167 hackney vehicles (buses and taxis) on the roads. World War One did much to check the growth of motor transport, although it did encourage technical development. After the War a Ministry of Transport Act of 1919 classified the roadway system for the first time. The Society for the Promotion of Nature Reserves was established in 1912; the British Ecological Society was founded in 1913. 1919 saw the setting up of the Forestry Commission and the building of a second garden city, Welwyn Garden City, twenty miles north of London.

Charles Ginner *Hartland Point from Boscastle.* Tate Gallery

Photograph of Roger Fry painting

Artistic

and 1912, and in 1912 they moved to Lamorna. John Nash visited Wormingford, Essex, for the first time in 1912; Spencer Gore moved to Letchworth, Hertfordshire in the same year, taking over Harold Gilman's house. The Camden Town painters Gore, Charles Ginner and Robert Bevan had been paying frequent visits to Applehayes Farm on the Devon-Somerset border since 1910, and in 1916 Bevan rented a cottage nearby. Sickert spent the summers of 1916, 1917 and 1918 in Bath. William Rothenstein moved to Far Oakridge in Gloucestershire in 1912; in 1916 Vanessa Bell and Duncan Grant moved to Charleston, East Sussex. From 1917 until 1924 the Old Mill at Tidmarsh, Berkshire, was the home of Lytton Strachey and Dora Carrington. Garsington Manor in Oxfordshire was the home of Lady Ottoline Morrell from 1915 to 1927: her hospitality was unflagging, and visitors included Augustus John, Henry Lamb, Gilbert Spencer, Dora Carrington and Mark Gertler. In 1917 Paul Nash was in the Ypres Salient. 1911 saw the founding of the Camden Town Group, and 1912 that of the Scottish Society of Eight, which included Guthrie, Lavery, Cadell, Peploe and later, Sir William Gillies. Roger Fry's two Post-Impressionist exhibitions took place in 1910 and 1912. The Seven & Five Society was formed in 1919. From *c.*1912 onwards and through the 1920s, there appeared a spate of landscape poetry and regional novels by the 'Georgians' (Rudyard Kipling, Hilaire Belloc, Rupert Brooke, A. E. Housman, Vita Sackville-West, Edward Thomas, Walter de la Mare, John Drinkwater, Mary Webb, Sheila Kaye-Smith and others) reflecting an upsurge in patriotism, partly inspired by the First World War. England and her rural virtues suddenly seemed all the more precious for being threatened. Music reflected this sentiment too: George Butterworth (who also collected folk songs) was writing works such as *Two English Idylls* and *The Banks of Green Willow*; in 1911–12 he published six songs from *A Shropshire Lad*. Frank Bridge wrote the symphonic poem *Summer* in 1914, and in 1915 set *Two Poems by Richard Jefferies* to music. Arnold Bax wrote *November Woods* and *Tintagel*; Vaughan Williams's *The Lark Ascending* appeared in 1914, and Elgar wrote *The Spirit of England*, three choral settings, around the same time.

1920–1930

By the mid 1920s the high corn prices of wartime had begun to fall, and the world market collapsed. Government promises of financial protection were revoked, and the farmer was left virtually to fend for himself. The early '20s were thus a period of lethargy, permeated by a feeling

1920–1930

In 1920 Matthew Smith was living in St Columb Major. Also in 1920, S. J. Peploe began to visit Iona; F. C. B. Cadell visited the island every summer through the '20s and '30s. Alfred Munnings moved to Castle House at Dedham, Suffolk in 1920. In 1951 he recalled: 'I was

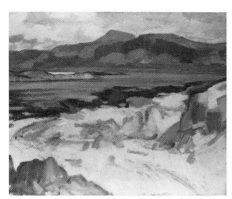

S. J. Peploe *Ben More from Iona*. Glasgow University, Macfie Collection

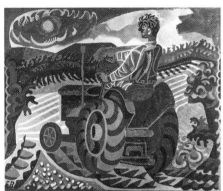

Edward Bawden *The Tractor*

Social

of helplessness. The number of agricultural workers in England and Wales fell sharply. (Between 1921 and 1939 the number of agricultural labourers fell by 25%.) The late '20s, however, saw the beginning of an improvement, as Free Trade was once again abandoned and state assistance was gradually applied in a more and more positive form. Electricity and piped water began to reach some rural homes and motor buses furthered communication between villages and towns, but progress remained slow. As the '20s progressed, the railway system proved increasingly unable to compete with the roads. From 1920 onwards, there was an immense growth in the private ownership of motor vehicles; an immense growth, too, in the commercial road haulage and road passenger transport industries. Between 1920 and 1939 private ownership of cars increased over ten times (though not below middle income groups). The Rural Industries Board was established in 1921, 'to salve and re-animate traditional country crafts'. The Council for the Preservation of Rural England came into existence in 1926, founded in an attempt to stem the tide of indiscriminate building undertaken in the decade after World War One, when agriculture was in distress and land was cheap. The Council for the Protection of Rural Wales followed in 1929. The Men of the Trees organization was founded in 1924, intended 'to develop an appreciation of the ecological indispensability of trees and their amenity value and to encourage their planting and protection'. 1926 saw the setting up of an Environmental Health Officers Education Board. The Ulster Tourist Development Association was set up in 1924.

Artistic

riveted by the drawing-room with its regency bow windows looking out across peaceful paddocks with chestnut trees and cows grazing'. Paul Nash spent the summer of 1921 at Dymchurch in Kent, and moved there for two years in 1923. John Nash settled in Suffolk in 1929: a cryptic postcard read 'good river scenery – think we might stay here'. Bernard Leach started his pottery at St Ives in 1920; in 1925 Alfred Wallis started to paint at the age of seventy, to be 'discovered' by Ben Nicholson and Christopher Wood in 1928. Between 1920 and 1931, the Nicholsons divided their time between Cumberland and London, but spent the summer of 1928 in South Cornwall. In 1924, dissatisfied with the Ditchling 'Guild of Craftsmen', Eric Gill moved to Capel-y-Ffin in Wales; he was joined there by David Jones, Philip Hagreen, Joseph Cribb, René Hague and Donald Attwater. Later he recalled: 'And we bathed naked all together in the mountain pools and under the waterfalls. And we had heavenly picnics by the Nant-y-buch in little sunny secluded paradises, or climbed the green mountains and smelt the smell of a world untouched by men of business'. 1920 saw the founding of the Society of Graphic Artists; the St Ives Society of Artists came into being in 1926. Paul Henry's posters advertising Connemara on London, Midland and Scottish Railways appeared in 1925. A new edition of Mary Webb's *Precious Bane* (set in Shropshire, like all her novels, and originally published in 1924) came out in 1929, with illustrations by Rowland Hilder and a lengthy foreword by Stanley Baldwin, the Conservative Prime Minister. T. F. and John Cowper Powys were both writing through the '20s, both intimately linked with the West Country. William Walton's overture *Portsmouth Point* appeared in 1925; *There is a Willow grows aslant a Brook* by Frank Bridge was published in 1928; Gerald Finzi began writing settings of poems by Thomas Hardy in the late '20s.

1930–1940

As the 1930s progressed, an increased official awareness of the dangers of a second world war led to preparatory measures being taken in the form of incentive and subsidy to agriculture. A 1931 Marketing Act saw the start of organized marketing, while in 1933 the first steps were taken to restrict imports of food. By 1933, Dutch Elm disease had spread to Great Britain (probably introduced to Europe from Asia during World War One). Although war was again to check the growth of the motor transport industry, by 1937 over 300,000 new cars were being registered every year. 1930 saw the founding of the Youth Hostel Association,

1930–1940

Edward Bawden and Eric Ravilious began renting Brick House at Great Bardfield in Essex in 1932. This was to remain Bawden's permanent residence until 1970 whilst Ravilious moved to Castle Hedingham in 1935. (In the 1950s Great Bardfield became a well-known art centre.) Cedric Morris moved to Benton End, near Hadleigh, Essex in the '30s, and in 1936 helped to establish the East Anglian School of Painting at Dedham. Graham Sutherland visited Pembrokeshire for the first time in 1934, and continued to visit regularly until 1942. In 1936 he moved to Trottiscliffe, Kent, just east of Shoreham. Paul Nash 'discovered' the Avebury

Eric Ravilious. Frontispiece to
The Writings of Gilbert White of Selborne
published in two volumes, Nonesuch
Press, 1938

Social

intended 'to help all, but especially young
people, to a greater knowledge, care and love of
the countryside'. By 1939 there were nearly 300
hostels and over 83,000 members in England. A
Green Belt (London and Home Counties) Act
was passed in 1938, 'to make provision for the
preservation from industrial or building
development of areas of land in the
administrative county of London'. Gilbert
White's *Journals* were published in 1931; and in
general, the 1930s witnessed a spate of popular
publications dealing with rural England. B. T.
Batsford was the leader in the field, publishing
series such as *The Face of Britain*, 'designed for the
intelligent rambler by car, on bicycle or on foot',
and intended 'to keep the reader off the more
familiar and recognized tracks' (each book
contained a colour frontispiece by a 'modern
artist'); *The Pilgrims Library*, contributors to
which included Edmund Blunden, J. B. Priestley
and H. E. Bates; *The British Nature Library*, one
volume of which contained illustrations by John
Nash; *English Life*, which included one volume
by Gertrude Jekyll, and *The British Heritage*.
Macmillans published a *Highways and Byways in
Britain* series; and Shell started publishing its
guides to Great Britain (authors included John
Betjeman, John and Paul Nash, and John Piper).

Artistic

Stone Circles in 1933, while staying at
Marlborough; between 1934 and 1936 he was in
Swanage, compiling the *Shell Guide to Dorset*.
From 1939 until 1947 Frances Hodgkins was
living mainly at Corfe Castle, Dorset. Sickert
settled in Bath in 1937, being particularly fond of
Pulteney Bridge, whose combination of
architecture and water reminded him of his
beloved Venice. In 1930, John Tunnard settled
at Cadgwith, near Falmouth; and in 1937
Adrian Stokes 'discovered' St Ives-born Peter
Lanyon painting by the roadside. In 1939,
Stokes moved to Little Parc Owles, Carbis Bay,
and later in the year he was joined by Ben
Nicholson and Barbara Hepworth. In 1938
William Coldstream and Graham Bell visited
Bolton with Tom Harrisson, as part of a 'Mass
Observation' project. Unit One was formed in
1933; the Euston Road School came into being
in 1937; the St Ives School of Painting opened in
1938. The 1930s saw the publication of Arthur
Ransome's children's books, J. R. R. Tolkien's
The Hobbit (which at first had a mixed reception)
and the best work of H. E. Bates.

John Piper *Waterfall in Wales c.*1946. Borough of
Thamesdown, Swindon Permanent Art Collection

1940–1950

Agricultural statistics from the war years are
impressive: the arable acreage of England, for
example, was increased by 6.4 million acres. The
battle for the land was hard-won; but the
foundations of post-war prosperity were laid in
those years of shortage after the war. 1946 saw
the setting up of a National Agricultural
Advisory Service, marking the beginning of
increased government aid to farmers.
Mechanization took place with increasing
rapidity after 1945 (the combine harvester, for
instance, came into general use only in the '40s);
rural communities became less and less isolated,
and living conditions improved considerably. In
1943 private car registration had fallen to almost
one-third of the 1939 figure; petrol rationing
continued until 1950. Nevertheless, the 1940s
saw the increasing systematization of road signs,
the first national road safety campaign (in 1946),
and a 1949 Special Road Act that classified
motorways for the first time. The Youth
Camping Association of Great Britain and
Ireland was set up in 1941, 'to encourage in
young people of limited means, a pioneer spirit
of adventure'. The Field Studies Council was
founded in 1943, as a teaching and research body
on environmental matters; the Soil Association
came into being in 1945, to promote 'organic
husbandry, furthering better understanding of

1940–1950

Ivon Hitchens moved to Lavington Common,
near Petworth, West Sussex in 1940, after being
bombed out of his London home. During the
war, Paul Nash lived at Sandylands at Boar's Hill
in Oxfordshire, within viewing distance of
Wittenham Clumps. He had visited the area in
1911, and described the 'grey hallowed hills
crowned by old trees, Pan-ish places down by the
river wonderful to think on, full of strange
enchantment . . . a beautiful legendary country
haunted by old gods long forgotten'. A recurring
motif through his career, Wittenham Clumps
feature particularly strongly in the landscapes he
painted at Sandylands. John Piper's duties as a
War Artist took him to Wales. Since a childhood
visit to Pembrokeshire, he had explored the area
in depth (he bought a cottage in Wales in 1963
and still visits regularly). In 1944 Josef Herman
visited Ystradgynlais (Powys) and decided to
settle there permanently. Nicholson and
Hepworth moved from Carbis Bay to St Ives in
1943, and John Armstrong settled at Lamorna in
1947. The early 1940s saw the establishment of
the New Art Club (founded by J. D. Fergusson),
the New Scottish Group (of which Fergusson was
the first president) and The Centre, all intended
to provide better exhibiting facilities for
Glasgow's progressive artists. In 1946, Cedric
Morris helped to set up the Colchester Art

Social

the relationship between agriculture, nutrition and health'. In 1949 the National Parks Commission was set up, 'to keep under review all matters relating to the provision and improvement of facilities for the enjoyment of the countryside, the conservation and enhancement of the natural beauty and amenity of the countryside, and the need to secure public access to the countryside'. B. T. Batsford published their *Home Front* series in 1940, 'designed to meet the needs of those who, through war-time circumstances, must seek their own entertainment . . . It is intended particularly for people now living in the country for the first time, that they may use their leisure constructively for their own benefit and for the benefit of the nation in general'. Titles included *How to Look at Old Buildings*, *How to See Nature*, and *How to Grow your own Food*. Later in the decade, Collins published a series of naturalists' guides, and Paul Elek issued a *Vision of Britain* series, whose authors included Walter Allen and Geoffrey Grigson. The book on *The Cotswolds* contained illustrations by Humphrey Spender.

Artistic

Society, of which John Nash was the first president; the Penwith Society of Arts was founded in 1948. Most of Dylan Thomas' writing was done in the 1940s; 1950 saw the appearance of Vaughan Williams's *Folk Songs for the Four Seasons*, and the first performance of Finzi's setting of Wordsworth's *Intimations of Immortality*.

Paul Nash *Battle of Britain, August–October* 1940. Imperial War Museum, London

Catalogue

Dimensions are given in inches followed by centimetres, height before width.

The artists in the catalogue are arranged in chronological order of date of birth. Where one or more artists are born in the same year, they are then arranged by alphabetical order of their surnames.

Where the birth date of an artist is not known, his working period is indicated by fl.c. and date, e.g. fl.c. 1900s, and his entry in the catalogue is determined by an estimated birth date twenty years prior to that working period.

1

David Cox 1783–1859

Born at Deritend, in Birmingham, the son of a blacksmith. Apprenticed to a miniaturist. Worked in the Birmingham theatre as a colour-grinder and scene painter. Went to London in 1804, and met John Varley; other influences included Cotman, Prout and Girtin. Taught drawing at the Farnham Military College from 1813–14, and then at a girls' school in Hereford from 1814–27. In 1813 his *Treatise on Landscape Painting and its Effect in Watercolours* was published. Travelled to Holland and Belgium in 1826, and to France in 1829 and 1832. From 1827–41, lived in Kennington, and afterwards in Harborne in Birmingham. Toured widely in Britain: Wye Valley (1816), North Wales (1818), Yorkshire (1830), Derbyshire (1831, '34, '36, '39). Stayed at Bettws-y-Coed in 1844. Became increasingly interested in the passing effects of cloud, light, rain and wind; also had more than a picturesque interest in folk life and labour.

1 *Going to the Hayfield*
Oil on canvas 1852
10½ × 14 26.7 × 35.6
Victoria Art Gallery, Bath City Council

John Linnell 1792–1882

Son of a carver, gilder, print-seller and picture dealer. Became the pupil of John Varley through whom he met William Mulready. Studied at the Royal Academy Schools under Fuseli and in 1809 won a British Institution prize for landscape. Began painting out of doors with W. H. Hunt and in 1813 made a sketching tour of Wales, which left a deep impression on him, especially the valleys near Snowdon. Joined the Society of Painters in Oil and Water-colour, exhibiting landscapes but for a long period of time earnt his living by painting portraits and copies of Old Masters. In 1822 took lodgings at Hampstead and there entertained William Blake whose friendship he enjoyed. Occasionally visited Samuel Palmer at Shoreham. After Palmer married his daughter, relations between the two men became troubled, largely because of religious differences. In 1828, moved to Bayswater where he lived until 1851 when he took up residence at Redstone Wood, a house he had built for himself at Redhill. There he recovered the mystical attitude to nature that had earlier inspired Blake and Palmer. During the last thirty years of his life became the most prolific and successful

landscapist in Britain after Turner's death. Declared that it was the business of the artist not to imitate nature but to create spiritual perceptions.

2 *Under the Hawthorn*
Oil on canvas 1853
26 × 54 66 × 137.2
Aberdeen Art Gallery and Museums

James Barker Pyne 1800–1870

Born in Bristol, he was self taught. Painted landscapes in the Bristol area, before moving to London in 1835. Exhibited at the Royal Academy in 1836, but mainly showed at the Society of British Artists and the British Institution. In 1846 he travelled to Italy through Germany and Switzerland. In 1848 he was commissioned by Agnews of Manchester to paint twenty-four views of scenery in the English Lakes. He worked on this scheme for three years and painted twenty-five pictures, which were lithographed in 1853 and chromolithographed in 1859. In 1851 Agnews commissioned Pyne to make a three-year tour of Italy.

3 *The Cob, Lyme Regis*
Oil on canvas 1857
26½ × 36½ 67.3 × 92.7
The City of Bristol Museum and Art Gallery

Horatio MacCulloch 1805–1867

Born in Glasgow; studied under John Knox. Settled in Edinburgh and developed a preference for grand Highland subjects under the combined influence of the artist John Thomson of Duddington and the writings of Walter Scott. His style is also partly indebted to Dutch seventeenth-century landscapes. Enjoyed great popularity and influenced a whole generation of Scottish landscape painters. Was highly praised by his contemporaries who claimed him as their national painter, doing for the Scottish landscape what Constable had done for more homely English scenes.
'He can make you feel through his art the loneliness of mountain sides and great glens, and inspire you, if you will but open your

2

3

mind to receive the impression, with the feeling of religion and wonder, which, growing out of the sense of that loneliness, has imbued his own spirit'. (by 'Iconoclast', *Scottish Art and Artists in 1860*, 1860, p. 4)

4 *Loch Katrine*
COLOUR PLATE IX
Oil on canvas 1866
44 × 72 111.8 × 182.8
Perth Museum and Art Gallery

Samuel Palmer 1805–1881

Born at Walworth, London. First exhibited at the Royal Academy when he was 14. He met John Linnell in 1822, and eventually married his daughter Hannah in 1837. He met William Blake in 1824, and remained a friend until Blake's death in 1827. He visited Blake, Richmond and Calvert at Shoreham in Kent, and in 1827 settled there himself. Impressed by Blake's wood-engraved illustrations to Thornton's *Virgil*. With Hannah, he visited Italy 1837–9, and painted many Italian views. In 1835 he moved back to London for a period before settling in Redhill. In 1850 he took up etching and his first etching, *The Willow*, helped towards his election to the Old Etching Club. At the time of his death he was working on plates for the illustration of his own translation of *The Eclogues of Virgil*.

5 *The Travellers*
Watercolour, body colour, ink and varnish over pencil with surface scratching on cardboard
10½ × 17½ 26.7 × 44.4
Whitworth Art Gallery,
University of Manchester

William Dyce 1806–1864

At first studied medicine and theology at Marischal College, Aberdeen. In 1825 made a brief visit to London and was encouraged to take up art by Sir Thomas Lawrence. After a short period at the Royal Academy Schools, he travelled to Rome where he joined the colony of artists at the recently established British Academy. Either then or two years later, on a second visit to Rome, met the German Nazarenes and under their influence developed a style that earned him the title, 'the British Overbeck'. Between 1830–7 lived in Edinburgh and painted

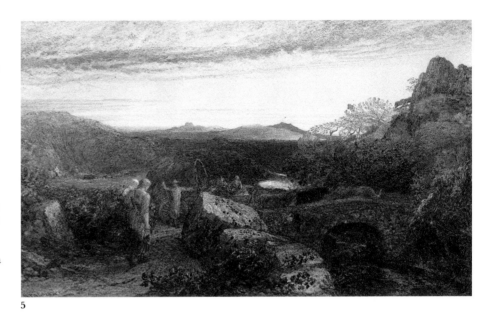

5

principally portraits, excelling at women and children. From 1837 onwards was much occupied as an arts administrator with the London School of Design, eventually becoming Director. Also became a High Churchman, involving himself in the attempts to revive Christian art, music, architecture and ritual. Spent the winter of 1845–6 in Italy studying frescoes and received important commissions for frescoes in the Palace of Westminster, All Saints, Margaret Street and in the House of Lords. Dyce had painted from nature in watercolour earlier in his career, but not until 1850 did open-air observation begin to affect his oils. Used his native landscape as a setting for religious subjects. His finest painting is, however, *Pegwell Bay* (Tate Gallery, London) in which his interest in scientific enquiry (he published, among other things, an essay on electricity and magnetism) is combined with his love of the limpid light of the English coast.

6 *George Herbert at Bemerton*
COLOUR PLATE X
Oil on canvas 1860
34 × 44 86.3 × 111.8
Guildhall Art Gallery,
Corporation of London

Thomas Creswick 1811–1869

Born in Sheffield, Creswick was trained by John Vincent Barber in Birmingham. He moved to London in 1828, where he exhibited at the British Institution and at the Royal Academy. Ruskin, in *Modern Painters*, estimated him to be 'one of the very few artists who *do* draw from nature, and try for nature'. He painted landscapes, usually containing extensive areas of water. He was elected a Royal Academician in 1851. His quite considerable popularity lasted at least until the 1870s.

7 *Landscape with River – The Ferry*
Oil on canvas
47½ × 72 120.7 × 182.8
Sheffield City Art Galleries

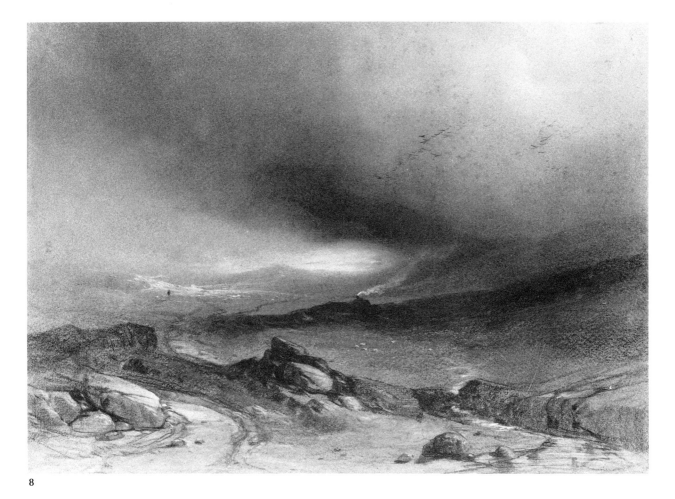

8

Henry Bright 1814–1873

The son of a jeweller from Saxmundham in Suffolk, Bright was indentured to the oil painter Alfred Stannard. He was also instructed by John Crome and J. S. Cotman. In 1836 he went to London where he remained until 1858, when he returned to Saxmundham. In 1860 he went to live in Redhill. As a painter he toured widely through the British Isles. He was an influential teacher, and published *Bright's Drawing Book* and *Bright's Graduated Tint Studies*. Sometimes his work has been denigrated as over-accomplished, especially his drawings on coloured grounds.

8 *Moorland Path*
Pastel and chalks
$10\frac{1}{2} \times 13\frac{7}{8}$ 26.8 × 35.3
Ipswich Museums and Galleries

Benjamin Brecknell Turner 1815–1894

Entered his family's tallow-chandling business at the age of 16 and managed it from his father's death in 1841 until his own death. Brecknell Turners were very reputable candles, as was the company's saddle soap, supplied to the Austrian Army until 1914. His wife was Agnes Chamberlain of a Worcester china family, and many of his photographs are of Worcestershire villages. Probably began to take photographs in 1849, and in 1852 he exhibited at the photographic exhibition organised by the Society of Arts. His major surviving work is a photographic album entitled *Photographic Views of Nature, Taken in 1853, 1854 and 1855* which is now in the collection of the Victoria and Albert Museum.

9 *Willows on a River Bank*
Photograph – carbon print
$13\frac{5}{8} \times 17$ 34.5 × 43.2
Private collection – on loan to
Victoria & Albert Museum, London

Francis Bedford 1816–1894

By 1860 Bedford was already a well-known photographer. A reviewer in the *British Journal of Photography* (1st Feb. 1860) wrote 'Mr Bedford charms us as usual with his highly-finished cabinet-picture style', and mentioned pictures taken in North Wales, at Aber, Pont-y-Pair and Capel Curig, and also in Chester and at Conway Castle. In 1861 he showed pictures from Somerset and North Devon, and of excavations at Uriconium (Wroxeter) as well as detailed 'studies of nature', such as ferns, ivy, meadowsweet, brambles. In 1862 his pictures taken whilst accompanying H.R.H. The Prince of Wales to the East were shown at the German Gallery in New Bond Street: 172 pictures were published in all, in 6 sets, the entire series in 3 volumes cost 43 gns. In 1862 he contributed to William and Mary Howitt's *Ruined Abbeys and Castles of Great Britain and Ireland*. In 1863 he exhibited more Welsh and Devon pictures, and a reviewer noticed that some had been bought by the City of London National Art-Union. In 1867 he showed at the Paris Universal Exhibition and won a silver medal; one reviewer criticised the photographs for their lack of 'a dominant light', and added 'Frequently the pictures look all over as a nicely made-up patchwork of light and shade – broad masses of high light and half-tone with dotted patches of connecting shadow'.

10 *Conway Castle from the Quay*
Photograph – albumen print *c.*1856
8¾ × 11¼ 22.1 × 28.5
Victoria & Albert Museum, London

Sir John Gilbert 1817–1897

Self taught. One of the busiest illustrators in Britain. Completed around 30,000 illustrations for the *Illustrated London News*, for which he was the main artist from its foundation in 1842. Showed watercolours at the British Institution from 1837 and at the Royal Academy from 1838. Famous as a painter of historical subjects taken from the 15th and 16th centuries. The watercolour exhibited here is one of twenty works which he gave to London in 1893, at a time when his popularity was declining. Bettws-y-Coed, his subject here, was one of the most painted places in Britain in mid-century: see

11

other works in the exhibition by Walter Crane, Benjamin Leader and George Sheffield.

11 *The Churchyard at Bettws-y-Coed*
Watercolour
10 × 14 25.4 × 35.6
Guildhall Art Gallery, Corporation of London

George Frederic Watts 1817–1904

Born in London, the son of a piano-maker. Unable to attend school with any regularity due to his poor health. Received formal instruction in art from the sculptor William Behnes and for a period entered the Alfred House Academy. In 1835 entered the Royal Academy schools and studied the Elgin Marbles in the British Museum. Influenced by the art of William Etty and, later, of the Venetians, especially Titian. Entered a competition for the decoration of the Houses of Parliament and with the prize money he won travelled to Florence. He drew greatly on the hospitality of patrons, in Florence spending almost four years as the guest of Lord Holland. On his return to England, after a brief period of despondency, he became resident artist in the home of Mr. and Mrs. Thoby Prinsep at Little Holland House. In 1864, at the age of forty-seven, he married Ellen Terry, who was then sixteen. They separated within a year and were formally divorced in 1877. In 1886, at the age of sixty-nine, Watts married again, thereby gaining a companion to look after him in his declining years. His aims tended to outstrip his achievement: he planned, but never painted, a cycle of pictures illustrating the history of mankind. Until the 1880s was chiefly known as a portraitist, but during the last part of his career painted a series of allegorical paintings, such as *Hope* (Tate Gallery), which brought him widespread fame. His landscapes, though they form the subject of a book by the artist Walter Bayes, were few in number; those painted at Freshwater on the Isle of Wight are domestic. Others, like *Ararat* (York Art Gallery) reflect his love of the grand and poetic.

12 *Sunset on The Alps*
Oil on gilded canvas 1888
56½ × 43½ 14.3 × 110.5
Trustees of the Watts Gallery, Compton

13

George Heming Mason
1818–1872

Initially studied to be a doctor. In 1844 he
visited France, Germany, Switzerland and
Italy, settling finally in Rome for several
years, and there decided to take up painting
as a profession. In the winter of 1852–3 met
Frederic Leighton and Giovanni Costa and
with them went sketching from nature.
After his marriage in 1857 he settled into
the family home, Wetley Abbey, in
Staffordshire. Family responsibilities and
economic insecurity left him depressed and
unable to paint. A visit from Costa in 1863
encouraged him to look at the countryside
around where he lived and he experienced a
rebirth of interest in painting. Was also
introduced by Costa, on a visit to Paris, to
the work of Corot and the Barbizon School.
During his mature and late years, his
landscapes become increasingly poetic and
sentimental. He developed a preference for
twilight or sunset scenes, arranging his
pastoral subjects in a frieze-like procession
across the foreground of his pictures. These
earned him popularity and the admiration
of many painters, including his former
friend, Frederic Leighton.

13 *A Derbyshire Farm*
Oil on paper *c*.1870
9½ × 28¼ 24.1 × 71.8
Private Collection

Roger Fenton 1819–1869

Born at Crimble Hall in Heywood, near
Rochdale, Lancashire, into a family of
bankers, and cotton spinners and weavers.
In 1832 his father was elected as the first
Member of Parliament for the new
Rochdale constituency. Studied at
University College, London, from 1838. In
1841 studied art in Paris under Paul
Delaroche. In 1844 returned to London and
studied to be a solicitor, during which time
he became interested in photography. In
1847 was one of the twelve founder
members of the Photographic Club
(Calotype Club). In 1853 was instrumental
in forming the Photographic Society, of
which he was Honorary Secretary.
Photographed in Russia in 1852 with the
engineer Charles Vignoles. Worked for the
Department of Antiquities in the British
Museum during 1854, and began to take
topographic and architectural pictures in
England. In 1855 was employed by Thomas
Agnew to record the war in the Crimea. In
1856 he resumed his landscape work in
Britain, visiting North Wales in 1858. In
1861 he took up still life photography. He
abandoned photography in 1862.

14 *Miner's Bridge, Llugwy*
Photograph – albumen print *c*.1858
14 × 16⅝ 35.5 × 42.2
Robert Hershkowitz Ltd.

John Ruskin 1819–1900

Born Bloomsbury, London, an only child.
Educated at Christ Church, Oxford.
Travelled in France, Switzerland and Italy
with his parents. Moved to write a defence
of Turner by an article which attacked this
artist: the result was *Modern Painters* which
ran to five volumes and had a major
influence on landscape painting in Britain.
His marriage to Effie Gray in 1848 was
annulled six years later when he lost her to
Millais, one of the Pre-Raphaelites whom
Ruskin had championed in 1851. Became
the most influential art critic in England,
directing Victorian taste. Defeated in the
Whistler v. Ruskin trial in 1878, after which
his ascendancy is slowly undermined.
Meanwhile his interest in art and
architecture had led on to a consideration of
the social conditions that helped to
determine them. Entered the field of
Political Economy, writing *Unto this Last*
and a series of letters to working men, *Fors
Clavigera*, which ostracized him from
Victorian society but made a profound
impression on political thinkers such as
William Morris and the founders of the
Labour party. Having inherited his father's
fortune (made in sherry), he tried to put his
social and artistic ideas into practice with a
marked lack of success. Suffered increasingly
from bouts of madness, interwoven with
periods of calm and mental clarity which
enabled him to write an account of his early
years, *Praeterita*, his last and arguably his
greatest work. He continued to draw and
paint throughout his life. His attention to

the minutiae of natural effects is not pains-taking but inspired – a visual indication of the exceptionally subtle and intricate workings of his mind.

15 *Sunset at Herne Hill*
Watercolour
$10\frac{1}{16} \times 14\frac{3}{4}$ 25.5 × 37.5
The Ruskin Museum, Coniston

16 *Study of wayside plants on a rocky river bank*
Bodycolour, watercolour and ink
$5\frac{1}{4} \times 9\frac{5}{8}$ 13.5 × 24.5
Guild of St. George, on loan to
Sheffield City Art Galleries

Henry White 1819–1903

A solicitor, who became one of England's most distinguished photographers in the 1850s and 1860s. He showed at the Manchester Photographic Exhibition in the spring of 1856: 'The finest works there, are, undoubtedly, those by Henry White; there is not a single picture in the gallery which can be compared to them for an instant; there is *real* distance, real sunshine, and real *atmosphere* about them. The water, foliage, and foreground are perfect in all – and such a clean look as they have is seldom seen – they are more artistic, and more like *pictures*, than anything else in the room' – Thus wrote Theta in the Journal of the Photographic Society. Later in the year he exhibited in the Universal Exhibition of Photography in Brussels and showed *Views on the Thames*, *Studies of Hedges* and *The Cornfield*. By June 1857, his work shown at the Manchester Art Treasures Exhibition was already described as well known. By February 1860 had added pictures of *Scotch Firs*, *Chobham Common* and *Ottershaw Homestead* to his list; was criticised in the same year for blurring in his pictures. In 1863 he reduced the scale of his pictures, and exhibited scenes from North Wales. Showed for the last time at the Universal Exhibition in Paris in 1867.

17 *The Cornfield*
Photograph – albumen print *c*.1856
$7\frac{1}{2} \times 9\frac{1}{2}$ 19 × 24
Robert Hershkowitz Ltd.

18 *The Cottage*
Photograph – albumen print *c*.1856
$7\frac{1}{2} \times 9\frac{1}{2}$ 19 × 24
Robert Hershkowitz Ltd.

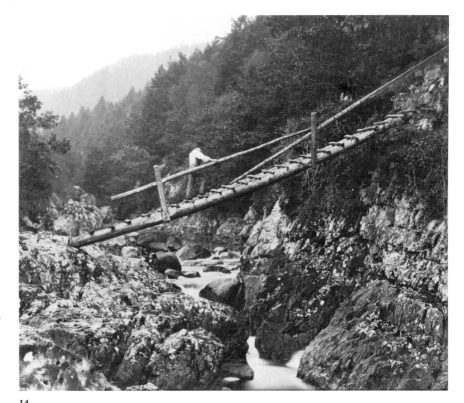

14

18

Daniel Alexander Williamson
1823–1903

Born in Liverpool, one of a family of artists. Apprenticed to a Liverpool cabinet maker as a draughtsman but turned to painting. Attended life-classes in Newman Street in London where he lived from 1849–60. Began as a portrait painter but turned to landscape in the mid 1850s. In 1861 settled in North Lancashire at Warton-in-Carnforth and in 1864 at Broughton-in-Furness. Came under the influence of Pre-Raphaelitism for a period during the 1860s, using intense, brilliant colour and a minute impasto technique. In the 1870s his style became increasingly free and impressionistic. He turned almost entirely to watercolour for a period of about twenty years before returning to oil again. For some years in middle life he was incapacitated by a serious illness and ceased to work out of doors, but studied cloud effects through his window.

19 *The Startled Rabbit,*
Warton Crag
Oil on canvas *c.*1861–64
10½ × 15¼ 26.8 × 38.7
Williamson Art Gallery and Museum, Birkenhead, Wirral

George Washington Wilson
1823–1893

A crofter's son, the second of eleven, brought up at the Waukmill of Carnoustie in Banffshire. Apprenticed as a carpenter and builder at the age of twelve. Travelled to Edinburgh *c.*1846 to study as a miniaturist, and in 1848 he settled in Aberdeen. In 1849 he continued his training for a short time in London. In 1852 whilst practising as a miniaturist began to take portrait photographs. In 1854 took pictures of the building of Balmoral, and became associated with the Royal Family in Scotland, although it was only in 1873 that he received a warrant to The Place and Quality of Photographer to Her Majesty in Scotland. In 1856 started to advertise stereoscopic views of the Aberdeen area, and began to be known as a landscape photographer. In 1858 photographed sky and sea studies at Oban. In 1859 took pictures into the sun at the Loch of Park, near Aberdeen, which made him famous. In

19

1860 took photographs of the South Coast of England, and from this period onwards he travelled widely through the British Isles and became the country's leading landscape photographer. Began the mass production of photographs in the 1860s, and by 1872 employed 30 assistants; in the 1880s began to employ staff photographers. The business began to decline in the 1890s, and Wilson died of Bright's Disease, or of a similar convulsive illness, which might have been brought on by his business.

20 *Loch of Park,*
Pike Fishing
Stereo photograph–albumen print 1863
3 × 2⅞ 7.7 × 7.2
Howard and Jane Ricketts Collection

21 *Ellen's Isle, Loch Katrine*
Photograph–albumen print 1863
3 × 2⅞ 7.7 × 7.2
Howard and Jane Ricketts Collection

22 *The Pass of Glencoe, looking down*
Photograph–albumen print 1863
3 × 2⅞ 7.7 × 7.2
Howard and Jane Ricketts Collection

Myles Birket Foster 1825–1899

Born at North Shields. When he was five his family moved to London. Was apprenticed to Peter Landells, one of the leading wood-engravers of his day and a pupil of Bewick. Foster was employed by Henry Vizetelly to illustrate Longfellow's *Evangelina*. He also cut blocks for *Punch*, the *Illustrated London News* and other periodicals. He made drawings of topical scenes and events and was sometimes sent around the country for this purpose. In 1846 he set up on his own, illustrating many books and producing a series of landscapes and rustic subjects for the *Illustrated London News*. In 1859 turned to watercolour and after 1860 abandoned book illustration; his *Pictures of English Landscape* (1863) is the only important exception. He was elected associate of the Old Water-Colour Society in 1860 and a full member in 1862. He made several visits abroad, making colour sketches and drawings, and was commissioned to paint fifty Venetian scenes for the sum of £5,000. In 1863 he built a house at Witley, near Godalming in Surrey, and was there visited by Frederick Walker. Is today best known for his watercolours of the Surrey landscape.

23 *Children running down hill*
Watercolour 1886
$13\frac{1}{4} \times 27\frac{5}{8}$ 33.7 × 70.2
Victoria & Albert Museum, London

George Price Boyce 1826–1897

Born in Bloomsbury. Was articled to an architect and travelled on the Continent for study purposes. In 1849 met David Cox at Bettws-y-Coed and afterwards abandoned architecture for painting. His early training left him with a predilection for architectural subjects which he painted with Pre-Raphaelite intensity. Between 1851 and 1875 Boyce kept a diary (published 1941) in which valuable references are made to his own work and to the Pre-Raphaelite circle, especially Rossetti who was a close friend.

24 *Landscape: Wootton, Autumn*
Watercolour 1864–5
$9\frac{3}{4} \times 13\frac{3}{4}$ 24.8 × 35
The Trustees of the Tate Gallery, London

23

24

25

William Holman Hunt
1827–1910

Born Cheapside, London. Attended
drawing classes at the Mechanics Institute
and received encouragement from John
Varley. Took painting lessons from the
portraitist, Henry Rogers. Continued to
study art in his spare time while employed
as a clerk, reading avidly and producing
occasional textile designs. 1844 met Millais
and entered the Royal Academy Schools.
Late in 1847 read Ruskin's *Modern Painters*
and discovered the poetry of Keats. In 1848
shared a studio first with Millais, then
Rossetti, and helped found the Pre-
Raphaelite Brotherhood. Employed tight
realistic detail and strong colour in order to
express moral ideas, but in the process
discovered the effect of light on colour. In
1854–5 visited the Holy Land. Was one of
the few Pre-Raphaelites to maintain the
painstaking realism associated with this
style, though during the 1860s his paintings
took on increased breadth and scale, in
keeping with the contemporary trend. By
the mid-seventies he had replaced the Pre-
Raphaelites' use of a wet, white ground for
one that was stone-coloured. His oils or
tempera paintings gradually developed
harder finish and harsher effect. His
watercolours combined 'crisp topographical
exactness with a personal approach to view-
point and most particularly to local colour,
light and atmosphere'. (Mary Bennett,
William Holman Hunt, Walker Art Gallery,
Liverpool, exhibition catalogue, 1969,
p. 11.) In 1905 he published an auto-
biography, *Pre-Raphaelitism and the Pre-
Raphaelite Brotherhood*, which, like his
paintings, contains an enormous mass of
detail and remains a prime source on the
history of this movement.

25 *Asparagus Island, Kynance, Cornwall*
Watercolour 1860
$7\frac{3}{4} \times 10$ 19.7 × 25.4
Private Collection

26 *Harvest Landscape*
Oil on canvas early 1860s
18 × 12 45.8 × 30.5
Private Collection, England

27

James Campbell 1828–1893

Born in Liverpool. Employed in an
insurance company before studying
painting at the Royal Academy Schools.
For a period came under the Pre-
Raphaelite influence. Around 1862 started
broadening his style and at the end of this
year moved to London where he met with
little success. Painted some landscapes but is
mostly known for his genre pictures and
character studies. His later work shows a
considerable falling off, possibly due to
failing eye-sight since at the end of his life he
went blind. He returned to Birkenhead and
was given a house and garden and an
annual pension of £50 by the Royal
Academy. After a period of eclipse, his work

is gradually being rediscovered. His *Wife's
Remembrances* (1858; Birmingham City Art
Gallery) was formerly attributed to Millais.

27 *The Dragon's Den*
Oil on canvas
$15\frac{13}{16} \times 15\frac{13}{16}$ 40.1 × 40.1
Walker Art Gallery, Liverpool

William Henry Millais
1828–1899

Brother of Sir John Millais. In the *Pre-
Raphaelite Brotherhood Journal* of November
1849 W. M. Rossetti noted that William
Millais had begun painting from still lives,
and that John intended to get him to paint
landscapes. The entry for 29th September

29

reads: 'John is to bully him into doing nothing all summer but paint in the fields'. In the summer of 1850 he painted landscapes in Jersey, and in the following summer painted with his brother and Holman Hunt at Worcester Park Farm, at Ewell in Surrey. In 1852, spent the summer with his brother painting at Hayes, and 1853 with his brother and John and Effie Ruskin in the Trossachs. Never became a professional artist, but continued to paint all his life, mostly in watercolour.

28 *The Valley of the Rocks, Lynton, North Devon, showing Lee Abbey*
FRONTISPIECE
Watercolour 1875
5⅛ × 31⅞ 13 × 81
Private Collection

Henry Clarence Whaite
1828–1912

Born in Manchester. Though success in London always eluded him, was a major and influential figure, both within the Manchester Academy and the Royal Cambrian Academy, becoming President of the latter. His paintings were highly sought after in the North-West and Midlands. A watercolourist and oil painter, he achieved early acclaim with his *The Rainbow* (1862; Castle Museum, Nottingham) in which he combined a panoramic effect with Pre-Raphaelite observation and the sentiment of Birket Foster. Ruskin, reviewing a picture by Whaite in 1859, warned him against excessive finish and this may have contributed towards the subsequent loosening of his style. Like many other

Victorians, painted at Bettws-y-Coed and specialized in Welsh scenes. His paintings became increasingly conventional although he excelled at Turnerian effects, as found in *Harlech Castle.*

29 *Harlech Castle, 'Four square to all the winds that blow'*
Oil on canvas
35½ × 59½ 90.2 × 151.2
Christopher Newall

Sir John Everett Millais
1829–1896

Born in Southampton. Travelled to London in 1839 with an introduction to Sir Martin Archer Shee, P.R.A. Worked in the British Museum, Henry Sass's Academy and in 1840 entered the Royal Academy Schools. In 1848 met D. G. Rossetti and with him and others formed the Pre-Raphaelite Brotherhood. In 1849 began painting in a new style, signing his pictures with the initials P.R.B. In 1850 Pre-Raphaelite pictures shown at the Academy aroused hostile criticism and the following year the Brotherhood was championed by Ruskin. In 1853 visited Scotland with Ruskin and his wife Effie. In London during 1854 completed his portrait of Ruskin, begun in Scotland, while divorce proceedings began and the following year Millais married Effie Ruskin. That same year he settled at Annat Lodge, near Bowerswell, Perthshire and painted many landscapes in the surrounding countryside. He continued to spend part of each year in London. His style of painting increasingly loosened in touch and he exchanged the admiration of Ruskin for great popular success. Received many honours and was created a baronet in 1885. Between 1887–96 painted a series of landscapes at Murthly.

30 *Chill October*
COLOUR PLATE IV
Oil on canvas 1870
$55\frac{1}{2} \times 73\frac{1}{2}$ 141×186.7
Private Collection

John Brett 1830–1902

Born in Surrey and entered the Royal Academy Schools in 1854. Of key importance to his career was a trip to Switzerland in 1856 during which he met Inchbold, watched him work and realized 'that I had never painted in my life, but only fooled and slopped'. Must also have been influenced by the fourth volume of Ruskin's *Modern Painters* published in April 1856, subtitled 'Of Mountain Beauty', and which deals more with geology than painting. Was taken up by Ruskin who described Brett as 'one of my keenest-minded friends'. In 1858 exhibited at the Royal Academy *The Stonebreaker* (Walker

Art Gallery, Liverpool) which made his reputation. In June 1858 began work on *Val d'Aosta* (Private Collection), a *tour de force* on which Ruskin offered advice and encouragement. Ruskin in his *Academy Notes* praised the work fulsomely but also declared that it was 'wholly emotionless: I never saw the mirror so held up to Nature; but it is Mirror's work, not Man's.' Here Brett arrived at the detached scientific observation that Ruskin had encouraged in his earlier writings; but not the imagination that Ruskin hoped would follow upon this training. Specialized in sea subjects; on a large scale these tend to become mechanical, their clarity reminiscent of the Pre-Raphaelite technique but their wide viewpoint resulting in an emptiness antithetical to Pre-Raphaelitism. (Quotations from Allen Staley's *The Pre-Raphaelite Landscape*, 1973, pp. 124–25 and 131.)

31 *Calm Day East of the Lizard*
Oil on canvas 1877
$12\frac{1}{2} \times 24\frac{1}{2}$ 31.8×62.2
Private Collection

Alfred William Hunt 1830–1896

Born in Liverpool. Studied at Oxford where he won the Newdigate Prize for English verse. Remained a Fellow at Oxford from 1853 until 1861 when he married and decided to devote his career to art. Moved to London in 1862 and exhibited at the Royal Academy as well as the Liverpool Academy, becoming a member of the latter. His early work was in watercolour and inspired by David Cox, a friend of his father, also a landscape painter. Around 1855–6 his style changed under the influence of Pre-Raphaelitism. Almost certainly read the fourth volume of Ruskin's *Modern Painters* (1856), its geological concerns finding expression in Hunt's *Rock Study* of 1857. His sketchbooks in the Ashmolean Museum, Oxford, contain many studies of rocks and lichen. His habit later in life was to sketch from nature in the summer and work up these sketches into oils in his studio during the winter. Received high praise from Ruskin, qualified with warnings against excessive finish. Visited Ruskin at Brantwood and made him the godfather of one of his daughters.

32 *Rock Study; Capel Curig – The Oak Bough*
COLOUR PLATE I
Watercolour 1857
$10\frac{1}{8} \times 14\frac{3}{4}$ 25.7×37.5
Christopher Newall

Frederic, Lord Leighton
1830–1896

Born in Scarborough, Yorkshire. During his boyhood his family spent much time on the Continent where he visited art galleries and filled notebooks with sketches. He also studied for a time at the Academy in Berlin and at the Accademia di Belle Arti in Florence. In 1848 he enrolled at the Städelsches Kunstinstitut at Frankfurt where he came under the influence of Edward von Steinle, a leading member of the Nazarenes; in 1852 he moved to Rome. Between 1855–8 Leighton lived in Paris and began exhibiting at the Royal Academy. Finally settled in London in 1859 and remained there for the rest of his life. After he was elected as associate of the Royal Academy in 1864, his career was a notable success. He built a house in Holland Park, entertained regularly and became President of the Royal Academy in 1878. His dedication and gift for administration did much to increase the prestige of this institution and he attracted into its ranks outsiders like G. F. Watts and Burne-Jones. He never married but remained a close friend of the two artists he had met in Rome, Giovanni Costa and George Heming Mason. He had a passion for travel and when abroad, either in Greece, North Africa, Spain or Germany, and freed from his responsibilities, he painted small landscapes in oil which have a much greater freshness than the elaborately studied subject pictures that he sent each year to the Royal Academy. These landscapes he regarded merely as studies for the backgrounds of his larger paintings. He gave some away to friends but most were found in his studio after his death.

33 *Malin's Head, Donegal*
Oil on canvas 1885
$9\frac{1}{2} \times 10\frac{1}{2}$ 24.2×26.7
Hugh Lane Municipal Gallery of Modern Art, Dublin

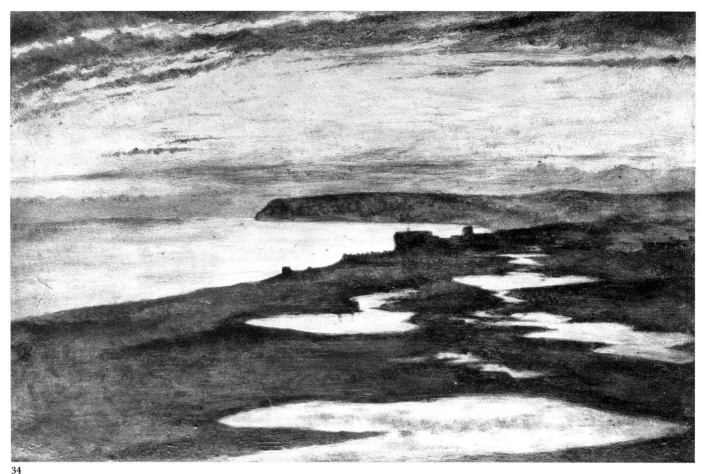

34

Henry Wallis 1830–1916

Studied in London and Paris. During the 1850s came under the influence of Pre-Raphaelitism and painted some work of major importance, such as *The Death of Chatterton* (Tate Gallery) and *The Stone-breaker* (Birmingham City Art Gallery), the last an outstanding piece of social realism combined with a deeply poetic response to landscape. After the Pre-Raphaelite period, his work declined.

34 *A Coast Study – Sunset*
Oil on board 1859
8⅞ × 14 22.5 × 35.5
Walker Art Gallery, Liverpool

William J. Webbe
fl. *c*.1850s–60s

An artist about whom little is known. His paintings emulate the detailed observation of nature found in Holman Hunt's *Strayed Sheep* (Tate Gallery). Between 1855 and 1860 he lived on the Isle of Wight, painting pictures of animals and exhibiting landscapes. In 1862 he travelled to the Holy Land and all the works that he exhibited subsequently were of Eastern subjects.

35 *Twilight*
Oil on canvas *c*.1870
36 × 36 91.5 × 91.5
John Hewett

Benjamin Williams Leader
1831–1923

Born in Worcester, the son of a distinguished civil engineer, and trained at the Worcester School of Design, and after 1854 at the Royal Academy Schools. In 1857 went to Scotland, and then painted in Wales. In 1858 he exhibited at the National Institute and Thomas Creswick, the painter, bought *Where the Mosses Thrive*; in 1859 David Roberts bought *A Quiet Pool in Glen Falloch*. In 1863, W. E. Gladstone bought the *Church at Bettws-y-Coed*. In 1862 he moved to Whittington, near Worcester, and in 1890 to Gomshall in Surrey. By the '80s

he had turned his attention largely to English landscape, and was known for the dour aesthetic of *February Fill Dyke* (1881, Birmingham City Art Gallery) and *At Evening Time it Shall be Light*. His work became repetitive after 1900. A friend of Vicat Cole.

36 *The Churchyard, Bettws-y-Coed*
Oil on canvas 1863
32 × 53 81.3 × 134.7
Guildhall Art Gallery,
Corporation of London

37 *Album of Drawings*
Watercolour *c*.1870–80
$15\frac{1}{8}$ × 11 × $1\frac{3}{8}$ 38.3 × 28 × 3.4
Victoria & Albert Museum, London

Keeley Halswelle 1832–1891

Born in Richmond, Surrey. Initially employed in an architect's office, but left to work for an engraver and to study in the British Museum. Employed as a draughtsman by the *Illustrated London News* and other publications. Moved to Edinburgh *c*.1854 and continued to work as an illustrator. In 1866 elected associate of the Royal Scottish Academy. First exhibited at the Royal Academy, London, in 1867 and won acclaim two years later with *Roba di Roma*, painted after a visit to Rome in 1868. Originally a genre painter, turned to landscape, excelling at sky effects and specializing in Newhaven fishing scenes, highland landscapes and views of the Thames. This painting is a study for *Fenland*, exhibited at the Royal Academy in 1881.

38 *Study for Fenland, Sky Effect*
Oil on canvas *c*.1881
$10\frac{1}{2}$ × $16\frac{1}{4}$ 26.7 × 41.2
Private Collection

36

38

69

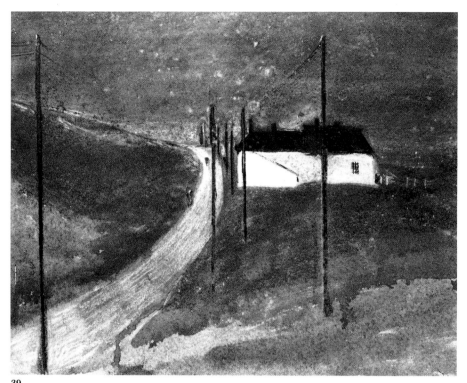

39

Sir Edward Coley Burne-Jones
1833–1898

Born in Birmingham, where his father was a gilder and frame-maker. In 1854 went to Exeter College, Oxford, where he met William Morris, with whom he was to be associated for the rest of his life. Impressed by Kenelm Digby's book *The Broadstone of Honour*, a compilation of legend which he kept by his bed for the whole of his life, and by Dürer's engraving of *The Knight, Death and the Devil*. Discovered Malory's *Morte d'Arthur*, 'the strange land that is more true than real'. After Oxford studied painting with D. G. Rossetti. Looked at the Italian Primitives in the National Gallery, and throughout studied art more than he studied Nature. Although impressed by Ruskin, whom he knew, did not think naturalism a basis for art. In the 1850s G. F. Watts taught him that 'painting is really a trade'. Designed stained-glass windows from 1857 onwards for James Powell and Co., and for Morris. In 1864 his *The Merciful Knight* was exhibited, and younger artists

were impressed. Sometimes worked from nature, as for *Green Summer* of 1864, but preferred Gerard's *Herbal* as a basis. In 1867 moved to The Grange in Fulham. Visited Italy several times in the 1860s. In 1877 exhibited at the Grosvenor Gallery, which made him famous. In 1880 moved to Rottingdean, where this drawing appears to have been made. Although he took legal measures against the introduction of electric light into Rottingdean, he was not bitter in his attitudes to modern developments.

39 *Study of a Road near Rottingdean*
Pastel
12 × 15 30.5 × 38.2
The Royal Pavilion, Art Gallery and Museums, Brighton

George Vicat Cole 1833–1893

Trained by his father, George Cole, he quickly became famous with such paintings as *Harvest Time*, which won him a silver medal from the Society for the Encouragement of the Arts, after its exhibition at the Society of British Artists. He was accustomed to close study in the open air at the outset of his career, when he painted in Surrey and in the Wye Valley. By 1853 he was a drawing master in London. From 1863–7, lived at Holmbury Hill in Surrey and then in Kensington. Noted for a tenderness of feeling in his landscapes of cornfields, rivers and woodlands.

40 *Harvest Time*
Oil on canvas 1860
37¾ × 59¾ 95.9 × 151.7
The City of Bristol Museum and Art Gallery

James McNeill Whistler
1834–1903

Born in Lowell, Massachusetts. Brought up in Connecticut, Massachusetts and in St Petersburg. Rejected, after three years in military academy, then found a job in a survey office where he learnt etching. Moved to Paris in 1855, studied in Gleyre's studio and befriended Fantin-Latour. First won success with his etchings, the 'French Set', partly inspired by the work of Charles Meryon. In 1859 moved to London and produced the 'Thames Set' etchings. Though based in London until 1892, when he moved to Paris, made frequent visits abroad. Moved into a house on Lindsey Row (now part of Cheyne Walk) and enjoyed friendship with D. G. Rossetti and Swinburne. Influenced by them and the painter Albert Moore, he developed his theory of 'art for art's sake' and called his portraits 'symphonies' or 'arrangements', and his river scenes 'nocturnes', much to the anger of the critics, in particular Ruskin who accused him of 'throwing a pot of paint in the public's face'. Whistler sued Ruskin and won the case but was bankrupted by the costs. He produced the 'Venice Set' etchings to recoup. His art became more elegant as his tongue became more virulent; the law suits increased and the butterfly with which he signed his work acquired a devil's tail. A city dweller, his rare contact

with nature seems to have been with rivers and the sea. His evocations of twilight on the Thames, painted from memory, are unique in nineteenth-century art.

41 *The Thames at Billingsgate*
Etching 1859
5¾ × 8¾ 14.7 × 22.3
Rowland Hilder

42 *Bathing Posts, Brittany*
Oil on panel *c*.1893
6½ × 9 9/16 16.6 × 24.3
Hunterian Art Gallery, University of Glasgow – Birnie Philip Bequest

William McTaggart 1835–1910

Born at Aros, a croft in Laggan of Kintyre. His father was a crofter, then a peat-cutter and carter; his mother, the daughter of Duncan MacDougall, a local religious poet. His parents, of the Reformed Church, were against his becoming an artist, and he was apprenticed to an apothecary in Campbeltown, who saw his gifts and encouraged him to attend art school. In 1852, he attended the Edinburgh School of Art, where he was influenced by the colourist Robert Scott Lauder; fellow students included Graham, Orchardson, Cameron and McWhirter. In 1860 he spent two weeks in Paris – but came to his own sort of Impressionism independently. Spent two months of the year on the Atlantic Coast at Machrihanish in Kintyre, and also worked at Carnoustie in the East. In 1889 moved to Broomieknowe in Mid-Lothian. People played less and less of a part in his richly worked landscapes.

43 *The Storm*
Oil on canvas 1890
48 × 72 1/16 121.9 × 183
National Gallery of Scotland, Edinburgh

44 *Broken Weather, Port Seton*
Oil on canvas
23¼ × 30¾ 59 × 78
Kirkcaldy Museums and Art Gallery

42

43

Sir Lawrence Alma-Tadema 1836–1912

A Dutch painter who, after training in the Antwerp Academy, working as an assistant to Baron Hendryk Leys and making a reputation with Merovingian and Egyptian subjects, came to London in 1870. Developed a talent for portraying domestic incidents in ancient Greece and Rome which won him great popularity. Became a Royal Academician, was knighted and rebuilt a large house in St. John's Wood where he regularly entertained. During the Edwardian period all the skilfully painted accoutrements in his pictures barely veiled the vapid sentimentality or eroticism of his subjects. Rarely painted nature for its own sake but in the 1870s occasionally employed garden settings. *94° in the Shade* was painted in a field at Godstone, Surrey; the figure was Herbert Thompson, the son of the eminent surgeon, Sir Henry Thompson.

45 *94° in the Shade*
Oil on canvas laid on panel 1876
$13\frac{7}{8} \times 8\frac{1}{2}$ 35.3 × 21.6
Fitzwilliam Museum, Cambridge

Atkinson Grimshaw 1836–1893

His family moved to Norwich in 1842. In 1852 he began to work as a clerk on the Great Northern Railway, and was still working thus when he married in 1858. He had begun to paint and by 1859 was selling 'studies of dead birds and blossoms ... of moss-grown rocks, ferns and foliage'. A professional painter by 1861, and doing well by 1864, selling pictures for £9–£10 each. In 1868 toured in the Lake District and in Yorkshire, and came to be known for his moonlight pictures. Exhibited at the Royal Academy in 1874, and in 1876 had built a battlemented, turretted house, completely surrounded by a conservatory, in Scarborough. Suffered a major financial disaster in 1879. In the 1880s began to paint town scenes in which natural and artificial light sources were mixed. In 1885 exhibited at the Grosvenor Gallery. Was a friend of Whistler.

46 *A Mossy Glen*
Oil on board 1864
$21\frac{9}{16} \times 25\frac{9}{16}$ 54.7 × 65
Calderdale Museums Service

45

John MacWhirter 1839–1911

Trained under Lauder at Edinburgh, along with Peter Graham, and after early success in Scotland settled in London in 1869. His early work was almost Pre-Raphaelite in its concern with detail. He enjoyed travelling, and sketched from nature in Norway, Switzerland, Italy and Scotland. He first visited the Austrian Tyrol at the age of sixteen and many years later revisited it to paint *June in the Tyrol* (Tate Gallery). Its pretty colouring and tranquil sentiment won him great popularity. Was a lifelong follower of Ruskin's theories on contemplative landscape as defined in *Modern Painters* and exemplified in Turner. Enjoyed consistent success and built himself a Renaissance palace in St. John's Wood. Said of his painting *Spindrift*: '"Spindrift" means the spray of the sea caught up and whirled away by the wind. I saw the seaweed cart coming along when I was working on a stormy day, and made a note of it in my sketch-book. I afterwards made careful studies of the wet road, gravel, etc. The scene is near Loch Range, Arran.' (Quoted in Jeannie Chapel, *Victorian Taste. The Complete Catalogue of Paintings at the Royal Holloway College*. 1982, p. 112.)

47 *Spindrift*
Oil on canvas 1876
32 × 56 81.3 × 142.2
Royal Holloway College,
University of London, Egham

46

47

George Sheffield 1839–1892

Born in Wigton, Cumberland, before moving to Warrington and then to Manchester, where he was apprenticed as a pattern designer. Taught to paint by Sir Luke Fildes, a genre and reportage painter. Devoted himself to landscape painting, and was especially well known for his monochrome coast scenes. At first he worked much in the South Lancashire and North Cheshire area, and along the Bridgewater Canal. In 1861 he settled at Bettws-y-Coed, and later lived in the Alderley district, on the Isle of Man and then in Warrington and in Manchester. Mainly did drawings and watercolours. In 1908 there was a Memorial Exhibition of his work in the Warrington Museum.

48 *Churchyard at Bettws-y-Coed*
Watercolour *c*.1865
$7\frac{7}{8} \times 11\frac{3}{4}$ 20 × 29.8
The Trustees of the Tate Gallery, London

49

Thomas Collier 1840–1891

Born in Glossop, Derbyshire. Attended the Manchester School of Art. Between 1864 and 1869 lived at Bettws-y-Coed, a place associated with the artist by whom he was chiefly influenced, David Cox. Became an associate of the Royal Institute in 1870 and a full member in 1872. Shy, sensitive and retiring, he built himself a large house at Hampstead, suffered from consumption and worked with feverish energy. Painted mostly out of doors, sketching even in the snow until his palette was covered with ice and his brushes frozen stiff. Excelled at sky effects. A man of private means, he travelled widely, painting all over England, but expecially on the Suffolk coast. During his later years poor health compelled him to work indoors. *Wide Pastures, Sussex* is unusually large in scale because it was commissioned to fill a particular spot in a patron's drawing-room.

49 *Wide Pastures, Sussex*
Watercolour 1879
$28 \times 42\frac{1}{8}$ 71.1 × 107
Victoria & Albert Museum, London

50

Frederick Walker 1840–1875

Son of a jeweller from whom he inherited consumption. Studied at Leigh's studio in Newman Street, in the British Museum and in the Royal Academy Schools. Apprenticed to the wood engraver J. W. Whymper where he met J. W. North who became a close friend and painting companion. From 1860–4 worked as a wood engraver and made his name as an illustrator, contributing to *Once a Week* and to the *Cornhill* then edited by Thackeray. Also did small watercolours like *Blackberrying* which he sold for modest prices. Was made an honorary member of 'The Clique', a group of artists based in St. John's Wood. Tired of wood engraving and turned to painting. His work was admired by George Mason and Birket Foster. In 1868 visited Italy. His chief concern was to combine observation of nature with an affective sentiment. The sweetness of his nature, the charm of his drawings and his early death combined to ensure him considerable posthumous fame.

50 *The Old Gate*
Oil on canvas
53 × 66¼ 134.6 × 168.3
The Trustees of the Tate Gallery, London

51 *Blackberrying*
Watercolour 1860
13⅜ × 16¾ 33.9 × 42.4
Cheltenham Art Gallery and Museums

Charles Napier Hemy 1841–1917

Born in Newcastle-upon-Tyne. Attended Ushaw College, County Durham to study for the priesthood. Married his early love for the sea with his love of art and became a marine painter. Studied at the Newcastle School of Art, worked briefly for Morris, Marshall, Faulkner & Co., and completed his training in Antwerp under Baron Leys. Entered a Dominican monastery in 1860, and remained there for three years. During the 1870s lived in London, painting and exhibiting river scenes. Settled at Falmouth in 1883 and converted a forty-foot, broad beamed fishing boat into a floating studio which he christened the *Van de Velde*. From this, and its successor the *Van de Meer*, he painted studies for most of his major works.

53

Elected associate to the Royal Academy in 1898 and a full member in 1910. He continued to paint until his death, and is today best known for his vivid sea paintings. *Among the Shingle at Clovelly* (1864) is a rare early work, indebted to Ruskin, to William Bell Scott, his teacher, and to John Brett whose *Stonebreaker* (Walker Art Gallery, Liverpool) must have inspired the rendering of the boy sitting on the minutely-painted pebbled beach. The Leathart Collection of Pre-Raphaelite paintings in Newcastle was also a source of inspiration. Napier Hemy's painting was exhibited at the Royal Academy in 1864, the year when *The Times* noted that 'seashore pictures abound, and Cornwall and North Devon are favourite "pitches" for this kind of subject'.

52 *Among the Shingle at Clovelly*
COLOUR PLATE II
Oil on canvas 1864
17⅛ × 28½ 43.5 × 72.1
Laing Art Gallery, Newcastle upon Tyne

John William North 1842–1924

Born at Walham Green and apprenticed as a wood-engraver to J. W. Whymper, working with Frederick Walker who became a close friend. Between 1862–6 was employed by the Dalziel brothers. He contributed landscapes to *Wayside Poesies* (1867) and other publications of the period. In 1868 he lived at Halsway Farm, Washford and wherever he lived thereafter he continued to regard Somerset as his spiritual home. As his grasp of life-drawing was poor, he tended to avoid putting figures in his landscapes but sometimes induced Walker to add one for him. Martin Hardie has observed: 'He was much more interested than Walker in atmosphere, and his wish to make his drawings tingle and shimmer with light led him to paint multitudinous details melting together, with spots and particles of pure colour. His method can be compared with *pointillisme*; certainly, he was groping for methods of expression which the French Impressionists developed more fully.' (*Watercolour Painting in Britain, Vol. III The Victorian Period*, 1968, p. 138.)

53 *Gypsy Encampment*
Watercolour 1873
25¼ × 36½ 64.2 × 92.8
Victoria & Albert Museum, London

Sir William Blake Richmond
1842–1921

Born Portman Square, London. Son of the artist George Richmond, studied at the Royal Academy Schools and won silver medals. Visited Italy in 1859 and during the 1860s spent about four years there learning fresco painting and studying the Old Masters. Exhibited at the Royal Academy from 1860. His early work showed Pre-Raphaelite influence, but in 1866 was introduced by Leighton to Giovanni Costa who advised him to cut away small details. In keeping with the mood of Etruscan School painting, he developed a poetic landscape style, based on his experience of travels in Greece and Italy but evocative of Arcadia. Became Slade Professor at Oxford 1878–83; made an associate member of the Royal Academy in 1888 and a full member in 1895 and was knighted in 1897. He painted portraits, figure subjects and landscapes and designed mosaic decorations for St. Paul's Cathedral. Gave valuable advice, at a crucial stage in their careers, to Paul Nash and Joseph Southall.

54 *The Arcadian Shepherd*
Tempera on panel
9 × 19¾ 22.8 × 50.2
Private Collection

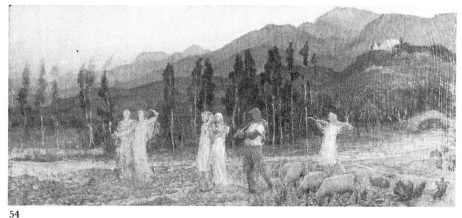

54

55

58

George Howard, 9th Earl of Carlisle 1843–1911

Studied at the South Kensington School of Art. In 1865 met Giovanni Costa while on a visit to Italy and in 1879 and 1888 gave hospitality to the Italian artist at his home, Naworth Castle in Cumberland, where both men painted landscapes, many examples of Costa's work remaining in Howard's collection. Travelled widely, making sketches and watercolours wherever he went. Also painted narrative pictures which show a debt to the Pre-Raphaelites, many of whom were his personal friends. Due to his aristocratic background is often considered a dilettante, but was a dedicated professional artist, exhibiting regularly at the Grosvenor Gallery and, subsequently, at the New Gallery, London. For thirty years acted as Chairman of the Trustees of the National Gallery. Grandfather of Winifred Nicholson.

55 *The Northumberland Coast at Bamburgh*
Oil on canvas *c*.1885
$17\frac{1}{4} \times 40\frac{1}{4}$ 43.8 × 102.3
Christopher Newall

Walter Crane 1845–1913

A designer, illustrator and teacher. His family moved from Torquay to London in 1857. He was apprenticed to the wood-engraver W.J. Linton and studied at Heatherley's School of Art. In 1863 painted in Derbyshire executing cloud studies with precise colours and the times of day noted. His Derbyshire paintings were bought by Sheffield businessmen who went annually to fish on the Derwent. By 1865 his landscapes became more generalised, and were based on two outline studies, on one of which basic features and shadow effects were noted, and on the other general tone and colour: 'the picture can be proceeded with after the first two studies ... This will be a great saving of time should there be much wet weather ... Last year on wet days I was at a standstill with my pictures because I painted them all out of doors'. Much impressed by Burne-Jones' painting of *The Merciful Knight* of 1864. Worked with the Dalziels and for *Once a Week* and *Fun* from 1867. In 1869 sketched at Bettws-y-Coed.

In 1871 married and went to Italy for two years. Around this time he met Burne-Jones and Morris, and was involved with Morris in the '80s.

56 *Llyn Elsie, Near Bettws-y-Coed*
Watercolour 1871
$15\frac{1}{2} \times 24\frac{7}{16}$ 39.4 × 62.1
Victoria & Albert Museum, London

Albert Goodwin 1845–1932

Born in Maidstone, the son of a builder and preacher. As a boy he was apprenticed to a draper but came to know Holman Hunt who introduced him to Ford Madox Brown and to Arthur Hughes, with whom he studied. He met Ruskin with whom he holidayed in Abingdon, at the Crown and Thistle Inn, in 1871. In the 1860s he sold work to Leathart, the great collector of Pre-Raphaelite painting in Newcastle. An intensely religious man throughout: 'The whole natural world, down to the smallest detail, is one great allegory, typical of the spiritual world. Our business is to study the natural world as the continued revelation of God, guiding us for ever into fresh revelation of himself' (from a diary entry of 1888). In his later work experimented with tinted paper, stippling, pastel, chalk and waterproof inks.

57 *Woolacombe Sands, North Devon*
Watercolour 1884
$6\frac{7}{8} \times 8$ 17.5 × 20.3
Maas Gallery, London

Walter Greaves 1846–1930

Son of a Chelsea boat-builder who used to ferry Turner across the river. Walter and his brother Henry performed the same service for Whistler, taking him out on the river at night so that he could make sketches for his *Nocturnes*. They met soon after Whistler moved into Lindsey Row (now Cheyne Walk) in 1863. Before this date Walter had painted *Hammersmith Bridge on Boat Race Day* (Tate Gallery) which in its naive style displays his knowledge of boats and of the river. 'To Mr Whistler a boat is always a tone,' Walter Greaves declared, 'to us it was always a boat.' He and his brother became Whistler's studio assistants; they bought his materials, prepared his colours, assisted with

the decoration of the Peacock Room and received no payment at all. 'He taught us to paint, and we taught him the Waterman's jerk.' Walter, the more talented of the two brothers, adopted Whistler's style and manner of dress, submerging his personal vision in imitation of his master's art. This dedication brought him little reward other than an exhibition at the Goupil Gallery in 1911. Towards the end of his life, his top hat battered and worn, he haunted the book-shops near the British Museum, offering sketches of Chelsea in return for books, and eventually died in a poorhouse.

58 *Old Battersea Bridge*
Oil on canvas *c*.1868
$12\frac{1}{4} \times 20\frac{1}{4}$ 31.1 × 51.4
Michael Parkin Fine Art Ltd.

Norman Garstin 1847–1926

Born in Ireland. Early in his life his father committed suicide and his mother developed a severe form of muscular paralysis. Was brought up by his grand-parents. Intended becoming an engineer but turned to architecture. Soon abandoned this for the diamond fields of South Africa where he hoped to make his fortune. Became involved with the foundation of the *Cape Times* which he sub-edited, and eventually returned to Ireland fortune-less. Entered upon a period of hunting in the winter and painting in the summer. Decided to take up art as a profession and studied under Charles Verlat at Antwerp. Moved to Paris and took lessons under Carolus-Duran. Travelled to Italy and Morocco and finally settled in Newlyn for three or four years before moving permanently to Penzance. In 1892 he made a visit to America where he is said to have painted the Rockies and the Saskatchewan plains. His contribution to the Newlyn School was a cool, silvery tonality and a strong interest in mood. His *The Rain it Raineth Every Day* was accepted at the Royal Academy in 1889 but not hung. Garstin was by then badly in need of money and to make ends meet wrote articles for art journals, taught, lectured and took parties of art students on study trips abroad. His interest in asymmetrical balance grew out of his love for Japanese art and his admiration for the work of Whistler. He also admired

Manet's paintings and despised anecdotal content. In *The Rain it Raineth*, however, he effects a compromise between narrative content and his concern with particular light effects. Later, presumably due to financial pressures, he turned to upper-class subjects and to sentimental costume painting.

59 *The Rain it Raineth Every Day*
Oil on canvas 1889
37¼ × 64 94.5 × 162.5
Penzance Town Council

Théodore Roussel 1847–1926

Born at Lorient in Brittany and moved to England in 1874. Settled first at Hastings but by the early 1880s was living in Chelsea where he met Paul Maitland. By 1885 had become a close associate of Whistler. Exhibited with the Society of British Artists and the New English Art Club, and, in 1888, at the Grosvenor Gallery. Specialized in landscapes and seascapes in the Whistlerian style, using fluid paint and subtle tonal transitions. Lived and taught at Bolton Studios in South Kensington until 1891 when he moved to Parson's Green.

60 *Approaching Storm, Dover*
Oil on canvas *c*.1920
19¼ × 24 49 × 61
Lincolnshire Museums:
Usher Gallery, Lincoln

Helen Allingham 1848–1926

Studied at the Birmingham School of Design, before going to the Royal Academy Schools in 1867. Her father had died in 1862, and the family had moved from Cheshire to Birmingham, where Helen began to draw in family drawing clubs. Her mother's sister had been the first woman to gain entry to the Royal Academy Schools. Influenced by Birket Foster and Frederick Walker. Visited Italy in the spring of 1868. In 1869 began to do the rounds of engravers' offices and through Joseph Swain got work on *Once a Week* and *Little Folks*. From 1870–4 was on the staff of the *Graphic* newspaper: pay was 12 gns. for a full, and 8 for a half page. Worked for the *Cornhill* and illustrated Hardy's *Far from the Madding Crowd*. In 1874 Helen (née Paterson) married the Irish poet William Allingham,

59

60

author of 'up the airy mountain' and editor of *Fraser's Magazine*. Became one of the Cheyne Walk set, with Carlyle, Ruskin, Browning and Tennyson. Began cottage garden painting in the late 1870s with pictures of the Pensioners' Hospital flower beds in Chelsea. In 1879 visited Shere and painted cottage gardens from nature. In 1881 moved to Witley close to Haslemere in Surrey.

61 *Feeding the Fowls, Pinner*
Watercolour
13½ × 20 34.3 × 50.8
The Trustees of The Royal Society of Painters in Water-colours, London

Matthew Ridley Corbet
1850–1902

Born in Lincolnshire and studied under Davis Cooper at the newly opened Slade School and later at the Royal Academy. At first influenced by G. F. Watts until, in 1880, he went for three years to Italy where he worked with Giovanni Costa and gave up portrait painting for landscape. He painted mostly Italian views, occasionally combining views of the Tuscan hills under evening light with pastoral subjects. Like others of the Etruscan School he exhibited at the Grosvenor Gallery and the New Gallery, as well as the Royal Academy and the Paris Salon. He married one of Costa's pupils, Edith Murch, in 1891. He painted small studies in oil from nature and on these based large canvases such as *Val d'Arno, Evening*, purchased for the Tate Gallery by the Chantrey Bequest in 1901.

62 *Arcadian Shepherd and his flock*
COLOUR PLATE III
Oil on canvas 1883
15½ × 25 39.4 × 63.5
Victoria Art Gallery, Bath City Council

64

George Christopher Davies
fl. *c*.1870s–80s

A writer, and photographer, specializing in country matters in East Anglia. In 1873 his *Fishing; a comprehensive handbook of the art* was published, as was *Mountain, Meadow and Mere; a series of outdoor sketches of sport, scenery, adventures, and natural history*. In 1882 Jarrold and Sons published *The Handbook to the Rivers and Broads of Norfolk and Suffolk*, which, under various titles, ran into 44 editions by 1914. The majority of many publications followed this pattern, interrupted by cruises to the Low Countries in 1887 and 1894. Edited Gilbert White's *Natural History of Selborne* in 1879, and Walton's *The Compleat Angler* in 1878. In 1883 W. Blackwood and Sons of Edinburgh and Glasgow published his *Norfolk Broads and Rivers, or the Waterways, Lagoons and decoys of East Anglia*, illustrated by photogravures, printed by T. R. Annan of Glasgow; the same pictures were published separately in portfolios.

63 *Whitlingham Vale from Postwick*
Photogravure 1889
15¼ × 11 38.7 × 28
Private collection

James Charles 1851–1906

A Warrington artist, who studied at Heatherley's School of Art, at the Royal Academy Schools and at the Académie Julian in Paris where he came under the influence of the *plein-air* movement. Exhibited at the New English Art Club all his life and made visits to Italy in 1891 and 1905. Was one of the first to practise an impressionist style in England. Having begun as a portraitist, spent most of his career painting landscape and rustic genre scenes, with great charm in an unpretentious style. His work has only recently begun to receive the appreciation it deserves.

64 *The Picnic*
Oil on canvas 1904
14¾ × 21¼ 37.5 × 54
Warrington Museum and Art Gallery

William Lionel Wyllie
1851–1932

Lived as a child in Albany Street, London, with summers in Boulogne. Trained at Heatherley's School of Art which he left at 15 to go to the Royal Academy Schools. Worked for 20 years for the *Graphic* from its inception in 1870; his last drawing was of the sinking of H.M.S. *Victoria* after its collision with the *Camperdown*. In 1875 sold pictures in Glasgow through Sir David Murray, and in 1878 J. C. Hook bought his picture of the Thames, *The Silent Highway*, from the Royal Academy. *Toil, glitter, grime, and wealth, on a flowing tide* was a Chantrey purchase for the Tate Gallery in 1883. A painter all his life of 'ships and sea and atmosphere', he was also deeply engrossed in the business and bustle of his time. In 1884 moved to Gillingham House, near Chatham, and shortly afterwards to Hoo St. Werburgh – until 1906, when he moved to Portsmouth. Sailed often in the barge *Ladybird*, and in yachts. Made painting trips to Holland and Northern France. Etched for Robert Dunthorne, who ran the Rembrandt Gallery. Did poster work for the Orient Company, the White Star Line and the Union Castle Line. In 1917 painted an aerial view of the Battle of Bourlon Wood, for which Air Marshal Trenchard sent maps and aerial photographs. In 1930 completed a panorama of the Battle of Trafalgar for the *Victory* Museum in Portsmouth. Subject of a most affectionate and detailed memoir, *We Were One*, by Marion Amy Wyllie (1935).

65 *Aerial View of the London Docks*
Mixed media on board
$14\frac{1}{4} \times 11\frac{3}{4}$ 36.2 × 29.8
The Fine Art Society plc, London

65

Sir George Clausen 1852–1944

At the age of 16 he became a draughtsman in a builder's office, and from there went to the National Art School at South Kensington. Worked for a time in the studio of Edwin Long and then in that of Bouguereau in Paris. Began to exhibit pictures of country life and landscape at the Royal Academy in the 1870s. From being a careful naturalist he became an atmospheric painter. Worked mainly in Essex and around his home in St. John's Wood. In 1923 designed posters for the London Midland and Scottish Railway Company. At the Academy in the 1920s was thought of as sympathising with 'modernism'. In 1931 explained his way of painting a sunrise: 'I go out half an hour before sunrise and paint till half an hour after sunrise. If the weather is favourable, I do it every morning, say, for a fortnight. By that time I get all I am likely to get out of it. Then I go indoors and paint. Perhaps I produce a picture – and perhaps I don't'.

66 *Artist painting out of doors*
Oil on panel 1882
$8\frac{1}{4} \times 4\frac{3}{4}$ 21 × 12.1
City of Bristol Museum and Art Gallery

67 *Dusk*
COLOUR PLATE XI
Oil on canvas 1903
$24\frac{1}{2} \times 29$ 62.2 × 73.7
Laing Art Gallery, Newcastle upon Tyne

Frederick Henry Evans
1853–1943

Born in Whitechapel, London, and became a bookseller. Knew and assisted Aubrey Beardsley. A photographer before 1886, he was initially interested in portraiture, but devoted an increasing amount of time to landscape. In 1898 he retired and moved to a cottage near Epping Forest. Gave more of his time to photography. Included by the American Alfred Stieglitz in his magazine

Camera Work in 1903. In 1900 he had a one-man show at the Royal Photographic Society and met the American photographers A. L. Coburn and F. H. Day. Began to work for *Country Life* in 1906. Gave up photography after the Great War, when platinum paper became hard to find. Many of his prints of the 1890s were of cathedral architecture, but he also made many images of pine woods in Surrey. Photographed in Sussex, on the Downs, and these pictures are comparable to those painted there by William Nicholson. Greatly interested in Japanese art. Photographed from the windows of Kelmscott Manor.

68 *Dirge in Woods*
Photograph
7 × 8 17.8 × 20.3
Trustees of the Sarah and
Roger Clark Trust

69 *Rye*
Photograph 1900
7¾ × 5¾ 19.7 × 14.6
Trustees of the Sarah and Roger Clark
Trust

Edmund Blair Leighton
1853–1922

Born in London, the son of Charles Blair Leighton, a painter. Attended the Royal Academy Schools. Known as a painter of history subjects such as the *Confessional* of 1886, the *Lady Godiva* of 1892 (Leeds City Art Gallery), *Sorrow and Song* (Bristol City Art Gallery) and *Launched in Life*, described by A. G. Temple as a 'charming idyll of eighteenth-century social life'. His work became well known through the sale of prints. Lived in London and in Norfolk.

70 *September*
Oil on panel 1915
9⅞ × 14 25.1 × 35.5
Laing Art Gallery, Newcastle upon Tyne

69

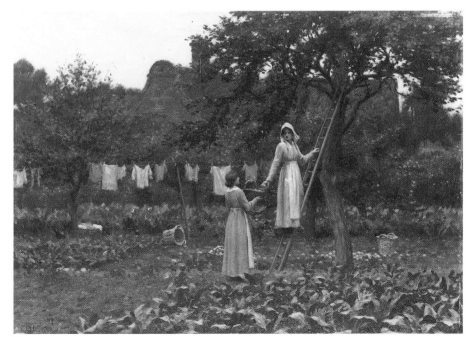

70

Alexander Mann 1853–1908

Born in Glasgow. Began a career in commerce but studied at the Glasgow School of Art in his evenings and eventually moved to Paris where he trained first at the Académie Julian and then under Carolus-Duran, an admirer of Velasquez. Painted genre scenes in Italy, France and Morocco. On his return to England, lived at Hagbourne in Berkshire before settling in the mid 1890s at Streatham and painting in a Chelsea studio. In his landscapes he often returned to the Berkshire downs. Also spent several summers painting at Walberswick. Favoured low, close tones and a subdued mood. The artist Norman Garstin observed in Mann's art 'a deep vein of poetry and pathos', a quality at odds with his strong, simple and direct character.

71 *Sunny Headland, Charmouth, Dorset*
Oil on canvas 1892
42 × 30 106.7 × 76.2
Private Collection

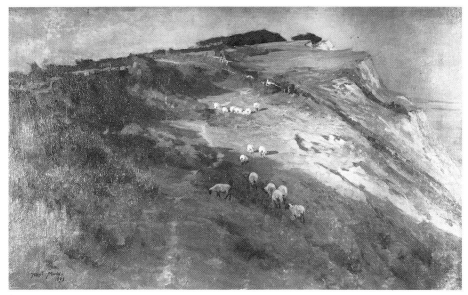

71

Frank O'Meara 1853–85

From County Carlow. Trained in France under Carolus-Duran in 1873. Had a reputation as a tempestuous man. Painted in the village of Grès, near Fontainebleau. Elements of the work of Bastien-Lepage and Puvis de Chavannes can be found in his painting. Died of malaria in County Carlow at the age of 35.

72 *Towards Night and Winter*
Oil on canvas 1885
58 × 48 147.3 × 122
Hugh Lane Municipal Gallery of Modern Art, Dublin

Frank Meadow Sutcliffe 1853–1941

His father was a well-known painter in Yorkshire. In 1870 the family moved to Whitby. Worked as a clerk at the Tetley's brewery in Leeds. Became a photographer, and as a young man took pictures of Yorkshire Abbeys for Francis Frith of Reigate. In 1873 met and photographed Ruskin at Brantwood. In 1875–6 worked unsuccessfully as a portraitist in Tunbridge Wells, before moving back to Whitby, where he established himself. Increased use of dry-plates in the 1880s allowed him greater mobility in the area around Whitby, and he became a recorder of local life and landscape: 'I believe that J.-F. Millet has shown me more than any other'. A friend of P. H. Emerson and in 1892 a founder member of the Linked Ring, a breakaway photography society in the manner of the New English Art Club. First one-man show at the Camera Club in 1888. In 1897 began to take instantaneous pictures with Kodak hand cameras. Photography prohibitions on the East Coast in 1914 stopped his recording of local life. Retired in 1922.

73 *A Country Lane with Windswept Trees*
Photograph–dry plate, silver bromide
8½ × 11¼ 21.6 × 28.6
The Sutcliffe Gallery, Whitby

George Davison 1854–1930

Born in Lowestoft, son of a ship's carpenter, and first employed as an audit clerk at the Treasury. In 1886 became Secretary of the London Camera Club, and a member of the Royal Photographic Society. In 1890 exhibited *The Onion Field*, one of photography's first soft-focus pictures, more suggestive than descriptive. One of the founder members, with Sutcliffe and Emerson, of the Linked Ring in 1892. In 1897 appointed Deputy Manager of the newly founded Kodak Limited in England, and in 1900 became Managing Director. In 1908 resigned from Kodak following pressure regarding his activities as an anarchist. Moved to Harlech to a well-appointed house, and continued his anarchist activities. Entertained the photographer A. L. Coburn in 1916 on his return from America. His photogravures of landscape subjects verge on the abstract, and can be compared to Whistler's *Nocturnes* and to Albert Goodwin's landscape arrangements.

74 *Near Portmadoc*
Photogravure
6⅜ × 9¾ 16.2 × 24.7
The Kodak Museum, Harrow

James Paterson 1854–1932

Born in Glasgow where he studied at the
School of Art from 1871–4. He spent two
periods in Paris, first during 1877–9 under
Jacquesson de la Chevreuse, and then from
1879–83 under Jean-Paul Laurens. He
returned to Glasgow and associated with
the Glasgow School, attending the winter
classes in the studio of his former school-
friend, W. Y. MacGregor who encouraged
artists to reject anecdotal subjects, use a
freer technique and bolder colour. After his
marriage in 1884, Paterson moved near to
the Dumfries village Moniaive where he
applied the system of tonal unification that
he had learned in France to the surrounding
landscape. He sought effects rather than
facts, declaring 'Absolute truth to Nature is
impossible'. His style is smoother, more
atmospheric and less experimental than
others of the Glasgow School.

75 *The Last Turning,*
Winter, Moniaive
Oil on canvas 1885
24⅛ × 36 61.3 × 91.4
Glasgow Art Gallery and Museum

74

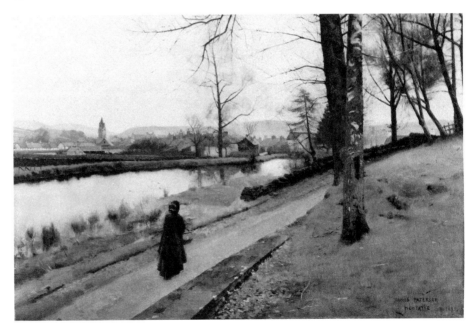

75

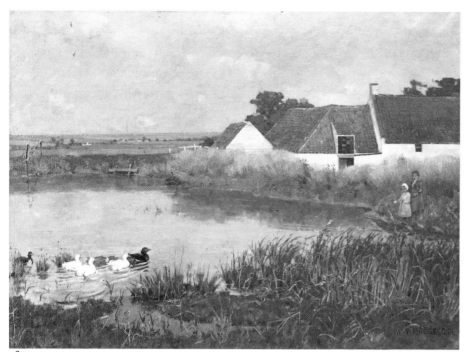

76

William York MacGregor
1855–1923

The son of a shipbuilder, he studied under James Docharty at the Glasgow School of Art and under Alphonse Legros at the Slade. Influenced by the Parisian-style painting of James Paterson. Set up a studio in Bath Street in Glasgow, which became the gathering place of such younger artists as Guthrie, Lavery, Walton, Crawhall, Roche, Henry and Melville. He opened life classes at this studio in 1881. From 1886 started to go to the Bridge of Allan, near Stirling, for his health. In 1889–90 visited South Africa, also for his health. Considered as the father of the Glasgow School.

76 *The Mill Pond*
Oil on canvas 1882
$35\frac{1}{2} \times 47\frac{3}{4}$ 90.2×121.3
Perth Museum and Art Gallery

Arthur Melville 1855–1904

Born at Loanhead-of-Guthrie, Angus. His family moved to East Linton on the Haddingshire Tyne, and there, at the age of fifteen, he was apprenticed to a grocer. Attended art classes in the evening, walking eight miles to Edinburgh every night. At nineteen changed employment, becoming a book-keeper in a shop, but still kept on the evening classes. After one of his paintings was accepted by the Royal Scottish Academy, his parents agreed to him studying full-time. In 1878 his *The Cabbage Garden* was hung in the Royal Academy in London. Moved to Paris, studied at the Académie Julian and there watched a watercolour demonstration in which brushfuls of strong colour were dropped on to an already soaked background to suggest figures in the rain. Melville began to specialize in watercolour, developing an individual impressionistic style using dabs, blurs and splashes of pure colour. He eliminated detail and created form by mass rather than outline. Visited Egypt in the summer of 1880 and bought back water-colours that puzzled the critics but attracted the young men later to form the Glasgow School. In 1883–4 painted with Crawhall, Guthrie and Walton at Cocksburnpath, a small village in Berwickshire on the east coast of Scotland. In 1885 visited the Orkneys with Guthrie and the following

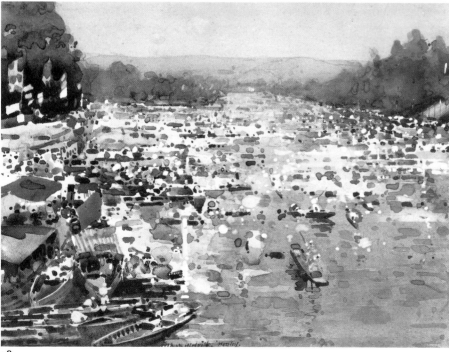

78

79

year accompanied him to France. In January 1889, the year that the Glasgow School joined the New English Art Club, Melville moved to London. In 1891 he exhibited a watercolour entitled *Henley Regatta* in Liverpool, in a show which he hung with Whistler at the Walker Art Gallery. Continued to travel abroad and died young, having contracted typhoid on a visit to Spain.

77 *The Cabbage Garden*
Oil on canvas 1877
$17\frac{3}{4} \times 12$ 45.1 × 30.5
Private Collection, London

78 *Henley Regatta*
Watercolour *c*.1891
$10\frac{1}{2} \times 14\frac{3}{8}$ 26.7 × 36.5
Whitworth Art Gallery,
University of Manchester

Alfred Wallis 1855–1942

The facts concerning Wallis's life are uncertain but he is thought to have been entirely uneducated. He was born at Devonport, near Plymouth and brought up on the Scilly Isles. He claimed he went to sea at the age of nine, first as a cabin boy, later as an ordinary seaman in Atlantic schooners and windjammers. Around 1880 he abandoned deep-sea fishing for local fishing with the Newlyn and Mousehole fleets, at a time when the Cornish fishing industry was at its zenith. Later joined his younger brother in the rag-and-bone trade which declined with the fishing industry. Withdrew into himself, keeping company only with his wife, newspapers and his Bible. After his wife's death in 1922, when he was aged 70, he took up painting 'for company' and for the next seventeen years of his life painted on pieces of old card,

mostly obtained from a nearby grocer. He ignored all artistic conventions in an attempt to express his nostalgia for the boats and harbours as they were when the fishing industry was at its height. His unconventional style had a liberating influence on Christopher Wood and Ben Nicholson when they discovered his work in St. Ives in 1928.

79 *Harbour Scene*
Oil on card
$11\frac{1}{4} \times 18$ irreg. 28.6 × 46 irreg.
Kettle's Yard, Cambridge

Peter Henry Emerson
1856–1936

Born on his father's sugar plantation in
Cuba. In 1869, educated in England at
Cranleigh School. In 1879 graduated as a
Member of the Royal College of Surgeons.
From 1879–1886 worked as a doctor,
mainly at King's College, London. In 1882
became interested in photography. In 1883,
visited East Anglia for the first time, and in
1884 took a cottage on Southwold
Common. Was one of the founders in 1885
of the Camera Club of London. In 1886
published *Idyls of the Norfolk Broads* and an
album of platinum prints, *Life and Landscape
on the Norfolk Broads*, with a text by himself
and a painter T. F. Goodall, whom he had
met in 1885. In 1887 published *Pictures of
East Anglian Life*, and began *Wild Life on a
Tidal Water*, which was published in 1890.
In 1889 his *Naturalistic Photography* was
published, a vigorous attack on 'falsity' as
well as a detailed text book on
photography; attacked G. H. Mason for his
'stage idealism', and Frederick Walker,
'who had a considerable grip of an insight
into nature. But in his work the traditions of
the idyllic peasants of the golden age linger,
and we find his ploughman merrily running
along with a plough as though it were a toy
cart; and what a ploughman! he never saw
a field in his life'. During 1891 worked on
literary projects, such as *English Idyls* and *A
Son of the Fens*. In 1892 was one of the
founders of the Linked Ring. In 1893
published *On English Lagoons*, with plates
etched and printed by himself. In 1895 his
Marsh Leaves was published from which the
print *Snow Garden* comes. Gradually
withdrew from photography thereafter.

80 *Snow Garden*
Photogravure on plate paper handpulled
by the artist 1895
$5 \times 7\frac{7}{8}$ 12.6 × 20
Robert Hershkowitz Ltd.

80

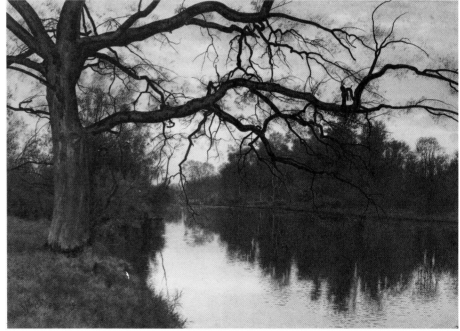

81

86

William Fraser Garden
1856–1921

Little is known about this artist. He was the
fourth of five sons of Dr Robert Winchester
Fraser, of Hemingford Grey Manor House.
In order to distinguish himself from two of
his brothers, who also painted, he reversed
his last two names. He lived at Hemingford
Abbotts until 1898 and later at Holywell,
both in Bedfordshire.

81 *The River Ouse in Winter*
Watercolour 1889
$7\frac{1}{2} \times 10\frac{1}{2}$ 19×26.7
Private Collection

Sir John Lavery 1856–1941

Born in Belfast, orphaned at the age of three
and brought up on his uncle's farm in
Ulster. At the age of ten sent to a relative in
Ayrshire. Ran away to Glasgow and was
sent back to his uncle's farm but eventually
returned to enter the Glasgow School of Art
in 1876. After his studio was gutted by fire
in 1879, he received enough insurance
money to study first at Heatherley's School
of Art in London, then at the Académie
Julian in Paris. At this time, was influenced
by Jules Bastien-Lepage. In 1883–4 spent
several months living among the artists
colony at Grès-sur-Loing and there painted
out of doors. Returned to Glasgow and
became a member of the Glasgow School;
was influenced by Guthrie and Joseph
Crawhall. Met Whistler in 1887 and was
influential in the formation of the Inter-
national Society, acting as vice-president
under Whistler. In 1888 was commissioned
by the Glasgow Corporation to paint the
state visit of Queen Victoria to the city.
After this he became a highly fashionable,
much sought after portrait painter and
received many honours. Made a member of
the Berlin, Munich and Vienna Secessions
and was knighted.

82 *A Day in Midsummer*
Oil on canvas 1884
$32 \times 21\frac{1}{4}$ 81.3×54
Private Collection

82

Stanhope A. Forbes 1857–1947

Born in Dublin. Studied at the Lambeth
School of Art, London and at the Royal
Academy Schools. Spent the winter of
1880–81 in Paris, attending Bonnat's atelier
and then accompanied H. H. La Thangue
to Brittany to paint *en plein air*, as was then
fashionable. He spent the next two summers
painting at Quimperlé, under the influence
of Bastien-Lepage, whom he may have met
on a visit to Concarneau where the French
artist was recuperating from an operation.
In 1884 went down to Newlyn where he
found a community of artists already
established. His success with *A Fish Sale on a
Cornish Beach* (Plymouth Museum and Art
Gallery) at the Royal Academy in 1885 and
his ability to get on well with both artists
and fishermen, made him a natural leader.
In 1889 married the artist Elizabeth
Armstrong with whom, in 1899, he opened
the Newlyn School of Painting. It lasted
until the Second World War and was
brought to an end only by Forbes' declining
health. He excelled at portraying the life of
Newlyn fishermen, rendering light and
atmosphere with a sure grasp of tone.

83 *The Drinking Place*
Oil on canvas 1900
$69\frac{1}{2} \times 61$ 176.5 × 155
Oldham Art Gallery

Sir Frank Short 1857–1945

Between 1891 and 1924 he was head of the
engraving school at the Royal College of
Art, and thus partly responsible for the
technical excellence of British etching in the
1920s. He revived both the mezzotint and
the aquatint processes. Elected President of
the Royal Society of Painter-Etchers and
Engravers in 1910, and he was President of
the Print Collectors' Club on its foundation
by that society in 1921. From 1884 he was
occupied with the engraving of Turner's
Liber Studiorum, and he made many
mezzotint versions of Turner's paintings. In
England he worked at Bosham, in the Rye
area, on Merseyside, at Polperro and at
Seaford. Completed 206 original etchings
and drypoints, and after 1884 made 122
mezzotints and aquatints. In etching
worked directly from nature on to the
copper plate. 'An artist must be a workman;
and an artist afterwards if it please God'.

83

84 *Lowtide, the Evening Star, and
Rye's Long Pier Deserted*
Etching 1888
$9 \times 11\frac{3}{4}$ 23 × 29.7
Cheltenham Art Gallery and Museums

85 *The Angry Cloud, Beachy Head*
Mezzotint
$5\frac{7}{8} \times 8\frac{3}{4}$ 14.9 × 22.3
Hastings Museum and Art Gallery

William Stott 1857–1900

Born in Oldham and usually referred to as
'Stott of Oldham' to distinguish him from
his namesake Edward. Studied in
Manchester and in Paris where he enrolled
under Gérôme at the Ecole des Beaux-Arts.
Spent his summers at Grès-sur-Loing, near
Fontainebleau, where he was influenced by
Frank O'Meara and shared the widespread
admiration for the work of Bastien-Lepage.
In 1882 he enjoyed considerable success at
the Salon and in 1889 had a one-man show
at Durand-Ruel's gallery. In 1885 he was

elected a member of the Royal Society of British Artists and enjoyed a close friendship with Whistler until 1887 when Stott's painting of Whistler's mistress as *Venus Born of the Sea Foam* (Oldham Art Gallery) caused their relationship to terminate. In 1890 was elected a member of the New English Art Club.

86 *The Ferry*
Oil on canvas *c*.1882
43 × 84¼ 109.2 × 214
Private Collection

George Henry 1858–1943

Born at Irvine, a brewer's son. Studied at the Glasgow School of Art and then at W. Y. MacGregor's studio. In 1881 painted in the Trossachs, at Brig O'Turk, with Guthrie, Walton and Crawhall. Also painted at Roseneath and at Eyemouth on the East Coast. In 1885 met E. A. Hornel to whom he gave a watercolour painting of Guthrie's cabbage patch at Cockburnspath. The two shared a studio and painted together in Kirkcudbright. They both subscribed to the Celtic revival and in 1889, together painted *The Druids*. In 1892 he arranged for a showing of the Glasgow School in Liverpool and sold *Summer* to the Walker Art Gallery. In 1893 he visited Paris. In 1893–4 he spent 18 months in Japan with E. A. Hornel, the journey sponsored by the art dealer Alexander Reid. He was a painter who used photographs for reference. Moved to London and became a successful portrait painter. In 1902 became a member of the Royal Scottish Academy, and in 1920 a Royal Academician.

87 *River Landscape by Moonlight*
Oil on canvas 1887
12 × 14½ 30.6 × 36.8
Hunterian Art Gallery,
University of Glasgow

84

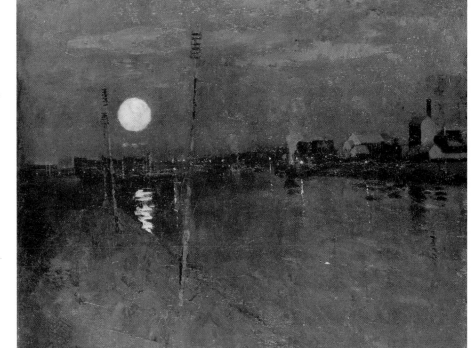

87

89

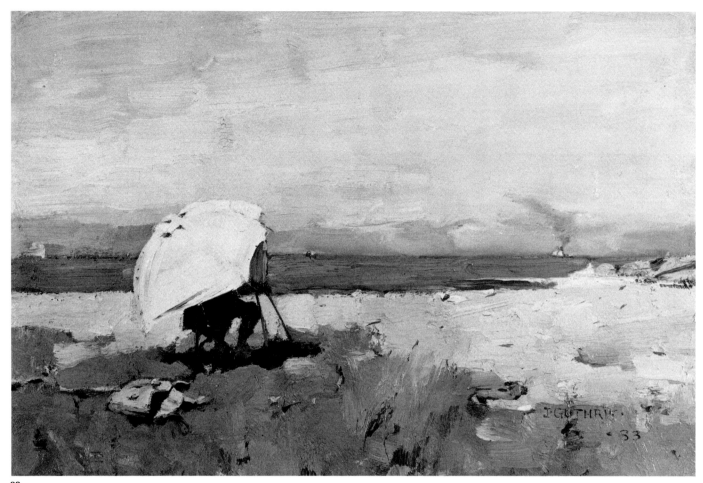

88

Sir James Guthrie 1859–1930

Studied law at Glasgow University but abandoned it in 1877 to paint under John Pettie in London. The sudden appearance of the influence of Bastien-Lepage in his art is attributed to a visit to Paris in 1882. There is no evidence to support this trip and it is more likely that Guthrie saw Lepage's paintings at the Glasgow Institute in 1881 and in London during the summer of 1882, at Tooth's and the United Arts Gallery. Became a leader of the Glasgow School, painting out of doors at Brig O'Turk and Cockburnspath. Rejected Pettie's use of literary subjects in favour of rustic scenes. Settled at Cockburnspath in order to relate to village life, like Lepage had done at Damvilliers. Employed the square-brush, an overall lightness of tone and a naturalistic style. Later rejected realism and became a successful portrait painter. Exhibited at the New English Art Club, was president of the Glasgow Art Club and received international acclaim.

88 *Hard at it*
Oil on canvas 1883
$12\frac{1}{4} \times 18\frac{1}{8}$ 31.1 × 46
Glasgow Art Gallery and Museum

89 *Fieldworkers in the Lothians*
Oil on canvas 1883
$26\frac{1}{2} \times 23\frac{1}{2}$ 67.3 × 59.7
Private Collection

William Kennedy 1859–1918

Born in Glasgow. Studied at Paisley School of Art and then in Paris from 1880 to about 1885 under Bouguereau and Fleury, and later with Bastien-Lepage, Collin and Courtois. When the 'Glasgow Boys' formed themselves into a society in 1887, Kennedy was elected President. Many of his paintings were of animal and military subjects. From about 1900 he stayed for long periods in Berkshire, painting rural scenes and cottages. For health reasons he moved in 1912 to Tangier (where Lavery already had a house) and painted scenes of Arab life. *Stirling Station* (1888) belongs to a group of nocturnal subjects painted by the Glasgow School and admits a debt to Whistler.

90 *Stirling Station*
Oil on canvas *c*.1888
22½ × 31½ 57.2 × 80
Private Collection, London

Walter Richard Sickert
1860–1942

Born in Munich, son of Oswald Sickert, a
painter and illustrator. Studied art at the
Slade School under Legros in 1881, having
spent a short period previously as an actor.
In 1884 exhibited, under the aegis of
Whistler, at the Royal Society of British
Artists, and belonged subsequently to quite
a number of societies. Travelled to Venice
first in 1895, and his Venetian pictures have
a Whistlerian look. Lived in Dieppe from
1900–1905. Was a founder-member of the
Camden Town Group in 1911, and of the
London Group in 1913. Lived in Bath
between 1916 and 1919, and returned there
in 1938. Projected himself as a 'character',
writing to *The Times* on such subjects as kilt-
wearing and the decline in the quality of
fresh herrings. Dressed sometimes as a
Norfolk farmer, sometimes as a Regency
buck. Never painted directly from Nature,
but from careful preliminary drawings and
in a systematic scale of tones in a given
colour scheme. Painted window views of
landscape. An inspirational, and very
unconventional, teacher at the Royal
Academy Schools in the 1920s.

91 *Auberville*
Oil over pencil on canvas *c*.1919(?)
19⅝ × 24 49.9 × 60.8
Norfolk Museums Service,
Castle Museum, Norwich

90

91

93

Philip Wilson Steer O.M.
1860–1942

Trained at the Gloucester School of Art, and then under Bouguereau at the Académie Julian in Paris before moving to the Beaux Arts where his teacher was Cabanel. Was one of the founding members of the New English Art Club in 1886. Most esteemed for his early beach pictures of Walberswick in Suffolk and for the delicacy of his watercolours, compared at the time to Chinese landscapes. Only became interested in Impressionism on his return from France.

Although he painted in North Wales, in 1906, he worked mainly in England, favouring river and coastal scenes – at Cowes, Harwich, Richmond, the River Theme and the Stroud Valley, for example. Gained official recognition in 1909 when the Tate Gallery accepted his *Chepstow Castle*, given by Miss Mary Hoadley Dodge. Devoted to painting, and to 'values' of tone and colour rather than to form. Notorious for his dislike of 'draughts', and famous for his collection of old Chelsea china. Taught at the Slade from 1893–1930.

92 *Ludlow Walks*
Oil on canvas 1899
21×26 53.3×66.1
Southampton Art Gallery

93 *Elm Trees*
Watercolour 1922
$9\frac{1}{8} \times 12\frac{7}{8}$ 23.2×32.8
The Trustees of the Tate Gallery, London

Edward Arthur Walton
1860–1932

Born in Renfrewshire. Studied in
Düsseldorf. In 1879 spent the summer with
Crawhall and Guthrie at Roseneath on the
Clyde Coast; the next year they went to
Brig O'Turk in the Trossachs, and in 1881
they were joined there by George Henry. In
1883–5 he spent the summer months
painting with James Guthrie at Cock-
burnspath in Berwickshire. His advice from
the painter W. Y. MacGregor was, 'Hack
the subject out as you would as you were
using an axe, and try to realise it; get its
bigness'. Moved eventually to Edinburgh.
In 1897–8 was a founder of the Inter-
national Society of Sculptors, Painters and
Gravers, of which Whistler was President.

94 *Hawthorn Bank*
Oil on canvas *c*.1910–15
30½ × 39½ 77.5 × 100.3
The Trustees of the Orchar Art Gallery,
Broughty Ferry

94

Joseph Edward Southall
1861–1944

Born in Nottingham, of Quaker parents.
In 1878 articled to a major firm of
Birmingham architects and a year later
began attending art classes in the evening.
In 1881 saw in a shop window some
Arundel Society prints, including one of the
Wilton Diptych. This 'opened my eyes', as
he said, to the beauty of medieval art and
decoration. In 1883 visited Italy and as a
result of reading Ruskin's *St Mark's Rest* and
seeing Carpaccio's *Life of St Ursula* in
Venice decided to paint in tempera, seeking
advice from Charles Eastlake's *Materials for
a History of Oil Painting*. Attended
Birmingham School of Art where he met
Arthur Gaskin who shared his interests. In
1901 was one of the founder-members of the
Society of Painters in Tempera. He
demonstrated this technique at Birmingham
School of Art but did not teach there,
though he did give informal lessons in his
own house, to Maxwell Armfield, Ethelbert
White and others. In 1906 toured Italy with
Charles Gere and his sister. With them,

Gaskin, Bernard Sleigh and others, formed
the Birmingham Group of Artist-Craftsmen
which exhibited for the first time in 1907 at
the Fine Art Society, London. In 1914 acted
as Chairman of the Birmingham City
Branch of the Independent Labour Party.
Was a conscientious objector during the
war. Sought to build up his pictures with
'spaces of bright colour', delicately but
firmly outlined. Abandoned the use of
shadow and often used an underpaint of
raw sienna to create a golden tone
throughout. *The Botanists* represents a view
overlooking Fowey Estuary from the
promontory above Ready Money Beach.
The left-hand figure is identical to that
which appears in *The Return* (Castle
Museum, Nottingham).

95 *The Botanists*
COLOUR PLATE XIII
Tempera on silk stretched over card 1928
10⅜ × 13¾ 26.2 × 34.9
Hereford City Museums and Art Galleries

Paul Maitland 1863–1909

Born in Chelsea. Dropped as a baby by his
nanny and suffered throughout his life from
a curved spine which caused his premature
death. Studied at the Royal College of Art
and under Théodore Roussel, an associate
of Whistler. Exhibited with the Society of
British Artists under Whistler's presidency
and withdrew, with others, when Whistler
was voted out of office. Unable to make
long journeys due to his health and confined
himself to the part of London where he
lived, painting the Chelsea riverside and
Kensington Gardens on a small scale. Like
other of the 'London Impressionists',
inspired by Whistler's praise of the 'beauty'
of the city, employed daring compositional
cuts and asymmetrical design, in a bid to
break away from academic conventions. It
has been observed that his paintings, even
when bright and sunny, have a pervasive
melancholy.

96 *Kensington Gardens*
Oil on canvas *c*.1898
10¼ × 18½ 26 × 46
The Visitors of the Ashmolean Museum,
Oxford

Julius Olsson 1864–1942

Born in London, and had no formal art training. Moved to St Ives, and remained there for twenty years, becoming a J.P. and Captain of the West Cornwall Golf Club. First exhibited at the Royal Academy in 1890. Specialized in seascapes, especially of stormy weather. Became president of the Royal Institute of Oil Painters in 1919, and was twice on the International Jury of the Carnegie Institute of Pittsburgh. Moved to London circa 1911, when the Chantrey Trustees bought his *Moonlit Bay* for the Tate. In 1925 married Edith Mary Ellison, daughter of a well-known horse breeder of Castlereagh. Died at Dalkey, Co Dublin, whence he had moved after his London home had been damaged in an air raid.

97 *Northern Ireland*
Poster 1924
40 × 50 101.6 × 127
National Railway Museum, York

John Quinton Pringle 1864–1925

The son of a station master on the Glasgow-Greenock line at Langbank, which was a site favoured by Glasgow artists. Trained as an optician, he followed that trade for most of his life. After 1885 attended the Glasgow School of Art on an Evening School bursary, and continued these studies until 1896. Was happy to remain both a painter and an optician. Influenced by the Pre-Raphaelites, but was also a realist in the late '80s and early '90s. Became interested in Impressionism around 1895, which culminated in a trip to Normandy in 1910. D. Y. Cameron had sketched the back streets of Glasgow before him, just as Sir Frank Short had previously worked at Bosham, which he visited in 1903. Looked after by his sister until 1911, after which time he lived alone: '. . . no longing, no desire to sell but to live all alone, Nature singing all the time to me . . .' – he wrote in a letter from Shetland in 1921.

98 *Children at the Burn*
Oil on canvas 1889
8 × 12 20.3 × 30.5
The Trustees of the Tate Gallery, London

LMS NORTHERN IRELAND
DUNLUCE CASTLE
BY JULIUS OLSSON. R.A.

97

98

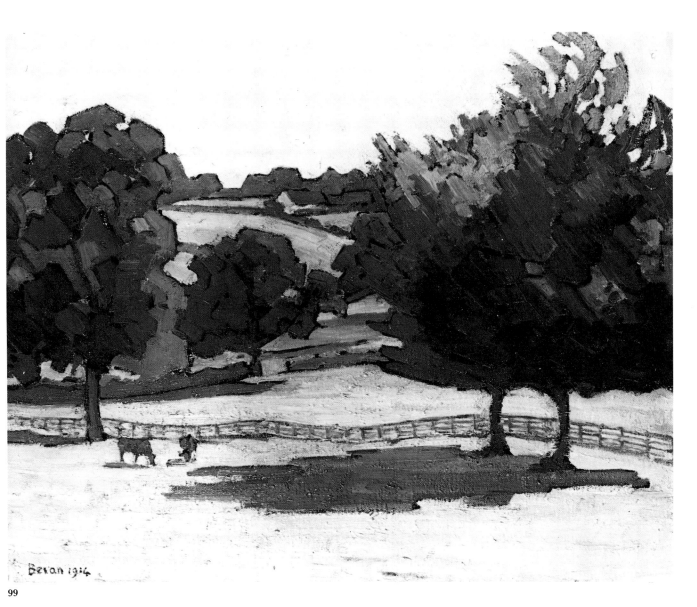

99

Robert Polhill Bevan 1865–1925

Spent much of his childhood and youth at Cuckfield, near Brighton. Studied at the Westminster School of Art and at the Académie Julian in Paris. Worked in Tangier with Joseph Crawhall in 1892 and at Pont-Aven in Brittany in 1893–4 where he met Gauguin. He married a Polish painter Stanislawa de Karlowska in 1897 and thereafter visited Poland on many occasions. Settled in London but often spent his summers in Sussex. Around 1907 abandoned making extensive colour sketches in oil from nature and instead worked from squared-up drawings, making constant visits to the subject, but painting in the studio. At the Allied Artists' Association in 1908 met Gore and Gilman and became a member of Sickert's Fitzroy Street Group. Sickert encouraged Bevan to paint London scenes and his horse-sale and cab-yard scenes began. Was influenced by Gore's Letchworth and Icknield Way paintings. With Gore and Ginner painted on the Blackdown Hills near Taunton in 1912–13, as guests of Harold B. Harrison who liked to gather a small colony of artists around him during the summer months. Was a founder member of the Camden Town Group in 1911 and of the Cumberland Market Group in 1914. Between 1916–19 painted at Lytchett, in the Blackdown Hills. In 1920 moved over the Devon border to Lippitt.

99 *The Maples at Cuckfield, Sussex*
Oil on canvas 1914
20×24 50.8×61
National Museum of Wales, Cardiff

Sir David Young Cameron
1865–1945

Born in Glasgow; attended school there and in Edinburgh. He became one of Britain's most prolific etchers, and possibly the most famous. His etchings of Scottish landscapes are best known: *Ben Ledi* in 1911 and *Ben Lomond* in 1923. His paintings are of strongly simplified landscape subjects. Was the only painter on the first Fine Arts Commission in 1924, and also knighted in that year. Was a trustee of the Tate Gallery, and an eloquent speaker.

100 *The Wilds of Assynt*
COLOUR PLATE XV
Oil on canvas *c*.1936
40 × 50 101.6 × 127
Perth Museum and Art Gallery

Sir Arnesby Brown 1866–1955

Born in Nottingham where he attended the local school of art, before going to the Herkomer School of Art at Bushey. First exhibited at the Royal Academy in 1890, and elected an Academician in 1915. Married Mia Edwards, a painter of child portraits, and they lived at the White House, Haddiscoe. In 1934 he was represented in the British section at the Venice Biennale. Associated throughout his life with East Anglia, and noted for his love of the country and his love of animals, also 'a cricketer who cares about fishing'. Painted the tall, thundery skies of East Anglia, and gave his pictures such titles as *September Morning*, *Haymaking*, *Full Summer* and *The Line of the Plough*. Blind for the last ten years of his life.

101 *The Riverbank*
Oil on canvas *c*.1902
50 × 72 127 × 182.8
Guildhall Art Gallery,
Corporation of London

102 *Study of Cattle*
Oil on panel 1921
6¼ × 9¼ 15.9 × 23.5
Norfolk Museums Service,
Castle Museum, Norwich

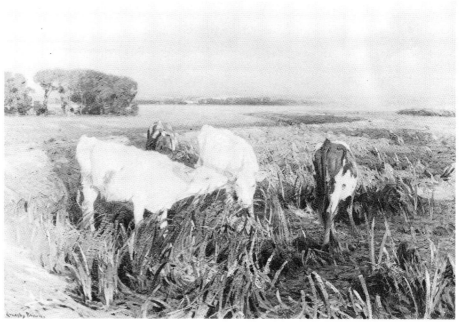
102

103

96

Roger Fry 1866–1934

Born into a strict Quaker family. Read natural sciences at King's College, Cambridge and then studied painting under Francis Bate, the Honorary Secretary of the New English Art Club. In 1891 made his first trip to Italy and enrolled at the Académie Julian in Paris. As painting did not absorb all his energies, he began lecturing for the Cambridge Extension Movement and became a scholar of Italian art, publishing *Giovanni Bellini* in 1899. Became art critic, first to the magazine *Pilot*, then to the highbrow periodical, the *Athenaeum*. In 1906 accepted the position of Curator of Paintings at the Metropolitan Museum of Art, New York, later changing this role for that of European Adviser. His appointment was abruptly terminated in February 1910 after a quarrel with the chairman of the trustees. In 1910 and 1912 organized the two famous Post-Impressionist exhibitions which radically affected the course of art in England. Continued to lecture and write art criticism and occupied a position of considerable influence in the London art world. Also painted all his life and regarded this as his primary occupation. He tried a variety of styles, experimenting briefly with symbolist landscape, imitating certain Old Masters, plunging suddenly into Post-Impressionism, but after the First World War returned to a more naturalistic style partly indebted to the French Impressionists and Dutch seventeenth-century masters.

103 *The Farm Pond at Charleston*
Oil on canvas 1918
22 × 30 55.8 × 76.2
Wakefield Art Gallery

104

Charles Conder 1868–1909

Born in London but spent his earliest years in India and Australia. In 1890 moved to Paris to study painting at the Académie Julian where he met William Rothenstein with whom he shared a studio in the rue Ravignan. Styled himself 'l'elève d'Anquetin', but owed more to the eighteenth-century French, his fantasies inviting comparison with the art of Watteau. In London during the 1890s became associated with the circle who contributed to *The Yellow Book* and other *fin-de-siècle* periodicals. Greatly admired Whistler. Lived at 91 Cheyne Walk which he filled with *objets d'art* and rare items. Exuded a gentle melancholy partly due to ill health and tried to convert Chelsea into another Montmartre. Experimented with a variety of media – oils, pastels, sanguines, watercolour, pen-and-ink, etchings and lithographs. Executed book illustrations, decorated suites of rooms and specialized in painted fans. Generally spent his summers abroad, but in 1904 stayed at Brighton where he painted several views of the sea from the esplanade, and in 1907, in poor health, stayed at Newquay. Exhibited with the New English Art Club and with the International Society.

104 *Silver Sands*
Oil on canvas
25$\frac{1}{8}$ × 30$\frac{1}{4}$ 63.8 × 76.8
Bradford Art Galleries and Museums

105

Charles Rennie Mackintosh 1868–1928

Born in Glasgow. Apprenticed to an architect and afterwards entered the firm Honeyman and Kepple as a draughtsman where he met Herbert MacNair. Won a travelling scholarship and visited Italy, France and Belgium. Attended evening classes with MacNair at the Glasgow School of Art and met Margaret and Frances Macdonald with whom they formed 'The Four', turning their hand to watercolours, designs, book illustrations, posters, leaded glass, beaten metalwork and furniture, all in a recognizably art nouveau style. Mackintosh also continued to work as an architect, winning a competition with his design for the Glasgow School of Art in 1896. In 1900 he married Margaret Macdonald. His work won recognition abroad and he became well-known on the Continent. Meanwhile the success of his architectural commissions aroused criticism among the forces of architectural conformity and in 1914 he resigned from Honeyman and Kepple and left Glasgow for good. From 1916–23 he lived in Chelsea, producing little architectural work. He designed textiles and turned increasingly to landscape watercolours. In 1923 he and his wife moved to Port Vendres in France, remaining there until 1927 when poor health brought him back to England. He died of cancer of the tongue.

105 *The Downs, Worth Matravers*
Watercolour 1920
$17\frac{3}{4} \times 21\frac{1}{8}$ 45.2 × 53.7
Glasgow School of Art

Charles Gere 1869–1957

Trained at the Birmingham School of Art which was a centre for the Arts and Crafts Movement and the Tempera Revival. As a teacher at that school he attracted the attention of William Morris, and was asked to design illustrations for Kelmscott books, including Morris's translation of *Sigurd the*

107

Volsung, though these were not used. Designed the view of Kelmscott Manor for the frontispiece to *News from Nowhere*. In 1904 settled in Painswick, in the hills between Stroud and Gloucester. Took holidays in the Italian Alps, Dolomites and Switzerland, as well as in the Wye Valley and the mountains of South Wales. He was interested in Calvert and Palmer and tried to catch something of the spirit of their work in small-scale tempera paintings which are often of the Severn, the Wye, the Vale of Gloucester or of Painswick itself.

106 *A Cotswold Walk: Painswick from the South*
Tempera on canvas *c.*1910
$16\frac{1}{2} \times 25\frac{1}{2}$ 42 × 64.8
J. A. Gere

Frances Hodgkins 1870–1947

Born in New Zealand, whence she moved to Paris in 1900 where she eventually taught at the Académie Colarossi, before opening her own art school between 1910 and 1912. Became known in England only in her sixties. She favoured still-life objects in front of landscape and often worked in the Constable country in East Anglia. She designed textiles for the Calico Printers' Association in Manchester, and was a member of the Seven and Five Society. Some of her most vivacious work was produced between the ages of 60 and 70.

107 *Flatford Mill*
Oil on canvas
$23\frac{1}{4} \times 28\frac{1}{2}$ 59 × 72.2
Towner Art Gallery, Eastbourne

William Ratcliffe 1870–1955

Born near King's Lynn, Norfolk. Studied design at Manchester School of Art under Walter Crane. A wallpaper designer for almost twenty years, his painting reveals a strong sense of two-dimensional pattern. Moved to Letchworth in 1906 and there met Gilman c.1908 who encouraged him to resume painting. Studied at the Slade, part-time for one term and between 1910–11 attended the meetings of Sickert's Fitzroy Street Group and Camden Town Group. After 1912 lived for some years at Hampstead Garden Suburb. His work has a gentleness and charm that distinguishes it from the work of Gilman and Ginner, though he shared the Camden Towers concern for strength of design. After 1921 painted mostly in watercolour in a more naturalistic style which lacks the imaginative grasp of form found in his earlier oils.

108 *Summer Landscape*
Oil on canvas 1913
$20\frac{1}{16} \times 30$ 51×76
Government Art Collection

108

Samuel John Peploe 1871–1935

Born in Edinburgh. Studied at the Edinburgh School of Art and at the Académie Julian in Paris. On his return to Scotland painted in the Hebrides on the island of Barra, producing seascapes, mostly small in scale and low in tone. Continued to paint out of doors, at the village of Comrie in 1902 (in an impressionistic idiom) and at Etaples and Paris–Plage with J. D. Fergusson during summer visits to France. In 1910 he married Margaret Mackay and took up residence in Paris, mixing with an Anglo-American circle of artists and writers which included Fergusson, Anne Estelle Rice, Katherine Mansfield and J. Middleton Murry. Made excursions to Brittany, Royan and Cassis, painting in bold colours and employing a simplified, rhythmic style of drawing. In 1914 returned to Scotland and was found unfit for military service. In 1920 was taken by F. C. B. Cadell to Iona. Painted it repeatedly over the next ten years, concentrating on the north shore where rocks break through the pale sand, offset by the green sea and blue sky, finding these colours exactly suited to

109

110

his palette. Painted the island under all conditions, at times drawing close in style to McTaggart. Continued to make visits to France as he wished to retain a high-key palette and distrusted the prevailing greyness of Scotland. Peploe to Mr William Macdonald, 5 November 1923: 'We had most miserable weather in Iona this year – worst in living memory, gales and rain the whole time, I got very little done. But that kind of weather suits Iona, the rocks and distant shores seen through falling rain, veil behind veil, takes on an elusive, mysterious quality, and when the light shines through one has visions of rare beauty. I think I prefer those days to your

blue skies and clear distance. It does not lend itself to the larger canvas, the decoration, the static. It is an immaterial thing, emotional, lyrical.' (Quoted in Stanley Cursiter, *Peploe: An Intimate Memoir of an Artist and of his work*, 1947, pp. 71–2.)

109 *Clouds and Sky, Iona*
Oil on panel 1928
16 × 18 40.9 × 45.9
Hunterian Art Gallery,
University of Glasgow, Macfie Collection

Algernon Talmage 1871–1939

Born at Fifield, Oxfordshire, the son of a clergyman. Studied under Herkomer at Bushey, and became a painter of landscape and of animals. Around 1900 he ran an art school in St Ives, and during the Great War he was, like Alfred Munnings, an official war artist to the Canadian Government. Elected a Royal Academician in 1929. Took up etching in 1927, at the height of the etching boom.

110 *The Sketchers*
Oil on canvas 1930
20 × 24 50.8 × 61
Victoria Art Gallery, Bath City Council

III

Harry Watson 1871–1936

Born in Scarborough, and studied at the
Scarborough School of Art from 1884–8
Went to the Royal College of Art, and then
to Rome on a scholarship. In 1895 won the
Queen's prize for modelling from life at the
National Art Training School. In his book
on *Figure Drawing*, published by Winsor and
Newton he noted: 'The landscape painter
draws with more appreciation of line after
he has drawn from life. Unless one perceives
beauty of line throughout nature, there is a
commonplace quality in the work'. From
1913 taught at the Regent Street Poly-
technic, and was an active member of its
Arts Club and Snooker Team. His advice
on painting in 1931 was: 'Students should
always study the subject carefully before
painting, and try to work out mentally what

they are aiming at, and then, when
working, retain the freshness of the idea
which is in their minds'.

III *Holidays*
Oil on canvas *c*.1922
40½ × 61 102.8 × 155
The City of Bristol Museum and Art
Gallery

Jack Butler Yeats 1871–1957

From 1879–87 he was brought up by his
grandparents, the Pollexfens, at Sligo.
Brother of the poet W. B. Yeats. He
returned to Sligo annually: 'Sligo was my
school and the sky above it'. In the late '80s
attended London Art schools at South
Kensington, Chiswick and Westminster.
During 1888–98 employed as a black-and-
white illustrator on various magazines, until
he moved to Devonshire where he began to
work in watercolour, before turning to oil in
1905. In 1910 returned to Ireland, and
under the pseudonym W. Bird drew for
Punch. Irish subjects come into his work
from 1898, and Civil War themes in the
early '20s. A friend of John Masefield in the
'30s with whom he shared a common
interest in toy theatres, model boats and

adventure stories. Documented scenes on the race tracks, among travelling people and of life on the outlying islands as did Edward Seago, another friend of Masefield. In his landscapes single figures are often caught up in a turbulence of paint; there is something nostalgic, even tragic, about them.

112 *Queen Maeve walked upon this Strand*
Oil on canvas 1950
36×48 91.5×122
Scottish National Gallery of Modern Art, Edinburgh

Sir William Nicholson
1872–1949

Studied under Herkomer and at the Académie Julian in Paris, where he met James Pryde and married his sister. As 'The Beggarstaff Brothers' he and Pryde designed theatrical posters in the 1890s. After the commercial failure of their posters he produced woodcuts in colour which were published by Heinemann. His oil paintings were shown at exhibitions of the International Society held at the Prince's Skating Rink, Knightsbridge; Whistler was president of this organization, and Nicholson was influenced by him. He became established as a portraitist in the 1920s. Designed costumes for the theatre, including the original setting for *Peter Pan*. Usually worked dressed in white ducks, and was best known for still-life paintings, for snow-scenes and for open downland views.

113 *The Whitestone Pond, Hampstead*
Oil on canvas 1908
15×11 38.1×28
The City of Bristol Museum and Art Gallery

114 *On the Downs, Wiltshire*
Oil on canvas 1924
23⅜×21 59.8×53.2
Leeds City Art Galleries

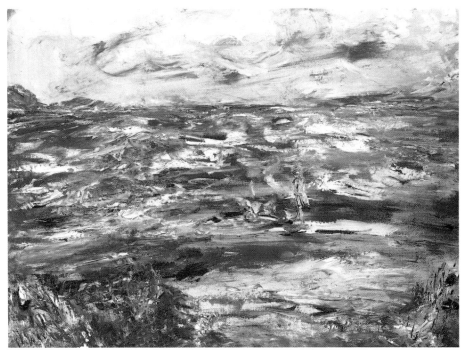

112

113

Sir William Rothenstein
1872–1945

Born in Bradford. Attended the Slade
1888–9, after which he left to join his friend
Arthur Studd at the Académie Julian in
Paris. A precocious talent, he quickly felt at
home there and made many acquaintances.
With Charles Conder and Louis Anquetin
he visited Toulouse-Lautrec's favourite
Parisian haunts. In 1894 he settled in
London, became a member of the New
English Art Club and enjoyed success with a
series of lithographic portraits. His early
subject pictures reflect the influence of
Degas whom he had met in 1892. In 1912
he found and bought Iles Farm at Far
Oakridge in Gloucestershire and was there-
after reluctant to leave it. He became one of
the most distinguished painters of the
Cotswolds. Enjoyed a successful career,
became director of the Royal College of Art
1920–35, published three volumes of
memoirs and received a knighthood in 1931.
The Old Quarry, Hawksworth was painted in
Yorkshire and preceded his move to Far
Oakridge.

115 *The Old Quarry, Hawksworth*
Oil on canvas 1904
33¼×36 84.5×91.5
Bradford Art Galleries and Museums

115

Bernard Sleigh 1872–1954

Born in Birmingham, and studied at
Birmingham School of Art, where he
continued to teach. Painted in both oil and
watercolour, and was a wood engraver,
muralist and stained glass artist, and a book
illustrator. Lived at Edgbaston,
Birmingham. After 1898 showed at the
Royal British Society of Arts.

116 *Tintagel*
Colour woodcut 1934
9×15¼ 22.8×38.9
Cheltenham Art Gallery and Museums

John Duncan Fergusson
1874–1961

Originally intended becoming a naval
surgeon, but turned to art, took a studio in
Edinburgh and from 1897 onwards made
regular visits to France. Had no formal art
training. Looked at the Impressionists in the

116

Luxembourg Museum in Paris and at
Durand-Ruel's and painted with S.J.
Peploe at certain Normandy seaside resorts.
Between 1907–14 lived in Paris where he
admired Matisse and mixed with an Anglo-
American circle of artists and writers. After
painting a picture of the same title, became
art editor to Middleton Murry's magazine
Rhythm. Returned to England in 1914 and
settled in London, continuing to paint with
rich colour and rhythmic geometric
patterning, in a style inspired by the Fauves
and by his experience of the light and
colour of the South of France which he had
visited in 1913. In 1918 painted a series of
pictures of Portsmouth docks as an official
war artist. In 1922 made a painting tour of
the Scottish Highlands. In later life was
concerned to emphasize the important link
between Paris and Scotland during the
period immediately preceding the First
World War. 'Paris is simply a place of
freedom. It allowed me to be Scots as I
understand it.' (J. D. Fergusson, *Modern
Scottish Painting*, 1943, p. 170.)

117 *A Lowland Church*
Oil on canvas 1916
20 × 22 50.8 × 55.9
Dundee Museums and Art Galleries

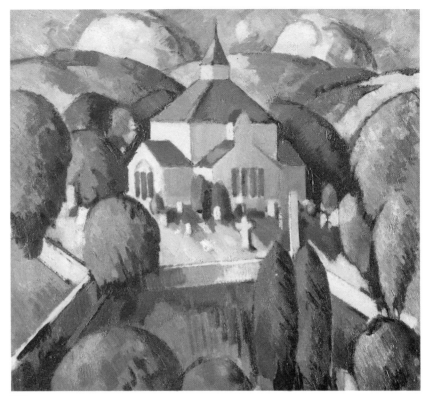

117

Philip Connard 1875–1958

Born at Southport. Studied at South
Kensington, where he won a scholarship
which took him to Paris. Worked as an
illustrator and a textile designer as well as a
painter. Taught at the Lambeth Art School.
In 1909 became a member of the New
English Art Club. Elected Associate of the
Royal Academy in 1918, and a Royal
Academician in 1925. Painted decorations
for the Queen's dolls' house at Windsor, and
murals at Delhi. In the '20s a painter of
decorative panels. Noted for his family
group portraits, like old English
conversation pieces. A quality of eighteenth
century 'dash' is apparent in his work,
reminiscent of the work of Rex Whistler.

118 *Abbey Ruins*
Oil on canvas *c*.1910
30 × 41 76.2 × 104.1
Bradford Art Galleries and Museums

118

120

preceding nine years. Drew and etched from nature: 'most of my country plates have been done direct on the copper from nature, as one works there under comfortable conditions, and the important thing to preserve is the feeling and freshness'. Throughout he specialized in the urban, architectural and industrial sublime, and can be compared to his contemporary Joseph Pennell.

120 *An Artillery Battery at the Battle of the Somme at Night*
Chalk 1916
7¾ × 11⅜ 19.7 × 29
Christopher Newall

Harold Gilman 1876–1919

Born in Somerset, the son of a parson. Spent a year at Oxford as a non-collegiate student and left on account of his health. Passed a year in Odessa as a tutor to an English family. Studied at Hastings School of Art and at the Slade and on leaving spent a year in Spain where he copied Velasquez in the Prado. Began as a naturalist with a skilled grasp of tone. In 1907 met Sickert and became a founder-member of, in the following order, the Fitzroy Street Group, the Camden Town Group and the London Group, acting as president of the last. After the 1910 Post-Impressionist exhibition made a visit to Paris with Ginner to study collections of modern art. Under the influence of Van Gogh, began to use thick impasto. Lived at Letchworth and let his house to Gore while he visited Sweden in 1912. Became a Socialist and developed a dread and mistrust of society, possibly as a result of the failure of his first marriage and the loss of a teaching post at the Westminster Institute. Married again in 1917, visited Nova Scotia in 1918 to paint Halifax Harbour for the Canadian War Records and died the following year of influenza. Apart from a series of paintings of beechwoods painted in Gloucestershire in 1916, Gilman showed a preference for the urban rather than the rural landscape.

121 *Clarence Gardens*
Oil on canvas 1912
20 × 24 50.8 × 61
Ferens Art Gallery, City of Kingston upon Hull Museums and Art Galleries

Fred Taylor 1875–1963

A prolific poster artist from *c*.1908 until the 1940s. Worked in a decorator's office at the age of sixteen; drew in the evenings, in Hyde Park, and developed a taste for crowd scenes. After five years of office work spent two years at art school and then joined the Waring and Gillow Studio, where he spent several years. Began to draw for advertising purposes under the supervision of H. E. Morgan, at the W. H. Smith studio. Continued to be a watercolourist and exhibited at the Royal Institution. He came to attention in 1908 with a poster for the London Transport Board *Book to Hampstead or Golders Green Fair*, an aerial view of a seething fairground. Also worked for Mr Teasdale at London North Eastern Region Railway.

119 *Hampstead, London Memories*
Poster 1918
40 × 25 101.6 × 63.5
London Transport Executive

Sir David Muirhead Bone 1876–1953

Born, one of eight children, in Glasgow, the son of David Drummond Bone, a journalist. Studied at the Glasgow School of Art. Intended to become an architect, but became a draughtsman instead. In 1901 illustrated James Hamilton Muir's *Glasgow in 1901* with vivid instantaneous sketches of street-life and industry. Took up etching in 1898, and quickly turned to drypoints, which he continued to make through to 1939. In 1901 moved to London, and in 1902 began to exhibit at the Carfax Gallery. In 1904 Obach and Company published his portfolio of *Ten Drypoints*, of crowd scenes and of architecture. His etchings, of which there are many, appeared in small editions, for he scarcely ever used steel-faced plates. From 1910–12 he spent his first long visit to Italy, where he made drawings from which he subsequently made plates. In 1913 worked in East Anglia, and made prints of Great Yarmouth and of Walberswick Ferry. In 1916 worked as a War Artist, and the results were published as an extended series of booklets by George Newnes in 1917 under the general heading *The Western Front*. In 1936 Macmillan published his book on Old Spain, with work from the

121

Frederick L. M. Griggs
1876–1958

Born in Hitchin, Hertfordshire, where he
lived until he was twenty-eight. He became
interested in etching in 1896. At first made
perspective drawings for local architects,
and in 1900 began to make drawings for
Macmillan's *Highways and Byways* guide
books; he illustrated thirteen of these. In
1903 he moved to Chipping Campden in
Gloucestershire (centre of a flourishing
Guild of Handicrafts). Began to etch
seriously in 1912, and in 1921 Colnaghi's
became his publishers. Produced 57 prints
in all and was successful until 1930 and the
Depression years. His often fantastic
inventions are characterized by an unusual
austerity: 'Silence of noons, in places no one
knows', was a comment added to an early
state of *Sellenger*.

122 *Sarras*
Etching, 8th state 1926–28
$9\frac{3}{4} \times 13\frac{1}{4}$ 24.9 × 33.8
Cheltenham Art Gallery and Museums

122

Campbell A. Mellon 1876–1955

Born at Sandhurst, Berkshire, and spent his
early days in Nottingham. At the end of the
Great War, when he was over 40, he retired
from business and went to live at Gorleston-
on-Sea, where he devoted the rest of his life
to painting. Took painting lessons from Sir
Arnesby Brown, who lived nearby at
Haddiscoe. In 1924 first exhibited at the
Royal Academy, and showed 50 paintings
there over the years. Painted Gorleston
beach, beach tents, bathing parties, children
at play, the jetty and the lighthouse. Also
painted along the Yare, below Yarmouth,
Walberswick, Breydon, Bradwell, Bungay,
Burgh Castle, and in Kent, along the Wye
Valley, and in South Wales.

123 *August Bank Holiday,*
Yarmouth
Oil on canvas 1931
20 × 24 50.8 × 61
The City of Bristol Museum and Art
Gallery

123

Dame Laura Knight 1877–1970

Born Laura Johnson, she was brought up in her grandmother's house at Long Eaton. Her father died when she was a child. Her mother studied painting in Paris, and taught drawing in Nottingham, but had trouble supporting her family. Her mother ill, Laura took over her art teaching jobs, aged 14. Studied at Nottingham School of Art, where she met Harold Knight whom she married in 1903 – he also was a painter, and initially more successful than herself. During 1904–7 spent a great deal of time in Holland and was impressed by Maris. Moved to Newlyn, and shared a house with Munnings: 'He was wearing a horse-coper suit, black and white checks . . .' 1913, moved to Lamorna in Cornwall, and then to London in 1918: 'Cornwall in beauty so fancified is an easy part of the country for an artist to go to sleep in'. Lived in St John's Wood, with summers in Lamorna. Increasingly interested in the backstage life of the ballet and the circus. Reflected on her own work thus, with reference to the music of Sir Arnold Bax: 'He composed music expressing the still balance of granite rock, staunch amidst nature's savagery, and I was trying to paint the same sort of thing'. Elected an Associate of the Royal Academy in 1927 and made a Dame in 1929.

124 *September Radiance*
Poster 1937
40 × 25 101.6 × 63.5
London Transport Executive

Charles Ginner 1878–1952

Born at Cannes, France, of Anglo-Scottish parents. Worked in an architect's office in Paris, 1899–1904, and then studied painting, first at the Académie Vitti, then at the Ecole des Beaux Arts and then again at Vitti's. In 1908 first exhibited with the Allied Artists' Association but did not join the Fitzroy Street Group until 1910 after he had moved to London. Became a founder member of the Camden Town Group, the London Group and the Cumberland Market Group. Painted murals for Madame Strindberg's 'Cave of the Golden Calf ' and was an official war artist during both world wars. Developed an idiosyncratic style, constructing his pictures out of small, tight touches of thick paint, making a more polite and controlled method out of Van Gogh's

125

love of rhythmic patterning. Lived in Hampstead and painted and drew several views of Flask Walk. Wrote the manifesto 'Neo-Realism' in 1914, outlining his aesthetic beliefs. In this he attacked the decorative tendency within Post-Impressionism, affirming instead that 'the creative power has always been realist': 'Each age has its landscape, its atmosphere, its cities, its people. Realism, loving life, loving its Age, interprets its Epoch by extracting from it the very essence of all it contains of great or weak, of beautiful or of sordid, according to the individual temperament.' ('Neo-Realism', published in *Harold Gilman and Charles Ginner*, catalogue to a Goupil Gallery exhibition, 1914.)

125 *Study for the Dorset coast*
Pencil and watercolour 1922
11½ × 8⅝ 29 × 22
Portsmouth City Museum and Art Gallery

126 *The Window*
Oil on canvas 1943
33 × 21 83.8 × 53.3
Arts Council of Great Britain

128

Spencer Frederick Gore
1878–1914

Born in Surrey, trained at the Slade and met Sickert at Dieppe in 1904. In 1907 was introduced to Neo-Impressionist colour theory by Lucien Pissarro and began to work in this style. Founder member of the Fitzroy Street Group in 1907, the Camden Town Group and the London Group. Responded to the impact of the Post-Impressionists and looked particularly at Gauguin, Cézanne and Matisse. Supervised the decorations for Madame Strindberg's 'Cave of the Golden Calf' and made regular painting trips out of London in the summer and autumn of each year. His most radical landscapes were painted at Letchworth in the autumn of 1912, while staying in Gilman's house. His method was to group the colours found in nature into patterns, reducing description to semi-geometric block-like shapes. This stylization was never arbitrary but the result of intense observation. *Canal Scene* shows him extracting coloured patterns from an urban landscape, under the inspiration of Sickert's example. Died of pneumonia in March 1914.

127 *The Garden*
COLOUR PLATE XVII
Oil on canvas
$15\frac{15}{16} \times 20\frac{1}{16}$ 40.5 × 51
Kirkcaldy Museum and Art Gallery

128 *Canal Scene*
Oil on canvas 1913
19 × 27 43.3 × 68.6
York Art Gallery

Augustus John 1878–1961

Born in Tenby, South Wales, brother of Gwen John. Attended Slade School of Fine Art from 1894–8. Exhibited with the New English Art Club and was given his first one-artist exhibition at the Carfax Gallery in 1899. In 1900 visited Paris and travelled in Europe. Acted as Professor of Painting, University of Liverpool from 1901–4, and was co-principal of 'The Chelsea Art School' with William Orpen from 1903–7. Met Picasso in Paris 1907. Member of the Camden Town Group, 1911, and elected president of the National Portrait Society, 1914. In Paris as official war artist in 1919. Elected to the Royal Academy in 1928, resigned 1938, re-elected 1940. Member of the London Group from 1940–61. Awarded Order of Merit in 1962.

John first arrived at the use of strong post-impressionist colour in flat areas while painting at Martigues in the spring of 1910. Fifty of these 'Provencal Studies' were exhibited in London the following November and impressed J. D. Innes. John had known Innes since 1907, but it was not until 1911 that he painted with him in Wales and shared a cottage near Rhyd-y-fen. John's experience of Provence affected his paintings of the British landscape and it is sometimes difficult to be certain whether an oil sketch was painted in the South of France, Dorset or Wales. A swashbuckling impresario, he celebrated in his landscapes a feeling of 'oneness with nature' which he admired in the life-style of the Romany gypsies. A brilliant draughtsman and skilled painter, he turned his hand to landscapes, large figure compositions and commissioned portraits. He also excelled at intimate portraits of friends, children and, above all, of his second wife, Dorelia.

129 *The Blue Pool*
COLOUR PLATE V
Oil on panel 1911
$12\frac{1}{2} \times 19\frac{1}{2}$ 31.8 × 49.5
Aberdeen Art Gallery and Museums

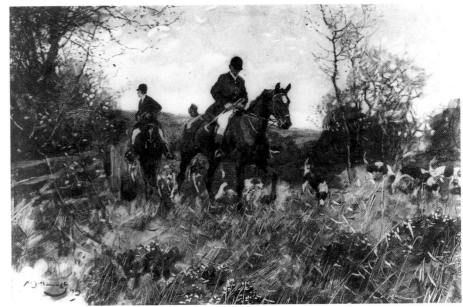

130

Sir Alfred Munnings 1878–1959

Born at Mendham in Suffolk, and spent his early youth in the East Anglian countryside 'devouring the works of Fenimore Cooper and Rider Haggard' and looking at images from the *Graphic* and *Illustrated London News*. Went to school at Framlingham College in Suffolk, among children whose fathers were Newmarket trainers. Apprenticed to the lithographers Page Bros. and Co. in Norwich. Studied at the Norwich School of Art, and then at the Académie Julian in Paris in 1903. Lost the sight of one eye during his years as a lithographer. His early bent was for landscape and paintings of rural life, with fairs, gypsies, cattle, ponies and donkeys as his favourite subjects. Of these years he said, 'I never started a large picture until I had painted small canvases of 30 × 25 inches, or 24 × 20 inches. Of these, one or two might be worthy of a larger subject. I kept my belongings in a cottage or building near my painting-ground. There, on a wet day, I stretched bigger canvases and designed pale-red-and-white enlargements on them from smaller work. Sir William Nicholson – a fine artist – told me often that it was easy to put on the paint if you knew where to put it'. He was attached to the Canadian Cavalry Brigade in France in 1917–18, and painted 45 war pictures for the Canadian Government. Began to paint the equestrian portraits for which he is so well known only in 1919. Became President of the Royal Academy and wrote a three-volumed autobiography, rich in detail.

130 *A Southerly Wind and a Cloudy Sky proclaim it a Hunting Morn*
Black watercolour with some gum arabic and wiping out 1903
$13\frac{5}{8} \times 20\frac{5}{8}$ 34.6 × 52.4
Norfolk Museums Service, Castle Museum Norwich

131 *The Poppy Field*
COLOUR PLATE XII
Oil on canvas 1905/6
30 × 50 76.2 × 127
Dundee Museums and Art Galleries

Sir William Orpen 1878–1931

Born of a Protestant family at Stillorgan, Dublin, and brought up at Blackrock, Co Dublin. His father was a solicitor. From 1890–97 went to the Metropolitan School of Art in Dublin, and was recognized as a child prodigy. Studied at the Slade School from 1897–99, where he won the composition prize in 1899; his rival and friend there was Augustus John, with whom he shared a studio. He shared rooms with Hugh Lane, an Irishman who was on the point of becoming a successful dealer (he went down in the *Lusitania*). In 1899 travelled to Vattetot in France and in 1900 to Cany in Normandy, with Charles Conder. In 1901 married Grace Knewstub whose sister Alice was married to the painter William Rothenstein. From 1902–14 taught each summer in the Metropolitan School of Art in Dublin, and rented a house, 'The Cliff', on Howth Head: 'Had a fine morning yesterday at Clonsitta but I find it very difficult to work from nature at a painting I am doing from a drawing–However I saw a few facts that I never would have got from a drawing'–he wrote in a letter of 1910. He was a follower of Manet rather than of the *plein-air* painters, and like William Nicholson and Sickert worked from drawings and preliminary studies. Much influenced by the large Rembrandt exhibition of 1899 at the Royal Academy. In the '20s was the most successful portraitist in England, earning up to £35,000 p.a. Also a much admired war artist, noted for the accuracy of his observation of military life.

132 *The Butte de Warlencourt*
Oil on canvas 1919
30 × 36 76 × 91.5
The Trustees of the Imperial War Museum, London

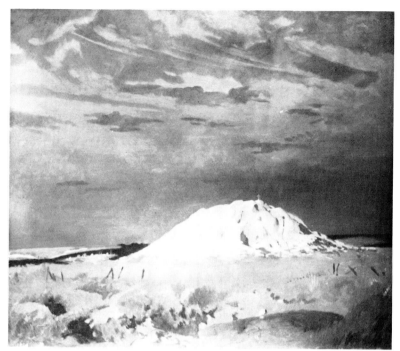

132

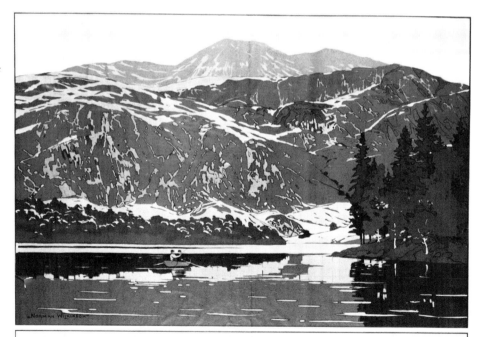

LMS **THE TROSSACHS**
LOCH KATRINE AND BEN VENUE
BY NORMAN WILKINSON. R.I.

133

Norman Wilkinson 1878–1971

Born in Cambridge where he attended the choir school. In 1895 his family moved to Southsea, where he attended the Portsmouth and Southsea School of Art. Dr Conan Doyle introduced him to Jerome K. Jerome, publisher of the *Idler* and *Today*. In 1898 his first drawing was printed in the *Illustrated London News*. In 1899 he went to St Ives to painting classes run by Louis Grier, and later in that year to Paris, where he did drawings for French illustrated papers; anti-British sentiment in the Boer war forced him home. Worked for Harmsworth's *The Illustrated Mail*. In 1901 went to New York for the Americas Cup, but did drawings of McKinley's assassination and funeral. Did finished drawings of the Russo-Japanese war for the *Illustrated London News*. Gained fame as a painter of ships, and one of his pictures went down with the *Titanic*. From 1905 became an innovative poster artist for the London North Western Region Company, 'Young artist leaps to fame from the hoardings'. From 1910 onwards, was a member of St John's Wood Arts Club, with Francis Barraud, inventor of the HMV dog. In 1915 went to the Dardanelles as a paymaster in the navy; witnessed 'the living cinema of battle' and did 'on-the-spot' drawings, used in his book, *The Dardanelles*, 1915. Invented dazzle camouflage in 1917 which turned allied merchant fleets into 'a flock of sea-going easter eggs'. In 1924, launched the London Midland Scottish posters by artists scheme – eighteen in all, by such artists as Arnesby Brown, D. Y. Cameron, G. Clausen, A. Talmage, G. Henry; £100 each with royalties on posters which sold at 5/– each. Worked for Anglo-Persian Oilfields (BP), the Rio Tinto Co. in Spain, and for the government of the Bahamas. In 1939 camouflaged airfields for the RAF. Painted 56 pictures of World War Two naval actions, now in the National Maritime Museum.

133 *The Trossachs*
Poster late 1920s
40 × 50 101.6 × 127
National Railway Museum, York

134

Vanessa Bell 1879–1961

The daughter of an eminent literary critic, Sir Leslie Stephen and the sister of Virginia Woolf. Trained at the Pelham School of Art and the Royal Academy Schools where she came under the influence of John Singer Sargent. After a visit to Paris in 1904 she founded the Friday Club the following year in an attempt to create an atmosphere more conducive to painting in London. In 1907 married the critic Clive Bell. In 1910 met Roger Fry and experienced the first of his two famous Post-Impressionist exhibitions. Her painting changed radically and is for a period characterized by the reduction of form to large, hewn blocks. Simultaneously, though based in London, she began to spend long periods in the country, first at Asheham (where *The Haystack* was painted) then at Charleston, both of which are situated a few miles from Lewes close to the South Downs. As her style matured and returned to a more naturalistic idiom, she became a subtle but rich colourist, orchestrating harmonies out of unprepossessing subjects, mostly confining herself to still-lifes, portraits and views of the garden and fields around Charleston. Like Duncan Grant, with whom she lived from 1915 until her death, she had a talent for decoration, designed fabrics, cushion covers, book jackets, dinner service patterns and also undertook many public and private commissions for the decoration of interiors.

134 *Landscape with Haystack, Asheham*
Oil on board *c*.1912
23¾ × 25¾ 60.3 × 65.4
Anthony d'Offay Gallery, London

135

Leslie Hunter 1879–1931

Born in Rothesay, Scotland. Following the untimely death of both his brother and sister, Hunter's family moved to California. After a vain effort to become a farmer, he took up art and visited Paris in 1904. He began work as an illustrator and in San Francisco mixed with a circle of artists and writers. His first one-man show was destroyed the day before it was due to open by the San Francisco earthquake and fire of 1906. In 1910 his family returned to Scotland and shortly afterwards Hunter joined them. In due course he became a well-known figure in Glasgow art circles, and occupied a number of studios, following an erratic life style. He had little regard for money, was unconscious of disorder and was frequently hard up. Shortly before the First World War his work caught the attention of the dealer Alexander Reid who promised Hunter an exhibition. Encouraged by this, the artist went to France and was there when war broke out. He returned to Scotland and throughout the greater part of the war worked on his uncle's farm. In 1922 he made a long tour of the Continent, saw a good deal of J. D. Fergusson and in 1923 exhibited in London with Peploe and Cadell. In Scotland he painted landscapes in Fife and among the houseboats on Loch Lomond. Constantly feeling an urge to go south, he lived in France between 1927 and 1929, moving from place to place along the Mediterranean coast, until a breakdown compelled his removal to a hospital at Nice.

135 *Reflections, Balloch*
Oil on canvas 1929–30
25 × 30 63.5 × 76.2
Scottish National Gallery of Modern Art, Edinburgh

Sir Matthew Smith 1879–1959

Born in Halifax. Entered Manchester School of Art late, having first worked in industry. At the age of twenty-six moved to London where he attended the Slade. For health reasons he spent a year in Brittany and then settled in Paris where he attended Matisse's school. In 1912 returned home and married the ex-Slade student Gwen Salmond. With her, returned to France and spent several months at Grès-sur-Loing. In 1914 set up house in Kensington and took a

136

studio in Fitzroy Street. In 1916 joined the Artists' Rifles and two years later was wounded. After demobilization, returned to Fitzroy Street, painted watercolours after Delacroix's illustrations to Faust and shunned society. In the summer of 1920 moved to Cornwall, first to St Austell, then St Columb Major, where he translated the landscape into astringent harmonies, employing reds, greens, purples, blues and blacks. During the 1920s and early 1930s divided his time between London and Paris and painted full fleshed nudes in hot colours. In 1933 settled at Aix-en-Provence and thereafter led a migratory existence between London and Provence. The landscapes that he painted in the South of France exchange the angularity of his Cornish scenes for curved forms and high-keyed but more naturalistic colours.

136 *Landscape at Aix-en-Provence*
Oil on canvas c.1936
18¼ × 21⅝ 46.3 × 54.9
Fitzwilliam Museum, Cambridge

Sir William Russell Flint 1880–1969

Born in Edinburgh, where he trained. Apprenticed as a lithographic artist and designer from 1894–1900, and worked as a medical illustrator in London from 1900–1902, and then for the *Illustrated London News* until 1907. A prolific book-illustrator, dry-point etcher and water-colourist, favouring exotic and erotic subjects. Greatly admired as a technician. He explained some of the intricacies of his procedures in C. Littlejohn's *British Watercolour Painting and Painters of Today*, 1931: 'simple skies which might be taken as the result of one wash, have very often taken five or more washes'. Even in 1931 was suspected of being 'too clever'. Most admired by other landscape artists for his Scottish and Northern landscapes.

137 *A Beach by the Farnes*
Watercolour 1920
19¹³⁄₁₆ × 26¾ 50.3 × 68
Victoria and Albert Museum, London

Algernon Newton 1880–1968

Born in Hampstead and educated at Farnborough School, and at Clare College, Cambridge. Studied under Calderon, the animal painter, at the Slade, and at the London School of Art. He worked in Cornwall after 1916, and returned to London in 1918. Spent time studying in the National Gallery especially the work of Canaletto and Richard Wilson. In 1923 began to paint architectural views of London – evening scenes, very thinly and precisely painted. In 1928 produced a large-scale, decorative *Dorset Landscape*, incorporating all the details of a picturesque scene. He continued to paint in this Neo-Georgian vein for the rest of his life. He can be compared with Rex Whistler in this respect.

138 *Landscape*
Oil on canvas
$9\frac{15}{16} \times 13\frac{15}{16}$ 25.2 × 35.4
The City of Bristol Museum and Art
Gallery

George Woods fl. *c*. 1900s

An amateur photographer who worked in the Hastings area around 1900. His work, consisting of original negatives and a large collection of prints arranged in several albums, is held by the Hastings Museum of Art. He was primarily interested in the folk life of East Sussex, and recorded local craftsmen at work and a wide range of agricultural labour. He was as interested in fox-hunting and the photographs included here are quite unlike any taken in England *c*. 1900 or at any other time.

139 *East Sussex and Romney Marsh Hunt*
Photograph – bromide print *c*. 1900
$6\frac{1}{4} \times 4\frac{1}{2}$ 16 × 11.4
Hastings Museum and Art Gallery

140 *East Sussex and Romney Marsh Hunt*
Photograph – bromide print *c*. 1900
$6\frac{1}{4} \times 4\frac{1}{2}$ 16 × 11.4
Hastings Museum and Art Gallery

142

Francis Campbell Boileau Cadell 1883–1937

Born in Edinburgh. When he showed aptitude for art he was sent by his parents, on the advice of Arthur Melville, to train at the Académie Julian in Paris. He studied there for four years, from 1899–1903, and spent most of the next six on the continent. Early influences include Melville, the Glasgow School and the French Impressionists. Between 1910–14 began painting in the distinctive style associated with the Scottish colourists, employing brilliant colour and an abbreviated method of drawing well suited to his aggressively good-natured, witty, light-hearted

character. In 1914 he joined up as soon as war was declared but was found to have 'smoker's heart'. He worked on a farm in Galloway until his health improved and then became an officer in the Argyll and Sutherland Highlanders. He introduced Peploe to Iona, the island which Cadell visited every summer for twenty years and where both painted some of their best pictures.

141 *Rocks, Iona*
Oil on canvas
$14\frac{5}{8} \times 17\frac{5}{8}$ 37.2 × 44.8
The Fine Art Society plc, London

Duncan Grant 1885–1978

Born at The Doune, Inverness-shire. Spent his early years in Burma and India but was educated in England. Attended Westminster School of Art and afterwards, on Simon Bussy's advice, Jacques Emile Blanche's school 'La Palette' in Paris. Did not respond to modern French art until Roger Fry's 'Manet and the Post-Impressionists' exhibition was shown in London in 1910. Then entered upon a period of bold experimentation that culminated in a brief engagement with pure abstraction. Like many artists, returned to a more representational style after the First World War, employing a high-keyed impressionism in which the calligraphy of his brushmarks sets up rhythms and repetitions that help structure the composition. A cousin of Lytton Strachey, he became associated with the Bloomsbury Group and from 1915 enjoyed a close working relationship with Vanessa Bell. With her, he set up the rural haven at Charleston in Sussex in 1916, and in the late '20s and early '30s made lengthy visits to Cassis where they rented a small farm building. He also painted landscapes at St Tropez in 1921. Most of his English scenes are painted in the area around Lewes, close to Charleston. His love of pattern was encouraged by his decorative work which left him well practised at filling a given space with colour and shape. With Vanessa Bell, executed many decorative commissions, having first become interested in this art form while working for the Omega Workshops before and during the 1914–18 war.

142 *Lewes Landscape*
Oil on paper laid on board 1934
$23\frac{1}{4} \times 22\frac{1}{2}$ 59×57.2
Leicestershire Museums and Art Galleries

143

Derwent Lees 1885–1931

Born in Brisbane, Australia. Studied in Paris and at Melbourne University. Lost a foot in a riding accident. 1905–07 studied at the Slade where he met J. D. Innes. 1908–18 worked as a teacher of drawing at the Slade and travelled widely in vacations throughout Europe. In 1912 took a cottage at Ffestiniog and, under the influence of Innes, imitated his lyrical, shorthand method of notation, attaining a similar intensity of colour and mood. Like Innes and John, a successful philanderer, despite his wooden leg, but also suffered from incipient mental ill-health which confined him to an asylum from 1918 until his death.

143 *The Little Gardens*
Oil on panel 1913
13×16 33×40.6
Leeds City Art Galleries

F. Gregory Brown 1887–1948

A commercial artist and textile designer, who was apprenticed to an art metalworker in 1903, but abandoned that for illustration. His first important contract was with *TP's Weekly* and *TP's Magazine*. First exhibited at the Royal Academy in 1908. Designed War Savings posters in 1915. From 1924–38 designed for the London Passenger Transport Board posters. From 1924–34, designed for Southern Railway; from 1935–8, designed for the Great Western Railway. Worked for the Empire Marketing Board in the '20s. Wrote of his posters in 1940 'Rightly or wrongly of late years I have endeavoured to introduce a third dimension into landscape posters, though I am aware that many still hold that the poster should only be two-dimensional. ... With landscape posters I am disposed to think that excessive patterning can destroy greater and more poignant qualities'.

144 *Near Dorking*
Poster 1922
40×25 101.6×63.5
London Transport Executive

James Dickson Innes
1887–1914

Born at Llanelli, studied at Carmarthen Art
School and at the Slade where he met
Derwent Lees and came under the influence
of Wilson Steer. In 1908 became friends
with Augustus John; painted in the South of
France where he first began to heighten his
palette; and learnt he had tuberculosis. In
1910 discovered the isolated inn Rhyd-y-
Fen on the road between Bala and
Ffestiniog. Woke the next morning to his
first view of Arenig Fawr. Repeatedly
painted this mountain under a variety of
light effects and buried a silver casket of
love letters beneath a cairn on the summit.
Entered upon a period of frenetic activity,
painting at intervals in Wales, with John or
Lees, carousing, drinking prodigiously and
pursuing women despite periodic break-
downs in health. Painted fast on a small
scale, with great freedom of touch, often
using small dabs to enliven the surface. His
colours, though subtle and related to
atmospheric effects of nature, acquire the
brilliance of stained glass. Transported his
style to the Pyrenees when in the winter of
1913 he and Lees painted near Collioure.
His strength rapidly deteriorated. Spent the
winter of 1913–14 in Morocco where,
according to a friend, he passed his time
experimenting with different combinations
of tobacco. Died soon afterwards, aged
twenty-seven.

145 *Arenig Mountain*
Oil on panel
10 × 14 25.5 × 35.5
Glynn Vivian Art Gallery and Museum,
Swansea

146

147

Laurence Stephen Lowry 1887–1976

Born in Manchester. Private painting classes with William Fitz, before working as a clerk in a firm of chartered accountants in 1904. 1905–15 studied at the Municipal College of Art, Manchester. In 1909 moved from Rusholme to Pendlebury in Salford. In 1910 began to work as a rent collector. 1915–20 studied at the Salford School of Art, and began to take an interest in city scenes. In 1931 illustrated *A Cotswold Book* by Harold Timperley. Began to exhibit in 1932 at the Royal Academy, and in 1939 started to exhibit regularly at the Lefevre Gallery. Until 1952 he continued to work for the Pall Mall Property Company and rose from being a rent collector to chief cashier. In 1948 moved from Salford to Mottram-in-Longdendale in Cheshire. Became greatly honoured, and his work was much exhibited in his later days. He spoke of his work to Edwin Mullins in the mid '60s: 'Had I not been lonely none of my work would have happened. I should not have done what I've done, or seen the way I saw things. I work because there's nothing else to do'. His sense of humour has often been remarked on.

146 *Lake Landscape*
Oil on canvas 1950
28 × 36 71.1 × 91.5
Whitworth Art Gallery,
University of Manchester

146a *Industrial Scene, Wigan*
Oil on canvas 1925
16 × 16 34.3 × 34.3
Private Collection

148

Frank Newbould 1887–1951

One of Britain's most prolific and distinguished poster artists of the '20s and '30s. During and after the Great War he was a black and white artist, illustrating for *Passing Show*, for example, but this was less profitable than poster work. At first he was in the influential Morton studios in Fleet Street, and then had his own studio in Kensington. Commissioned by the influential Mr Teasdale of the London and North Eastern Railway Company, who insisted that artists visit the areas they were called upon to illustrate; previously most seaside posters had been of 'golden haired children playing on sands'. Teasdale was also one of the first art directors to bypass boards of governors and to commission and supervise directly. Newbould's early posters of *c*.1925 still show the influence of the Nicholson/Pryde Beggarstaff style.

147 *Scotland by LNER (Fort William)*
Poster early 1930s
40 × 50 101.6 × 127
National Railway Museum, York

David Strang b.1887

Born in Dumbarton, the son of the etcher William Strang and brother of Ian Strang. Studied at the Glasgow School of Art. Was a painter and etcher, and exhibited at the Royal Academy and the New English Art Club. Lived in London.

148 *Landscape near Ascot*
Etching
$9\frac{7}{8} \times 15\frac{1}{2}$ 25.1 × 39.4
Cheltenham Art Gallery and Museums

Sydney Carline 1888–1929

Trained at the Slade under Professor Tonks, and spent time in Paris in 1912–13. Painted in Westmorland in 1914. Joined the army and trained as a despatch rider, before becoming a pilot in the Royal Flying Corps in 1916. He described the front in a letter from France, 'just bare desolated ground, the colour of a ploughed field and all around, holes and craters, and more trenches and every here and there, all along, little puffs of smoke from the bursting shells of the guns'. Became a war artist in 1918, and tried to represent the war as seen from the air; only completed seven large oils on this subject. In 1922 he was appointed Ruskin Master of Drawing at Oxford, where he was joined by Richard Carline, Gilbert Spencer and John Nash. Died of pneumonia in 1929 after a visit to John Nash on a frosty evening.

149 *The Destruction of an Austrian Machine in the Gorge of the Brenta Valley, Italy*
Oil on canvas 1918
30 × 36 76 × 91.5
The Trustees of the Imperial War Museum, London

149

Stanley Royle 1888–1961

Born in Stalybridge, Lancashire, son of a station-master. Attended Sheffield School of Art, winning bronze and silver medals for lithography. Member of the Sheffield Society of Artists and the Royal Society of British Artists. Travelled to Nova Scotia and by 1937 had become Director of the Art Gallery and College of Arts associated with the Mount Allison University at New Brunswick. Returned to England shortly before the Second World War and settled at Worksop. A provincial impressionist, he had a liking for pure colour and specialized in snow scenes, taking himself around Derbyshire on a two-stroke motorbicycle.

150 *Sheffield from Wincobank*
Oil on canvas 1923
28 × 36⅛ 71.1 × 91.8
Sheffield City Art Galleries

150

Leslie Moffat Ward b.1888

A painter and etcher of English landscape and architecture. Worked between 1916 and 1940 and is especially associated with the West Country, Dorset and the Cotswolds.

151 *The Long Man on the Downs*
Woodcut
11 × 9¼ 28 × 23.5
Towner Art Gallery, Eastbourne

Sir Cedric Morris 1889–1981

Born in Glamorgan, studied at the Académie Delacluse, Paris, and at the outbreak of the 1914–18 war joined the Artists Rifles but was later discharged as medically unfit. In 1917 painted in Cornwall. In 1918 began a life-long friendship with Lett Haines and with him settled into a cottage overlooking Newlyn harbour. Moved to Paris in 1921 and attended the Académie Moderne, working under Friesz, Lhôte and Léger. In the twenties became close friends with Frances Hodgkins and Christopher Wood; after seeing Morris's *Corner in Treboul*, Wood visited the village and produced some of his most memorable paintings. Travelled in France and North Africa. In 1927 moved back to London, exhibited with the Seven & Five Society. Later moved to Dedham, Suffolk but kept on a London studio. With Lett Haines, ran the small but celebrated East Anglian School of Painting and Drawing at Dedham. From 1950–53 lectured in design at the Royal College of Art; also continued to travel, teach, paint and garden, having developed a particular love of flowers. The strength of his paintings lies in their directness and honesty, in the unhesitant use of thick paint and undisguised brushmarks to build up a solid tapestry of colour.

152 *Corner in Treboul, Brittany*
COLOUR PLATE VI
Oil on canvas 1927
21½ × 26 54.6 × 66
Sir Peter Wakefield

151

Paul Nash 1889–1946

Born in London but brought up at Iver Heath in Buckinghamshire. Images from the landscapes of his childhood resurface throughout his art. After an abortive attempt to get into the navy, he studied art at Chelsea Polytechnic and at Bolt Court. Encouraged by William Rothenstein, he entered the Slade in 1910 but failed to grasp figure drawing. His early work is strongly influenced by Rossetti. Was persuaded by Sir William Blake Richmond, among others, to concentrate on landscape. His ink and watercolour drawings of 1912–14 contain elements he later developed: a strong feeling for geometric order underlying nature, and a powerful evocation of mystery. His growing reputation earned him an appointment as an official War Artist and he produced images which juxtapose scenes of devastation with sensations of rebirth. After the war, settled for a period at Dymchurch on the Kent coast, where he redirected his art, finding poetry in the simple geometry of beach, breakers and sea. Subsequently the sea becomes a frequent motif in his art, culminating in the great *Totes Meer* (Tate Gallery) of 1940–1. In 1933 was instrumental in founding Unit One. Increasingly, during the 'twenties and 'thirties, he introduced strange elements into his landscapes, flirting briefly with semi-abstraction and with surrealism, in an attempt to capture 'the mystery of relationship'. His last paintings, which juggle with sunflowers, solstices and fire wheels, are meditations on the cyclical relationship between life and death.

153 *We are making a new world*
Oil on canvas 1918
28 × 36 71 × 91.5
The Trustees of the Imperial War Museum, London

154 *The Orchard*
Pen, brush and indian ink over pencil 1922
26 × 34 66 × 86.3
Birmingham Museum and Art Gallery

155 *Wood on the Downs*
COLOUR PLATE VII
Oil on canvas 1929
28 × 36 71.1 × 91.4
Aberdeen Art Gallery and Museums

158

159

156 *The White Horse,
Uffington, Berkshire*
Photograph 1937
15 × 9 38 × 22.8
Arts Council of Great Britain

157 *Landscape of the
Vernal Equinox Two*
Oil on canvas 1944
25 × 30 63.5 × 76.2
Scottish National Gallery of
Modern Art, Edinburgh

Edward Alexander Wadsworth
1889–1949

Educated at Fettes College, Edinburgh.
Trained as an engineering draughtsman in
Munich, but returned to England in 1910 to
go to the Slade. Associated with the Rebel
Art Centre of Wyndham Lewis. Served with
the Royal Navy, and then worked on ship
camouflage in Bristol and Liverpool, as did
Norman Wilkinson. As an official War
Artist he painted pictures of camouflaged
ships for the Canadian Government. In
1920 showed drawings of the Black Country
at the Leicester Galleries; a selection was
published in that year, introduced by
Arnold Bennett. In 1926 exhibited tempera
pictures of ships and harbours of the
Mediterranean at the Leicester Galleries.
Continued to paint decorative
arrangements of nautical items. Painted
large panels of marine subjects for the
Queen Mary, and a panel for Mendelsohn
and Chermayeff's De La Warr Pavilion in
Bexhill. Designed posters and continued to
illustrate books: *Sailing Ships and Barges of the
Western Mediterranean and Adriatic Seas*, by
B. Windeler, 1927. A member of Unit One.

158 *Buxton Village*
Oil on cardboard 1922
28¼ × 37¼ 71.8 × 94.7
Bradford Art Galleries and Museums

David Bomberg 1890–1957

Born in 1890 in Birmingham into a Polish
immigrant family. Lived in Whitechapel,
London from 1895 to 1913. Apprenticed to
a lithographer and studied under Walter
Bayes at the City and Guilds evening
classes. Entered the Slade in 1911 and first
made his reputation as one of the most

160

original of the English cubists, creating
powerful splintered compositions in which
the emphasis is solely on form. After the
First World War he returned to a more
painterly style, discovering, on a visit to
Palestine in 1923, that by broadening his
brushstroke he could depict not only the
forms in landscape but also his response to
them and what he called 'the spirit in the
mass'. His art developed along these lines
over the next thirty years, increasing in
breadth and strength of vision. He never
enjoyed any financial success and spent
much of the last part of his career teaching
at the Borough Polytechnic where he
influenced a small but important group of
painters, among them Leon Kossoff and
Frank Auerbach.

159 *Bideford Bay, North Devon*
Oil on canvas 1946
24⅛ × 30 61.2 × 76.3
Laing Art Gallery, Newcastle upon Tyne

Paul Fripp b.1890

Born in Mansfield, Nottinghamshire, and
studied at the Leicester School of Art and at
the Royal College of Art, gaining his
diploma in 1919. Painted in oil and in
watercolour, and was a metalworker,
jeweller, cabinet-maker and photographer.
Exhibited at the New English Art Club and
ouside London. Lived in Cheltenham, and
was a member of the Cheltenham group of
artists.

160 *A Cotswold Farm*
Watercolour 1920
11¼ × 14⅝ 28.6 × 37.2
Cheltenham Art Gallery and Museums

Edward McKnight Kauffer
1890–1954

Born and educated in the U.S.A. and trained as a painter. Travelled in Europe and came to England in 1914. At the suggestion of the poster artist John Hassall took his ideas to Frank Pick at the Underground Railway Company and in 1915 was commissioned to do posters of *Oxhey Woods* and of *Watford*. In 1921 gave up painting entirely for commercial art. In the early '20s his work was attacked as 'certainly not attractive, and by no means sincere' (Mr B. Sands of Messrs. A. & F. Pears quoted in *Commercial Art*, 1924). In 1925, on the occasion of his retrospective exhibition at 60, Gower Street, London he was assessed thus in *Commercial Art*, June, 1925: 'Ten years ago McKnight Kauffer was quite unknown. Five years ago he was – by those who had not met him – considered to be a crank or charlatan who would ultimately revert to excessive realism in his painting or disappear from the hoardings altogether. To-day his works and his opinions are quoted in almost every newspaper and magazine of note the world over. Never before has such wide publicity been given to a commercial artist'. Worked for the London Transport Board, Shell-Mex and BP Ltd., the Great Western Railway, the Empire Marketing Board, the Orient Line, the G.P.O., the Gas, Light and Coke Co., Messrs. J. C. Eno Ltd., and the drycleaners, Messrs. Eastman and Son Ltd. Utterly outstanding as a poster designer, and considered by his contemporaries as a worker of miracles, in sales terms.

161 *Flowers of the Hills*
Poster 1930
40 × 25 101.6 × 63.5
London Transport Executive

162 *Stonehenge*
COLOUR PLATE XIV
Poster 1931
40 × 25 101.6 × 63.5
Victoria and Albert Museum, London

163 *Spring on the Hillside*
Poster 1936
40 × 25 101.6 × 63.5
London Transport Executive

164

Claughton Pellew-Harvey
b.1890

Brought up in Blackheath, London, and studied at the Slade. A contemporary of Paul Nash, who described their friendship of *c*.1911–12 at length in his autobiography *Outline* (1949): 'Among the few people at the Slade who seemed in the least interested in what I was doing was a slight dark man with a strange voice ... the first creature of a truly poetic cast of mind that I had met ... His own work was remarkable for a searching intensity both in thought and execution'. Nash goes on to credit Pellew with having opened his eyes to Nature: 'I found he had a deep love for the country, particularly for certain of its features, such as ricks and stooks of corn. At first I was unable to understand an almost devotional approach to a hay stack, and listened doubtfully to a rhapsody on the beauty of its form. Such objects, and, indeed, the whole organic life of the countryside were still, for me, only the properties and scenes

of my "visions". Slowly, however, the individual beauty of certain things, trees particularly, began to dawn upon me.'

164 *Embankment at Night*
Ink, pastel, gouache and watercolour 1920
$17\frac{3}{4} \times 23\frac{5}{8}$ 45 × 60
Hove Museum of Art

Mark Gertler 1891–1939

Born at Spitalfields, London, the son of Polish Jews. Brought up in conditions of great poverty until his father's furrier workshop began to enjoy a moderate success. In 1906 began attending art classes at the Regent Street Polytechnic but a year later, on the family's insistence, was apprenticed to the neighbourhood stained glass works. In 1908 William Rothenstein arranged for him to go to the Slade with financial assistance from the Jewish Education Art Society. Won various prizes and scholarships and fell in love with Dora Carrington. Drew inspiration from a variety

166

of sources, but in the winter of 1912–13 incorporated a semi-cubist style into his innate feeling for realism. Enjoyed friendships with Edward Marsh, Lady Ottoline Morrell, Gilbert Cannan and other leading names of the day but was tortured by his unsatisfactory relationship with Carrington. In 1916 he painted his masterpiece, *The Merry-Go-Round*, a savage indictment of the futility of war. He changed to a gentler style in landscapes painted in the early 1920s while recuperating in sanatoria from tuberculosis. During the second half of his career Gertler produced work of uneven quality and grew increasingly depressed at his lack of success. Committed suicide in 1939.

165 *Trees at Sanatorium*
Oil on canvas 1921
43 × 19 109.2 × 48.3
Private Collection

Sir Stanley Spencer 1891–1959

Born at Cookham-on-Thames, Berkshire, the eighth child of an organist and piano teacher. Trained at Maidenhead Technical Institute and the Slade and was to a limited extent influenced by the arrival of the French Post-Impressionists in England in 1910 and 1912. At Cookham had the mystical experience of walking in an earthly paradise, the village becoming in his pictures the setting for the Bible stories that his father read aloud at night. In 1915 enlisted in the Royal Army Medical Corps and was eventually sent to Macedonia with an ambulance brigade. His war-time experiences later reappear in his decoration of the Burghclere Chapel (1923–32). The experience of organizing multi-figure compositions aided his paintings of Lithgow's ship-building factory at Port Glasgow made during the Second World War. Between these two events Spencer's style gradually changed; his figures became chubbier, his colours dryer and paler in tone, his compositions more claustrophobic. Though prolific, he found he needed to paint landscapes to make money. Even so he brought to these his unique vision, which paradoxically achieved an overall unity through the separation of every part. Married twice, but continued to write love letters to his first wife, even after her death, for he was as profuse with words as with paint.

166 *Cookham from Cookham Dean*
Oil on canvas pre 1940
26 × 46 66 × 106.8
Bradford Art Galleries and Museums

Ethelbert Basil White
1891–1972

Born at Isleworth, Middlesex. Studied from
1911–12 at the St John's Wood School of
Art. Came to know Mark Gertler and
C. R. W. Nevinson, and with Nevinson
experimented with Futurism. They painted
jointly *Tum-Tiddly-Um-Tum-Tum-Pom-
Pom*, a large canvas for the Allied Artists'
Exhibition on Hampstead Heath on Fair
Day, 1913. Especially active as an illustrator
and wood-engraver: Herbert Reads's
Eclogues, of 1919 for the Beaumont Press,
Richard Jefferies' *The Story of My Heart*, for
Duckworth in 1923, and Thoreau's *Walden*,
for Penguin in 1938. Illustrated
monographs on ballets for Cyril Beaumont
in the 1920s. A watercolour painter from
the '20s onwards. Exhibited first in 1915
with the London Group; in 1921 with the
New English Art Club; and in 1934 with the
Royal Society of Painters in Watercolours.
Had the same studio in Hampstead Grove
throughout his working career.

167 *Sussex Landscape*
Oil on canvas
23¾ × 29⅞ 60.6 × 76
Towner Art Gallery, Eastbourne

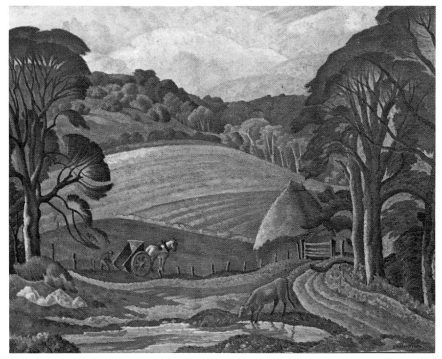

167

Henryk Gotlib 1892–1967

Born in Cracow, where he attended the
Academy of Fine Art. In 1919 was in the
Polish avant-garde 'Formist' group.
Exhibited in Amsterdam in 1920 and in
Berlin in 1921. In 1923 settled in France for
10 years, and visited Brittany in 1927. In
1935 spent a year in Spain, in Granada
particularly. In 1938 visited England for the
first time, and settled permanently in 1939,
when he spent three months painting in
Cornwall. In 1942 showed at Agnews, and
thereafter at Roland, Browse and Delbanco.
Had a studio in Surrey from 1950.

168 *At the Gate*
Oil on canvas 1942
20 × 24 50.8 × 61
The Roland Collection

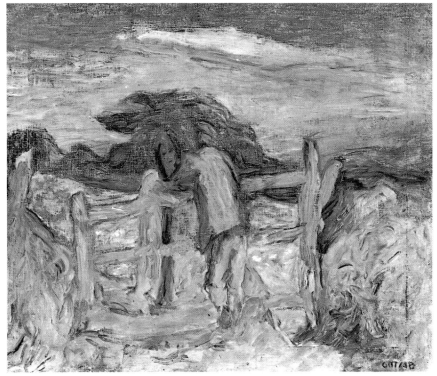

168

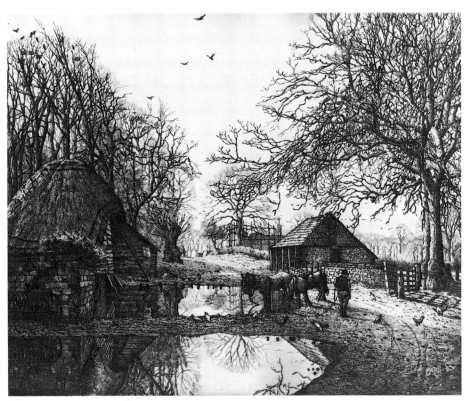

169

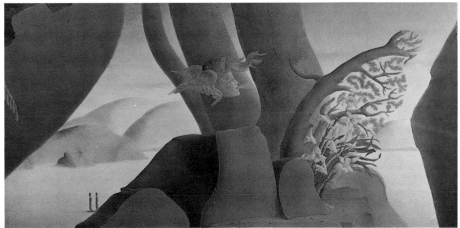

170

Allan Gwynne-Jones 1892–1982

Qualified as a solicitor, but began to work as a watercolourist in 1912. Served in the Welsh Guards during the Great War, and studied at the Slade afterwards. Went to the Royal College of Art in 1923, and became Professor of Painting. During the 1920s he made a number of etchings of rural subjects. His main interests from the '30s onwards were portraiture and still-life.

169 *Spring Evening, Froxfield*
Etching 1926
$5\frac{7}{8} \times 7\frac{1}{2}$ 15×19
Rosemary Gwynne-Jones

Thomas Lowinsky 1892–1947

Born in London, of Hungarian and South African descent. Educated at Eton and Trinity College, Oxford. Studied at the Slade between 1912–14 and served in France 1914–19. Exhibited with the New English Art Club and held his first one-artist show in 1926. Painted in tempera, creating surreal images and landscapes, occasionally painting biblical scenes. Illustrated Edith Sitwell's *Elegy on Dead Fashion* among other books. The precise, almost scientific accuracy that Lowinsky brought to his art may have stemmed from his home environment and his father whose chief interest lay in the hybridization of rhododendrons. He helped finance expeditions to the Himalayas and experimented with the plants that were brought back.

170 *The Breeze at Morn*
Tempera on canvas 1930
$17\frac{1}{4} \times 36$ 43.9×91.4
The Trustees of the Tate Gallery, London

Gilbert Spencer 1892–1979

Born at Cookham-on-Thames, Berkshire. In 1909 attended the Ruskin School at Maidenhead, then in 1911 went to Camberwell School of Arts and Crafts, before going to the Slade, 1913–15. Saw service in the Great War at Salonica. Expressed a continual interest in country life and landscape. In 1920 he and his

brother, Stanley, stayed with Henry Lamb at Stourpaine in Dorset, and he returned there often. In the '30s he rented a Dorset farmhouse. Illustrated books by the Dorset writer T. F. Powys: e.g. *Fables* (1929), and *Kindness in a Corner* (1930). His best known painting, *A Cotswold Farm* of 1930–31, was a Chantrey Purchase for the Tate. He stayed in the Cotswolds with Austin Lane Poole, principal of St John's, Oxford. Like John Nash, was interested in the practicalities of tillage – see his *The Progress of Husbandry* for Massey-Ferguson in 1963. From 1932 was Professor of Painting at the Royal College. Described the view from his Dorset garden thus: 'The garden sloped towards the shadow of Melbury Beacon, and in the distance Shaftesbury perched on its rocky headland overlooking Blackmore Vale'.

171 *Hughenden Valley*
Oil on canvas
28 × 40 71.1 × 101.6
Leeds City Art Galleries

Harold Sandys Williamson
b.1892

Born in Leeds and studied at the Leeds School of Art, 1911–14. Attended the Royal Academy Schools from 1914–15, where he received the Turner Gold Medal. Served with the King's Royal Rifle Corps during the Great War, and his work is represented in the Imperial War Museum. A painter and a poster designer, he was headmaster of the Chelsea Polytechnic, 1930–58. Lived in Norwich. Designed posters for the Empire Marketing Board, an organization set up in 1926 to create 'a background of interest in the subject of Empire buying' – by 1931, 1,700 frames had been set up in the 450 largest towns in Britain, and small versions of the posters were distributed to schools. Williamson also worked for the G.P.O. in 1934, as well as for the Council for the Encouragement of Music and the Arts in 1945. Throughout his career his was a documentary style, heavily detailed.

172 *September Hop-picking*
Poster for CEMA
29½ × 39 75 × 99
Kettering Borough Council

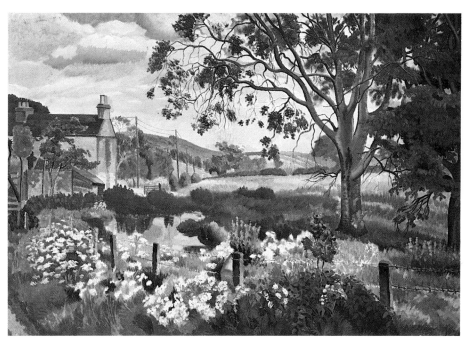

171

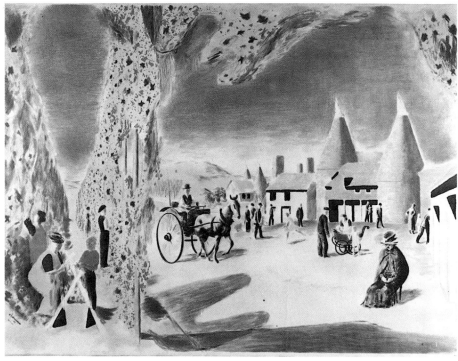

172

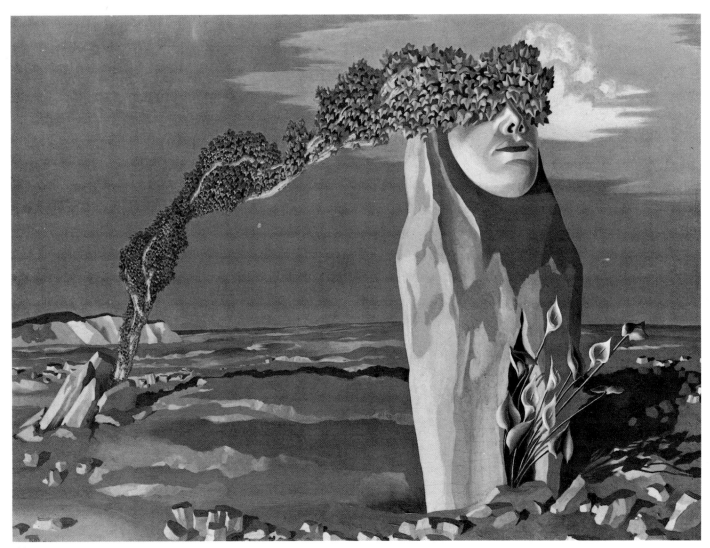

173

John Armstrong 1893–1973

Born in Hastings, the son of a parson. From 1907–12 went to St Paul's School and then studied law at St John's College, Oxford. Attended St. John's Wood Art School in an irregular fashion both before and after the 1914–18 war when he served in the Royal Field Artillery. Like Stanley Spencer, painted in a systematic fashion, beginning in the top left-hand corner and finishing every part as he progressed. Used tempera and held his first one-artist show in 1928.

Came to notice in the 1920s as an interior decorator. Designed sets for theatre and films and the conventions of theatrical design reappear in his art. Influenced by de Chirico after this artist's work was shown in London in 1928. In 1931 did the scenery and costumes for *Façade* by Edith Sitwell and William Walton. Joined Unit One in 1933, designed costumes for Korda's films through the '30s, and from 1932 designed posters for Shell. In 1938 he moved to near Dunmow, in Essex, and his painting of this time is dreamlike and

surrealistic. Made an official War Artist in the Second World War. Became interested in political themes, and in the destruction of beauty. During the 1950s was opposed to the proliferation of nuclear weapons. Traces of his early decorative style survived throughout his career.

173 *Heaviness of Sleep*
Tempera on panel 1938
$21\frac{1}{4} \times 29\frac{1}{8}$ 54×74
Private Collection

Dora Carrington 1893–1932

Trained at the Slade where she met, among others, John Nash who aroused her interest in wood engraving, and Mark Gertler whose powerful, almost symbolic figure paintings influenced her own approach to portraiture. Rejected Gertler as a lover in preference for the homosexual essayist and biographer Lytton Strachey, with whom she set up home, first at Tidmarsh Mill near Pangbourne, then at Hamspray in Hampshire. Only rarely painted landscape but was profoundly moved by it. In 1921 married Ralph Partridge, living with him and Strachey in a *ménage à trois*, surrounded mainly by literary friends and receiving little encouragement to exhibit. Turned instead to decorative work, emulating Duncan Grant and Vanessa Bell, but producing a style more native in inspiration and more naive. Dedicated her life to Strachey. After his death looked through all her paintings: 'Tidmarsh all came back. How much I love places. I remembered suddenly my passion for a certain tree in Burgess's back field. And the beauty of the mill at the back of the house and how once a kingfisher dived from the roof into the stream.' Less than two months after Strachey's death, she took her own life, at the age of thirty-eight.
(Quotation from Noel Carrington's *Carrington: Paintings, Drawings and Decorations*, 1978, p. 45.)

174 *The Mill at Tidmarsh, Berkshire*
Oil on canvas *c*.1920
27 × 40 68.6 × 101.6
Private Collection

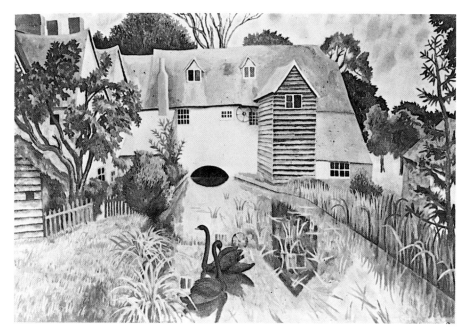

174

Ivon Hitchens 1893–1979

Studied at St John's Wood School of Art and the Royal Academy. Exhibited with the Seven & Five Society, the London Group and the London Artists' Association. Moved from the lyrical, semi-naive landscape painting associated with the Seven & Five into a more abstract style that briefly brought him close to the non-figurative artists of the 1930s. In 1937 returned to landscape painting and in 1940, after his London home was bombed, moved to Sussex, buying a tract of woodland at Lavington Common, near Petworth, building there a house and devising a large

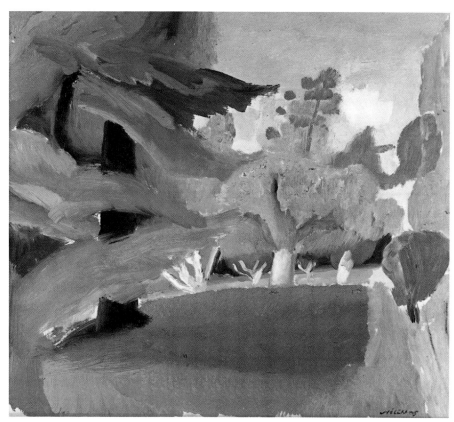

175

pond, later adding to his property by acquiring an orchard. His preferred canvas size was twice as wide as it was tall. Developed a notational style, drawing with large sweeps of the brush, suggesting light, reflections on water, distance and seasonal effects rather than the actual look of the landscape. During the 1950s his colours became tuned to a higher key, becoming still more strident in the 1960s. Often the bare canvas between the coloured marks gives a crystalline effect and increases the brilliance of his colour. Told Herbert Read, 'The essence of my theory is that colour is space and space colour'. (Herbert Read, *Contemporary British Art*, 1951, p. 27.)

175 *Sussex Landscape*
Oil on canvas
$22 \times 23\frac{1}{2}$ 55.9×59
Aberdeen Art Gallery and Museums

175a *The Chili Pine*
Oil on canvas 1945
$20\frac{1}{4} \times 41\frac{1}{2}$ 51.5×105.5
Private Collection

John Northcote Nash
1893–1977

On the advice of his brother Paul he kept away from art schools. Experienced active service in the Artists' Rifles from 1916–18, and became an official War Artist in 1918, painting *Over the Top* (Imperial War Museum, London) and *Oppy Wood*. Began wood engraving around 1921, in which year he went to teach at the Ruskin School at Oxford. He began to do book illustrations, for such as the *Nonsense Story Book* by Lance Sieveking, and had an early reputation as a humorist. During 1923–4 he worked in Dorset and Somerset. Joined the London Group in 1914, the New English Art Club in 1920 and the Society of Wood Engravers in 1921. Athough he continued to paint he is best known for book illustrations, lithographed posters and advertising work. In his many views of the country he favoured tilled rather than wild nature.

176 *Winter Evening*
Oil on canvas
$24\frac{1}{2} \times 29\frac{1}{2}$ 62.2×75
Worthing Museum and Art Gallery

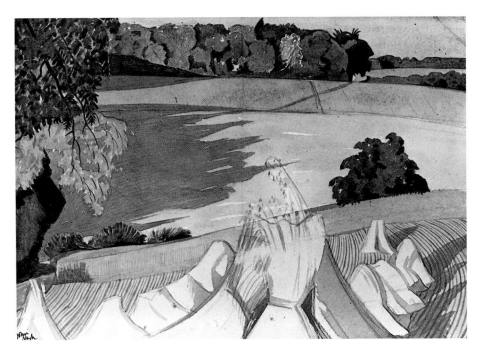

177

177 *The Cornfield*
Watercolour 1918
$7\frac{3}{8} \times 10\frac{5}{8}$ 18.8×27
The Trustees of the Tate Gallery, London

178 *Canal scene – design for a mural in Leeds Town Hall*
Watercolour
$15\frac{1}{4} \times 22\frac{1}{4}$ 38.6×56.4
Victoria and Albert Museum, London

Winifred Nicholson 1893–1981

Neé Winifred Roberts, the granddaughter of one of the Etruscan School painters, George Howard. Attended the Byam Shaw School of Art and also studied in Paris. Travelled to India and Burma with her father who was Under Secretary of State for India, and developed a love of strong colour. Married Ben Nicholson in 1920 and spent the next three winters in Castagnola, often painting out of doors in the snow. Shared her husband's interest in the bright light created by sun on snow and began to see colour as a series of iridescent veils. Compared colour to music in its effects of vibration. Exhibited with the Seven & Five Society 1923–35. Painted with Ben Nicholson and Christopher Wood in Cumberland and Cornwall, in a lyrical, naive style. During the 1930's shared the interests of her contemporaries in mathematical and architectural elements and produced a series of abstracts: 'When I was painting these canvases I felt in the company of star galaxies and their orbits.' Lived alone in Paris but returned to Cumberland at the onset of war. Resumed landscape painting, producing semi-mystical views of nature and developing in particular a love of flowers: 'I began to paint again, but paint near, small, close things, like the faces of flowers and the glimmer of sunbeams that touch them.' Listed rainbows among the important events of her old age.
(Quotations from *Winifred Nicholson: Paintings 1900–1978*, Third Eye Centre, Glasgow, 1979.)

179 *Sandpipers, Alnmouth*
Oil and sand on board 1933
$20\frac{1}{4} \times 25\frac{5}{8}$ 51.5×65
Private Collection

Harry Epworth Allen
1894–1958

Born in Sheffield and trained at Sheffield
School of Art. Lost a leg in the First World
War. A member of the Sheffield Society of
Artists and the Royal Society of British
Artists. Specialized in views of Derbyshire,
particularly the White Peak area around
Buxton. Before painting full-time, worked
for a period as secretary to Lord Riverdale.
Painted mostly in tempera, tending to
organize landscape into formalized units.
Found difficulty in getting about, but took
buses into the Derbyshire countryside.

180 *Hathersage, Derbyshire*
Gouache on board *c*.1949
19⅞ × 25 50.4 × 63.4
Laing Art Gallery, Newcastle upon Tyne

Ben Nicholson 1894–1982

Son of Sir William Nicholson. Attended the
Slade for little more than a year and
between 1912 and 1918 spent his time
travelling abroad. In 1920 married the
painter Winifred Roberts. He then began to
paint seriously and consistently, developing
with Winifred a *faux-naif* style for depicting
the countryside in Cumberland and
Cornwall. Exhibited regularly with the
Seven & Five Society and for a short period
worked closely with Christopher Wood,
with whom he discovered the primitive
artist Alfred Wallis in 1928. Wallis's boldly
designed, asymmetrical pictures had a
considerable influence on Nicholson's later
development. Became increasingly
interested in the abstract language of
painting, arguing, in his contribution to the
book *Unit One* (1934) that everything in
nature is a construction of the human mind.
This interest in abstraction coincided with
his developing relationship with the
sculptor, Barbara Hepworth, whom he
married in 1934. This same year made his
first white reliefs in which pictorial language
is reduced to rectangles and circles incised
into white plaster. During the 1930s lived in
Hampstead in close contact with Herbert
Read and Henry Moore, later with the
refugee artists Walter Gropius, L. Moholy-
Nagy and Naum Gabo, playing a central
role in the development of modernism.

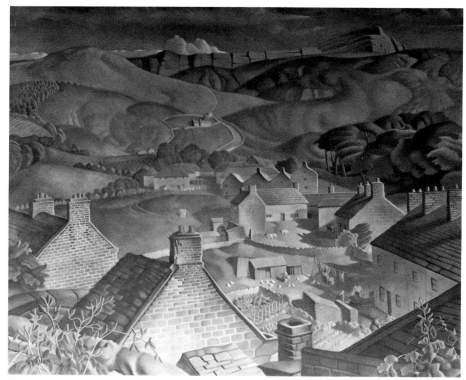

180

During the Second World War withdrew
from pure abstraction and re-introduced
still-life and landscape, featuring scenes in
Cornwall and Italy. His work remained to
the end a subtle play on representation and
abstraction.

181 *Walton Wood Cottage No. 2*
Oil on canvas 1928
22 × 24 56 × 61
Scottish National Gallery
of Modern Art, Edinburgh

182 *Tree at Saval*
Pencil and wash 1958
20 × 14 50.8 × 35.6
Huddersfield Art Gallery

David Jones 1895–1974

Born in Brockley, Kent. Attended
Camberwell School of Art and between
1915–18 served with the Royal Welch
Fusiliers. On his return studied at the
Westminster School of Art from 1919–21. In
1921 was received into the Roman Catholic
Church and joined Eric Gill's Ditchling
community where he learnt wood-
engraving. Moved to Capel-y-ffin with Gill
in 1921 and became engaged to his
daughter Petra. The engagement was later
broken off and Jones never married. Painted
landscapes at Capel and on Caldy Island,
also in the suburban environment of his
parents' house at Brockley. Joined the
Society of Wood-Engravers in 1927 and, the
following year, the Seven & Five Society
with which he exhibited until 1933. Drew
and painted in such a way that, though the
material aspect of an object is never denied,
it suggests an inner or spiritual life. He also
began to write an epic poem on the First
World War, *In Parenthesis*, after a trip to
France in 1928 when he visited the

countryside associated with *Le Chanson du Roland*. Continued to demand of painting that it reflect more than could be seen by 'the eye of flesh' and asserted 'the intimate creatureliness of things'. In 1932 suffered a breakdown and from then on periodically endured ill health. Lived at Sidmouth, Devon, within sight of the sea from 1935–9 and returned to London for the 1939–45 war. After a second breakdown in 1947 moved to Harrow where he lived for the rest of his life, for much of the time in a residential hotel.

183 *The Suburban Order*
Watercolour 1926
$15\frac{1}{16} \times 21\frac{1}{16}$ 38.6 × 53.9
Portsmouth City Museum and Art Gallery

184 *Mr Gill's Hay Harvest*
Pencil and watercolour 1926
$22\frac{1}{2} \times 15$ 57.1 × 38.1
Private Collection

Vivian Pitchforth 1895–1982

Born in Wakefield, Yorkshire. Studied art locally before attending the Royal College of Art at the time of the First World War. Taught at Camberwell School of Art from 1926, at St Martins School of Art from 1930 and then at Chelsea School of Art until the 1960s. Became deaf in middle age and always carried a note-pad for questions, providing witty and decorative replies. Attached to the Admiralty as an official War Artist in the Second World War, which fitted in well with his penchant for the subject matter of the sea and ships. As a devoted teacher, concentrated on painting in oils and watercolours and on drawing from the model. Elected an associate of the Royal Academy in 1942 and a Royal Academician in 1953. Became an Associate of the Royal Watercolour Society in 1957.

185 *Hillside, North Wales*
Watercolour 1939
$27\frac{1}{2} \times 19$ 69.9 × 48.3
Victoria and Albert Museum, London

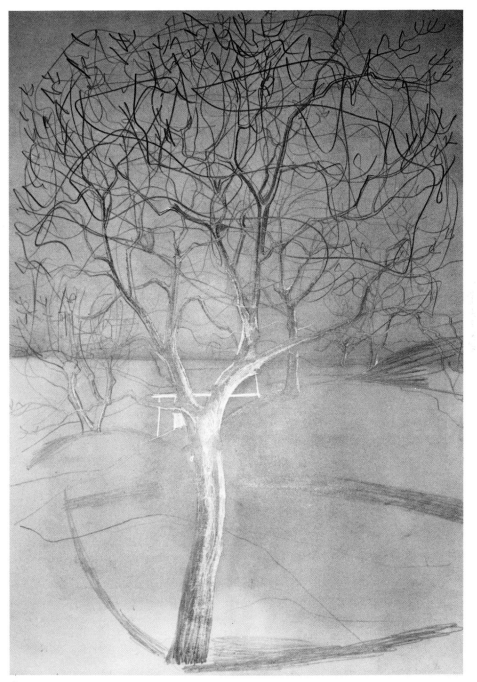

182

Anne Redpath 1895–1965

Daughter of a tweed designer in Galashiels ('I do with a spot of red or yellow in harmony of grey, what my father did in his tweed.') In 1913 entered Edinburgh College of Art and in 1917 qualified as an art teacher. In 1919 was awarded a travelling scholarship and visited, among other places, Siena, where she admired the Italian Primitives. In 1920 married an architect working for the War Graves Commission in France where they lived and had three sons. ('I could never have sacrificed my family to painting . . . I put everything I had into house and furniture and dresses and good food and people. All that's the same sort of thing as painting really, and the experience went back into art when I began painting again.') In 1934 returned to Scotland and for the next fifteen years painted mostly still-life and landscapes of the Borders and Skye. Then began to travel regularly, to France, Corsica, Portugal, Spain, the Canary Isles and Italy. ('To go to Spain to find dark grey skies and white villages; to Italy and find that the sky is more violet than blue; to Corsica and find violets and scarlets on the hillsides; all this enlarges one's range of colour and responsiveness.') (Quotations from *Anne Redpath: A Memorial Exhibition*, Arts Council of Great Britain, Scottish Committee, 1965–6.)

186 *Houses near Las Palmas*
Watercolour and pastel
$22\frac{5}{8} \times 29\frac{3}{8}$ 57.4 × 74.6
Birmingham Museum and Art Gallery

Leonard Russell Squirrell 1895–1979

Born in Ipswich, he studied at Ipswich School of Art and at the Slade. Deaf and dumb. He was an etcher and illustrator whose orderly manner sometimes recalls that of J. S. Cotman. Well known for his aquatints and etchings of beauty-spots and architecture in East Anglia, the Lake District and Scotland, and also an illustrator of carriage panels for the major railway companies.

187 *A Dovedale Gorge*
Watercolour 1922
$10\frac{1}{2} \times 16\frac{1}{8}$ 26.8 × 41
Ipswich Museums and Galleries

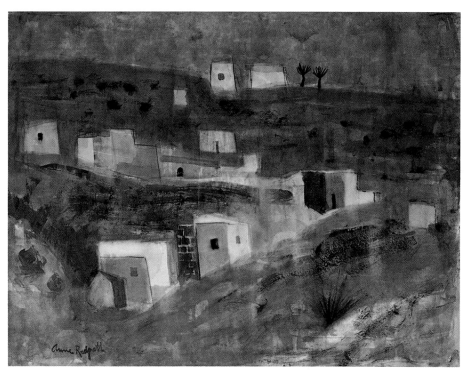

186

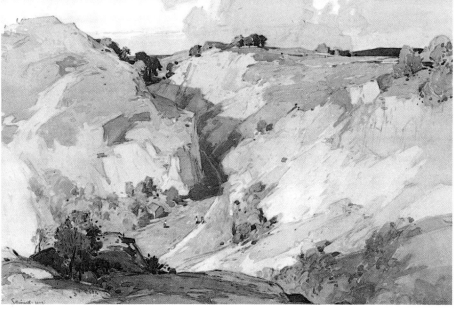

187

134

Raymond Coxon b.1896

Born at Hanley, Stoke-on-Trent. Served
with the Cavalry in Palestine in the
1914–18 war. Studied at Leeds College of
Art 1919–21 and at the Royal College of
Art 1921–5. Taught at Richmond School of
Art 1925. Married the painter Edna Ginesi
in 1926. Formed, with Henry Moore and
others, the short-lived British Independent
Society in 1927. Joined the London Artists'
Association, the London Group and the
Chiswick Group. Made official War Artist
between 1940–45.

188 *Autumn*
Oil on canvas
25 × 30⅛ 63.5 × 76.4
Wakefield Art Gallery

189 *October Tree Felling*
Poster for CEMA
29½ × 39 75 × 99
Kettering Borough Council

William Johnstone 1897–1981

Educated in Selkirk, and familiar from
childhood with farm work. Influenced
towards painting by Tom Scott, R.S.A., he
entered Edinburgh College of Art in 1919.
Moved to Paris in 1925 where he was
influenced by André Lhôte. Moved to
America, but returned in 1929 and became
increasingly involved in art education which
made him Principal of Camberwell School
of Arts and Crafts 1938–46 and then
Principal of the Central School 1947–60.
Retired to become a full-time painter and
sheep-farmer in Roxburghshire.

190 *Border Landscape:
The Eildon Hills*
Oil on canvas c.1929
28 × 35¾ 71 × 91
Glasgow Art Gallery and Museum

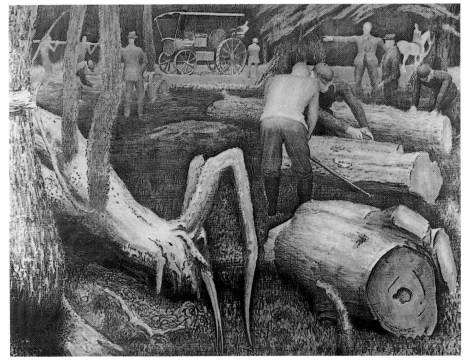

189

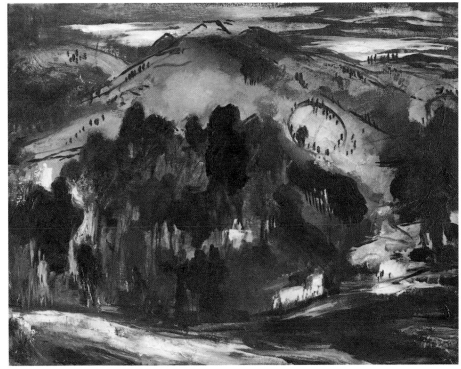

190

135

Sir William Gillies 1898–1973

Born at Haddington, East Lothian, and as a boy went out sketching in the area with his uncle, the painter William Ryle Smith. His period of training at the Edinburgh College of Art was interrupted by two years war service. In 1924 won a travelling scholarship, went to Italy and studied for a period in Paris under André Lhôte, author of a treatise on landscape painting. In 1925 returned to Scotland and took up teaching posts, first at Inverness, then at the Edinburgh College of Art where he eventually became Head of Painting and, later still, Principal. In 1932, due to the influence of Peploe and Cadell, entered the select and influential Society of Eight. In 1939 moved to Temple, Midlothian, in order to have landscape always near at hand. A prolific artist, he painted at the College of Art, in the evenings and at weekends, working in all seasons. During the 1920s and '30s he worked chiefly in watercolour, handling this medium almost impetuously, achieving momentary effects with broad, simple means. By comparison, his later oils and watercolours are tighter and more deliberate.

191 *Fields and River*
Oil on canvas
24¾ × 33⅞ 62.9 × 86
Scottish National Gallery of Modern Art, Edinburgh

Douglas Percy Bliss b.1900

Born in Karachi, where his father was a trader. Educated in Edinburgh. Spent four years at the University of Edinburgh and emerged with a degree in rhetoric and English literature and a medal for fine art. Accepted at the Royal College of Art, where his contemporaries included Henry Moore, Barbara Hepworth, Eric Ravilious and Charles Tunnicliffe. Although on the fine art course attended print-making classes and while still a student produced a book of wood-engravings, *Border Ballads*, which was published by the Oxford University Press. On leaving the Royal College of Art he was commissioned to write a history of wood-engraving by Campbell Dodgson, keeper of prints and drawings at the British Museum.

Took a series of teaching jobs, and was head of the art-teaching course at Hornsey College of Art from 1929–39. Exhibited in London at the New English Art Club and the Royal Academy. He was also an art critic at this time, writing for *The Scotsman* and for *The Print Collectors' Quarterly*. In 1939 volunteered for the R.A.F. and was appointed to a branch which dealt with concealment and decoy. In 1946 became Director of the School of Art in Glasgow, and remained there until 1965. Took vacations on the Isle of Barra, and painted there. Bought a house in Derbyshire, to which he retired. Has recently written a book on Edward Bawden.

192 *February in my Garden*
Oil on canvas 1938
30 × 40 76.2 × 101.1
Douglas Percy Bliss

Mary Potter 1900–1981

Born in Beckenham (neé Attenborough) where she attended the School of Art under A. K. Browning. She spent two years at the Slade, taught for a year at Eastbourne College of Art and at first specialized in portraits, enjoying a success she distrusted. She joined the Seven & Five Society soon after its foundation but resigned after two years, subsequently joining the London Group. In 1927 she married Stephen Potter, the author and BBC producer. A busy social life and the birth of two sons cut down her painting time, but she still continued to work, holding exhibitions in 1931 and 1934. During the 1930s the Potter family lived at Chiswick where the artist painted views of the river. During the war she was obliged to travel round the country with her husband. On occasions they made use of a family house in Essex where *Rising Moon* was painted. In 1951 the family moved to the Red House, Aldeburgh. In 1955 the marriage was dissolved, and in 1957 Mary Potter sold the Red House to Benjamin Britten and Peter Pears, moving into a house on the sea front until a house and studio had been built for her in her former garden. She worked there, in relative isolation, concentrating on the Suffolk landscape, employing a delicacy and suggestiveness influenced by Klee and

Chinese and Japanese ink painting. She had a natural preference for pale colours and cursory definition.

193 *Rising Moon*
COLOUR PLATE XIX
Oil on canvas
18 × 30 45.8 × 76.2
Ferens Art Gallery, City of Kingston upon Hull Museums and Art Galleries

194 *The Mere*
Oil on canvas 1958
19¾ × 30 50.5 × 76.2
Norfolk Contemporary Art Society, on loan to Norwich Castle Museum

John Tunnard 1900–1971

Born in Bedfordshire, the son of a sporting painter and country gentleman. Educated at Charterhouse. From 1919–23 was a design student at the Royal College of Art. During the '20s he was a designer for a number of textile manufacturers, and only became a painter in 1929. Also active as a semi-professional jazz drummer through the '20s. Lived in Chiswick in London. In 1933 had his first one-man show at the Redfern Gallery, after which he and his wife bought a caravan, and went to live on the Lizard Peninsula in Cornwall. Set up a hand-block silk-printing business, and during the '30s turned from figuration to abstraction. Influenced by Miro, Klee and Moore, and included in Surrealist shows in the late '30s. Influenced too by Gabo and the Constructivists, and reviewed in 1939 as 'the Heath Robinson of the Constructivists'. Continued to live in Cornwall, and during the '40s worked as a part-time teacher. Throughout his career he combined in his work technological and natural forms.

195 *Departure*
Gouache 1946
19⁵⁄₁₆ × 24⅝ 49 × 62.5
Kettering Borough Council

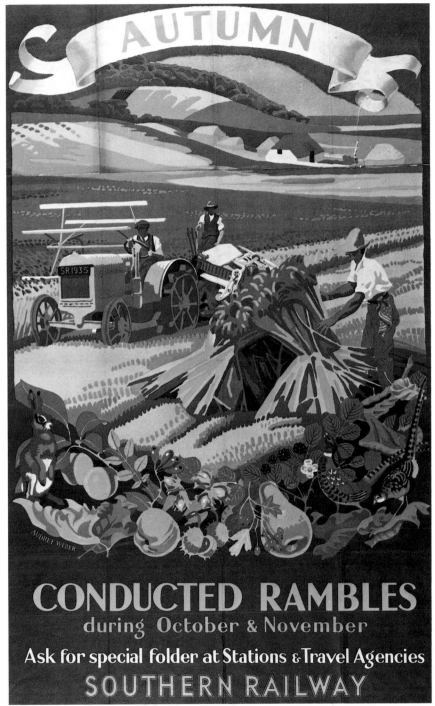

196

Audrey Weber fl. c.1920s–30s

A painter, illustrator and poster artist who exhibited between 1920 and 1934 at the Cooling Galleries, the International Society, the New English Art Club and the Royal Academy. In the late 1930s she designed posters for the Southern Railway Company, and illustrated the Southern Railways booklet *Hills of the South* by S. P. B. Mais. Her paintings of the late 1930s look like highly coloured versions of the work of Charles Gere.

196 *Autumn, Conducted Rambles during October and November*
Poster 1938
40 × 25 101.6 × 63.5
National Railway Museum, York

Gertrude Hermes b.1901

In 1919–20 studied at the Beckenham School of Art, and then went to Germany, 1920–21. Was in Leon Underwood's School of Painting and Drawing from 1921–25, during which period Henry Moore, Raymond Coxon and Vivian Pitchforth also attended evening classes there. Made her first wood engraving in 1922. In 1926 married Blair Hughes-Stanton, and they collaborated on wood-engravings for *The Pilgrim's Progress*, Cresset Press (1928). In 1928 moved to Gregynog in Wales and worked for the Gregynog Press. In 1929 moved to Hatcheson in Suffolk, and completed 20 engravings for *A Florilege*. During 1934–6 visited Scotland and the Outer Hebrides. In 1938 illustrated the Penguin edition of Richard Jefferies' *The Story of My Heart*, and in 1939 Izaak Walton's *The Compleat Angler*, also for Penguin. Through these years she was also working as a painter, sculptor and decorator at international exhibitions: she produced murals for the restaurant in the British Pavilion at the Paris World Fair (1928); a 30-foot sculpted glass panel with the Britannia motif for the British Pavilion, International Exhibition of Arts and Industry, Paris (1937); glass panels for the British Pavilion at the World Fair, New York (1939). After 1945 taught engraving, wood and lino-block cutting and printing.

197 *Through the Windscreen*
Wood engraving 1926
5 × 7 12.7 × 17.8
Towner Art Gallery, Eastbourne

197

Charles Knight b.1901

Trained at Brighton Art School and then at the Royal Academy Schools for four years – where he was instructed by Charles Sims and then by W. R. Sickert. He learned Sims's technique of painting in oil over a tempera base, whilst Sickert taught him to look at life. He won the gold medal, the Landseer scholarship and a portrait drawing prize. Returned straightaway to a teaching job in Brighton, which he held until his retirement on a full and then part-time basis. Worked for an architectural firm, J. L. Denman of Brighton, detailing perspective drawings. Did 40 drawings for the Pilgrim Trust's *Recording Britain* project in 1940 and was paid £5 each. Painted railway carriage panels of Lancashire scenes for which he was paid transport costs only. His landscape style was influenced by Cotman; but also by Titian, whom he studied in the National Gallery. This view of Ditchling Beacon, near to his home, was published by Medici in 1950.

198 *Ditchling Beacon*
Oil on canvas
27½ × 35½ 70 × 90.2
Towner Art Gallery, Eastbourne

William Larkins 1901–1974

Born into a family of steeplejacks at Bow, London. Spent five years at Goldsmiths' College of Art in London. Became a skilled etcher under the supervision of Frederick Marriott, Alfred Bentley and Malcolm Osborne. Alfred Drury introduced him to Frank Brangwyn who was impressed by his Welsh and Belgian etchings of 1922–3. Elected a member of the Print Society in 1922, and his work was widely reproduced in *The Studio* and in *Fine Prints of the Year*. In 1929 worked with the film director Eisenstein, and was one of the original members of the Film Society formed by Ivor Montagu. His etchings of the late '20s are rich in expressionist shadows and atmosphere. In 1932 joined J. Walter Thompson as an art director where he designed the Black Magic chocolate box, a streamlined modern design in use for 35 years. In 1949 joined *Reader's Digest* to direct their art and graphics.

199 *Troutwater*
Etching 1926
6½ × 9¾ 16.5 × 24.7
University of London,
Goldsmiths' College Gallery

Christopher Wood 1901–1930

Born at Knowsley, near Liverpool. Studied architecture at Liverpool University and met Augustus John at Liverpool's Sandon Studios Society. On leaving university, Wood apprenticed himself to a London fruit merchant and began to haunt various clubs. Friendship with the wealthy Jewish patron and collector, Alphonse Kahn, took him to Paris where he led an exhausting social life. The Chilean diplomat, Antonio de Gandarillas, payed for him to attend the Académie Julian and took him on trips around the Mediterranean. Wood sought in his art for the vision of a child, and was confirmed in his naive style when he saw the paintings of Alfred Wallis in 1928. Enjoyed friendships with Picasso and Cocteau and under the latter's influence became addicted to opium. In 1926 met Ben and Winifred Nicholson and painted with them in Cornwall and Cumberland. He was impressed by their dedication and simple life-style, and turned away from society to concentrate more on his painting. During the last two summers of his life painted many port scenes and seascapes on the Brittany coast. Died in 1930 by falling under an express train at Salisbury station.

200 *Sleeping Fisherman, Ploare*
Oil on board 1930
$14\frac{7}{8} \times 28\frac{5}{8}$ 37.8 × 72.8
Laing Art Gallery, Newcastle upon Tyne

198

200

George Downs b.1902

Born and lived in London all his life. Began
to paint in 1937, and was discovered by
Julian Trevelyan. Untrained, and worked
as a salesman, selling for factories on
commission; this allowed him three days a
week in which to paint. Jankel Adler hoped
that Downs would be his assistant, but he,
valuing his independence, declined. Never
moved far afield from his home base in
Chiswick, although in the era of Mass
Observation did attend a weekend seminar
in Newcastle with Julian Trevelyan. In
1942–43, he served on the Central
Committee of the Artists' International
Association, and was one of the organizers
of the annual exhibition in 1943. Moved to
Macclesfield, Cheshire, in 1982. Always
painted for the sheer love of painting.

201 *Landscape*
Oil on canvas 1940
28 × 39 71.1 × 99
Swindon Permanent Art Collection,
Borough of Thamesdown

201

203

Walter Thomas Monnington
1902–1976

Grew up in Sussex. Went to the Slade at an early age, where he became interested in mural painting. Awarded a scholarship to the British School at Rome; D. Y. Cameron and George Clausen were on the selection board. In 1925 was one of the artists chosen to decorate St Stephen's Hall, Westminster, under the supervision of D. Y. Cameron –the murals were unveiled in 1927 by Stanley Baldwin. Unlike many of his contemporaries had a deep and unaffected love of modern forms, such as pylons and radio transmitters, and he revelled in practical minutiae. He was a camouflage officer in the war, and attached to Bomber Command. In 1953 he executed a large ceiling painting commission for the Conference Hall in the new Council House in Bristol – done on a geometric basis linking the music of the spheres and the rhythm of modern machines. Such rhythms are evident in his paintings of rocks and trees done in the '50s.

202 *St Mawes, Cornwall*
Oil on panel 1933
10 × 14 25.4 × 35.9
Meredith Monnington

Edward Bawden b.1903

Born at Braintree, Essex. Studied at Cambridge School of Art and at the Royal College of Art under Paul Nash. At the Royal College of Art met Ravilious and entered into friendly competition with him. With Cyril Mahoney, Bawden and Ravilious executed murals (destroyed during the Second World War) in Morley College, London. With Ravilious, took Brick House at Great Bardfield in Essex, Ravilious later moving out to nearby Castle Hedingham. They became the centre of a small group of artists (linked by geography rather than style) sometimes referred to as the Great Bardfield school. With Ravilious, Bawden helped revive the art of watercolour painting in the 1930s, bringing to it a fresh, breezy, unfussed style, in which the use of pattern and texture owes much to their experience of print making and designing. Between 1940–44 worked as an official War Artist in France and the Middle East.

205

203 *The Larch Wood*
Watercolour
17⅞ × 22½ 45.4 × 57.2
Sheffield City Art Galleries

204 *Brick House Garden Party*
Illustration to '*Good Food*'
Pen and ink 1932
8 × 11 20.3 × 27.9
Towner Art Gallery, Eastbourne

Paul Drury b.1903

The son of Alfred Drury, a distinguished sculptor and Royal Academician. From 1920–26 was a full-time student at Goldsmiths' School of Art. In 1924 won an Open Scholarship in engraving from the British Institute. Was influenced by Dürer, Rembrandt and F. L. M. Griggs, and was instructed in etching by Malcolm Osborne. From 1926–31 worked as an assistant to his father. His first etchings, portraits, date from 1922; *Nicol's Farm* appeared in 1925, and *After Work* in 1926. *September* was made in 1928, in an edition of 75. Up to 1939 he produced nearly 50 recorded etchings of which over 30 were smallish portraits and figure subjects. Many of his editions were as small as 20 or 30. From 1937–69 taught at Goldsmith's School of Art, where he was Principal from 1967–69.

205 *September*
Etching 1928
4⅛ × 5⅛ 10.4 × 13
Robin Garton Gallery, London

Richard Ernst Eurich b.1903

His family lived in Bradford. His father, Dr F. W. Eurich, was a bacteriologist who had worked for the Anthrax Investigation Board in Bradford. Attended Bradford Grammar School and then Bradford School of Art, which emphasised commercial art and design. His family moved to Ilkley: 'The first winter in Ilkley opened my eyes to the great beauty of landscape under weather conditions which in town were only a signal for putting on extra clothing ...' In 1924 studied at the Slade, but much influenced by sculpture in the British Museum. In 1929 came to know Sir Edward Marsh who introduced him to Eric Gill; their interest gained him a one-man show at the Goupil Gallery. Met Christopher Wood, who was to have a strong influence on his work. In 1934 married and moved to Dibden Purlieu near to Southampton. Served in the Royal Navy as a War Artist, but returned to paint Yorkshire landscape afterwards. From 1949, taught at Camberwell and illustrated Shell and BP Shilling guides. His landscapes are often both intricately detailed and vast in scope, and his narrative pictures are rich in incident.

206 *Men of Straw*
COLOUR PLATE XX
Oil on hardboard 1957
20 × 40 50.8 × 101.6
Castle Museum, Nottingham

207

Thomas Barclay Hennell
1903–1945

Brought up in his father's rectory at Ridley, in Kent – not far from Palmer's 'valley of vision' at Shoreham. He was trained at the Regent Street Polytechnic from 1921–5. He knew the Bawden and Ravilious families at Bardfield in Essex, and visited them from 1931 onwards when he was preparing his book *Change in the Farm* (1934). Mentally ill in the early 1930s, he returned to painting in 1936 and moved back to Ridley in Kent. In addition to being an expert on farm practices he was a poet of distinction and an illustrator. He worked for the Pilgrim Trust/Oxford University Press *Recording Britain* project in 1940, and was commissioned as a War Artist in 1941, seeing service on the Home Front, off Iceland, in Normandy, in India, Burma, and in the East Indies, where he was killed in November 1945 by Indonesian nationalists.

207 *Landscape: Flint Heaps, Roadmaking*
Watercolour 1937–41
12½ × 19 31.7 × 48.2
The Trustees of the Tate Gallery, London

Edward Morland Lewis
1903–1943

His landscapes were often based on photographs taken by himself. Initially trained at St John's Wood School of Art and at the Royal Academy Schools, where he met Sickert who was teaching there, as an Associate Royal Academician in the spring of 1926. Lewis promptly left the Royal Academy to work under Sickert as pupil and assistant. In 1930 joined the London Artists' Association and exhibited with this group until it disbanded in 1934. Like Sickert, he tended to paint in patchwork areas of colour laid over warm underpainting. He concentrated on seaside towns: in South Wales, Carmarthen, Ferryside, Laugharne and Tenby; in Ireland, Cork and Waterford; and occasionally painted ports in northern France and Spain. A comparison of one of his photographs with the painting of the same scene reveals how completely he transformed the information from one medium into the language of another. The main composition is faithfully transcribed but the tonal relationships are slightly exaggerated; small figures and accents of light have been sharpened so that without any substantial alteration of the scene the whole has been recomposed. Aside from his

connection with Sickert and the London Artists' Association, Morland Lewis remains an isolated figure. The only large exhibition he had after the close down of the London Artists' Association was at Picture Hire Limited, Brook Street in 1938. In 1939 he bought a house at Green Tye, near Much Hadham, and began to paint views of this area. He also joined the staff of Chelsea College of Art, where his colleagues included Henry Moore, Graham Sutherland and John Piper. He died in North Africa in 1943 while on active service as a camouflage officer.

208 *The Strand, Laugharne*
Oil on canvas 1931
15 × 24 38.1 × 61
National Museum of Wales, Cardiff

John Piper b. 1903

The son of a solicitor. Brought up in Epsom, and showed an early interest in church architecture. Became an articled clerk in his father's firm, for which he worked until his father's death in 1928. Aged 25 he decided to become an artist; attended Richmond and Kingston Schools of Art, the Royal College of Art, and the Slade in 1930. Wrote for the *Nation* and the *Listener*, and with Clarice Moffat, Eileen Holding (his first wife) and P. F. Millard he exhibited at the Mansard Gallery in 1931. In 1933 travelled to Paris to meet Hélion, Braque, Léger and Brancusi. Became involved with the magazine *Axis*, which had been founded by Myfanwy Evans, who was to be his second wife. Moved to Henley-on-Thames and became a constructivist sculptor, but reverted to painting in 1934. In 1938 exhibited collages, and began to take photographs of Welsh Nonconformist chapels. Worked for *Architectural Review* and *Country Life*. Produced the *Shell Guide to Oxfordshire* in 1938 and *Brighton Aquatints* in 1939. Painted many watercolours. In 1941 the Queen commissioned him to draw Windsor. Sir Osbert Sitwell asked him to make paintings of Renishaw, his house in Derbyshire, 'a territory peculiarly suited to his sombre yet fiery genius ... his landscapes are imbued with the very spirit of a countryside that knows no rest from work; for under the age-old surface processes of farming, forestry and the like, runs the cramped subterranean existence of the

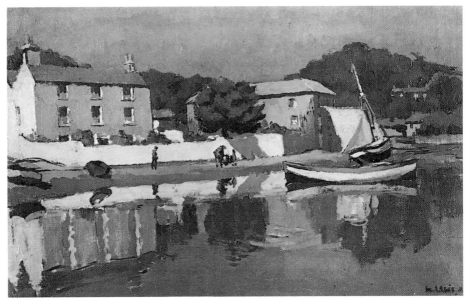

208

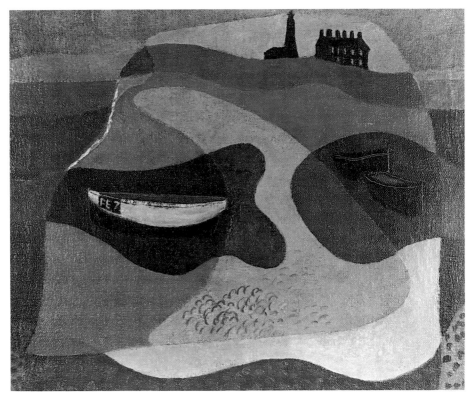

209

mines ...' Continued to work after the war as an author, muralist, illustrator and stage designer.

209 *Boats on Shore*
Oil on burlap 1933
$17\frac{1}{2} \times 22$ 44.5 × 55.9
Huddersfield Art Gallery

210 *Portland, the Top of the Quarry*
Ink and watercolour
$12\frac{3}{4} \times 20\frac{5}{8}$ 32.5 × 52.5
Towner Art Gallery, Eastbourne

Eric Ravilious 1903–1942

Born in London but brought up in Eastbourne where his father had an antiques shop and where he first saw examples of English watercolours. Attended Eastbourne School of Art, 1919–22, then entered the Design School of the Royal College of Art where he was taught by Paul Nash and met Edward Bawden. In 1926 won a travelling scholarship to Italy and was impressed by the work of Italian Primitives. On his return devoted himself chiefly to wood engraving, contributing to the revival of interest in this medium. In 1928 executed a mural decoration with Bawden at Morley College, London, and the following year they took a joint-rent on Brick House in Great Bardfield, Essex. At first this was used as a weekend retreat, then it became a permanent home for both artists and their wives until 1935 when Ravilious moved to Castle Hedingham. His output was prolific, both in watercolour and black and white work. In 1936 he was commissioned by Wedgwood to execute designs for pottery and china which enjoyed wide success. In 1940 was appointed an official War Artist, first with the Royal Marines, then with the Royal Air Force. Was killed in an aeroplane accident.

211(1)

211(3)

211 *Illustrations from 54 Conceits*
by Martin Armstrong, published by Martin Secker Ltd
Wood engravings 1933
(1) Mountains $2\frac{1}{2} \times 2\frac{1}{4}$ 6.5 × 5.7
(2) Anchor $2\frac{1}{8} \times 2\frac{3}{4}$ 5.5 × 6.8
(3) Earth and birds $2\frac{1}{2} \times 3\frac{1}{4}$ 6.5 × 7.8
Towner Art Gallery, Eastbourne

212 *Illustrations from 'The Natural History of Selborne'*
by Gilbert White, selected and edited by H. J. Massingham
Wood engravings 1937
(1) Cockatoos in arbour $2\frac{3}{4} \times 4\frac{1}{8}$ 7 × 10.5
(2) Stork in pool $2\frac{3}{4} \times 4\frac{1}{8}$ 7 × 10.5
Towner Art Gallery, Eastbourne

213 *Train Landscape*
COLOUR PLATE XVI
Watercolour on paper 1940
$17\frac{1}{2} \times 21\frac{1}{2}$ 44.5 × 54.6
Aberdeen Art Gallery and Museums

Ceri Richards 1903–1971

Born in Dunvant, a mining village outside Swansea. The Gower peninsula, with its cliffs, recur as a source of imagery at several periods in his career. His father, a tin-plate worker, communicated his love of music and poetry to his son, and these arts were to be a continuous inspiration to his painting, particularly the poetry of his compatriot Dylan Thomas. In 1921 studied at Swansea Art College and afterwards at the Royal College of Art where he became interested in the writings of Kandinsky and the art of Picasso and Matisse. At first earned his living as a commercial artist. In the mid-thirties became interested in relief construction and collage and exhibited in the 1936 International Surrealist exhibition. During the war lived at Cardiff and was Head of Painting at the School of Art. In 1945 returned to London, painted on a larger scale and found expression in several other media such as lithographs, book illustration, costume, mask and scenery design for operas (including Britten's *Noyes Fludde*) and stained glass windows (Derby Cathedral and the Cathedral of Christ the King, Liverpool).

214 *Welsh Coastlines*
Oil on canvas 1942
10×14 25.4 × 35.6
National Museum of Wales, Cardiff

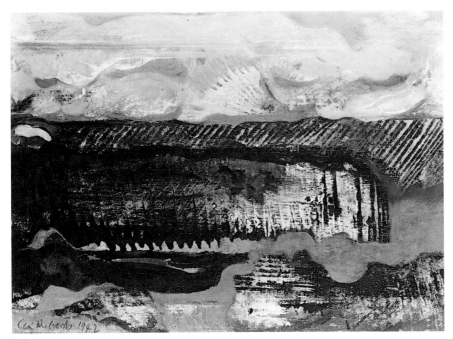

214

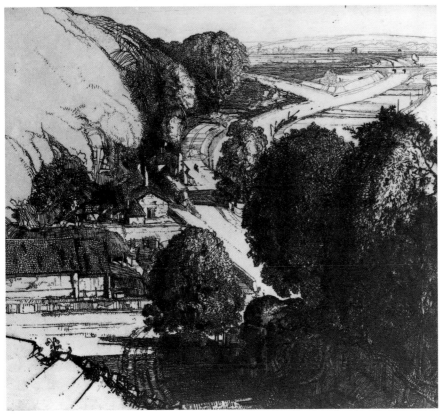

215

Graham Sutherland 1903–1980

Born in London, son of a lawyer. Brought up in Surrey. Originally intended for a career in engineering and in 1920 was apprenticed at the Midland Railway Works at Derby. Between 1921–6 studied at Goldsmiths' School of Art, specialising in etching. In 1925 was elected an associate member of the Royal Society of Painter-Etchers and Engravers. In 1926 became a Roman Catholic and between 1927–39 taught two days a week at Chelsea School of Art. In 1927 married and moved to Kent, making annual visits to Dorset during the next few years. The sudden collapse of the print market obliged him to earn money by designing posters, china, glass and fabrics; he also took up painting. In 1934 made his first visit to Pembrokeshire which he revisited every summer until the outbreak of war. Allowed his earlier interest in Samuel Palmer, combined with his awareness of Surrealism, to create visionary landscapes that had an important influence on other neo-romantic artists in Britain. Between 1940–5 worked as an official War Artist, drawing and painting scenes of bomb damage, blast furnaces, tin mining and quarrying. Continued to make visits to Wales every year until 1945. Became a friend of Francis Bacon and was one of the first to champion his work. In 1947 visited the South of France where he spent part of each year from then on. In 1952 was commissioned to design a vast tapestry for Coventry Cathedral. At this time began to paint portraits. These further enhanced his reputation which in Britain was at its height during the 1950s. Though honours and awards continued to be bestowed on him, he received more critical acclaim in Italy than in this country during the last years of his life.

215 *The Black Rabbit*
Etching 1923
$7\frac{5}{8} \times 8\frac{1}{2}$ 19.4 × 21.6
Cheltenham Art Gallery and Museums

216 *Dark Hills – Landscape with Hedges and Fields*
Watercolour
$19\frac{1}{4} \times 27\frac{1}{2}$ 49 × 70
Swindon Permanent Art Collection, Borough of Thamesdown

Sir Cecil Beaton 1904–1980

Educated at Harrow, and from 1922 at Cambridge. Interested in the theatre and in photography from childhood. After an unsuccessful period in business he became a full-time photographer, partly due to the encouragement of Osbert Sitwell. Showed photographs at the Cooling Galleries in Bond Street: 'I was the first photographer whose work caught the imagination of the general public'. Was influenced by the Sitwells, Surrealism and a trip to Venice where he saw Tiepolo ceilings and met Diaghilev. Began to work for *Vogue* and in 1930 Duckworth published *The Book of Beauty*. Worked often in New York, and in the mid-'30s took Ashcombe on a long lease, 'a very remote and romantic house situated among the most beautiful woods in the Wiltshire Downs'. In *Photobiography* (1951) he describes it thus: 'With its pale light colours and silver ornamentation indoors, and its ilex trees, stone garden-ornaments and high surrounding line of downs, it was an ideal setting for photography ... As the year progressed I photographed the may trees in blossom, the old lilac sprawling over the kitchen-garden wall, the Caroline Testout roses, the statues decorated with garlands of flowers; the more bucolic scene – the new chicks seen between the spokes of the farm cartwheel, the evenings' count of eggs placed on an old tree stump'.

217 *Ashcombe*
Ink and gouache on grey paper 1937
14¾ × 20½ 37.5 × 52
Sir Brian Batsford

218 *Country Still Life with Eggs*
Photograph – silver print
8½ × 7¾ 21.6 × 19.5
Sotheby's, London

219 *Magnolia Tree*
Photograph – silver print
8 × 5¾ 20.4 × 14.5
Sotheby's, London

220

Walter Bell b.1904

Born in Sheffield and trained at the Sheffield School of Art. Became a hairdresser at Stoney Middleton in Derbyshire but continued to paint in his spare time, becoming a member of the Sheffield Society of Artists and exhibiting in local galleries. *Derbyshire Quarry* (originally entitled *Cement Works*) was exhibited at the Royal Academy in 1937 and won him some acclaim. Moved to Cornwall where he became a full-time painter, relying for his income on the tourist trade.

220 *Derbyshire Quarry*
Oil on canvas 1937
25 × 30 63.5 × 76.2
Sheffield City Art Galleries

Stephen Bone 1904–1958

Born at Chiswick, the son of the illustrator Sir Muirhead Bone. Educated at Bedales, and then at the Slade. A member of the New English Art Club and of the Association of Independent Artists. He was a camouflage officer and then an official War Artist attached to the Royal Navy. Illustrated books by his mother Gertrude Bone *(Of the Western Islands)* and the poems of W. H. Davies. In the mid '30s prepared the 12th Shell Guide, *The West Coast of Scotland*; others were by John Betjeman, the Nash brothers and John Piper. Published *Albion: An Artist's Britain* in 1939 – a study of Britain in context, stressing The Weather and The Seasons, The Traveller and The Industrial Landscape; this revealed his benevolent attitude to modern devices – 'The car is freedom ...'

221 *Springtime in the Woods*
Oil on canvas
48⅛ × 48⅛ 122.2 × 122.2
Cheltenham Art Gallery and Museums

222

Alan Sorrell 1904–1974

Born in Tooting, and brought up in
Southend. His father was a master jeweller
and watchmaker. In 1919 went to the
Southend Municipal School of Art. After
work as a commercial designer in the City
went to the Royal College of Art in 1924. In
1928 won the Prix de Rome in painting;
spent two years in Rome, returning in 1931.
Taught drawing at the Royal College of
Art, and painted murals for the Southend
Municipal Library: *Refitting of Admiral
Blake's Fleet at Leigh* was completed in
1933 – worked on these murals until 1936.
In 1935 travelled to Iceland, and exhibited
drawings at Walker's Galleries in Bond
Street. In 1936 recorded the archaeological
excavations of the Roman forum in
Leicester and in 1937 these, and recon-
structions, were published in the *Illustrated
London News*. Dr Mortimer Wheeler asked
for similar reconstructions of Maiden Castle,
Dorset which he was then excavating, and
these too were published in the *Illustrated
London News*. During 1937–40 he drew
archaeological reconstructions for Sir Cyril
Fox and W. F. Nash-Williams of the
National Museum of Wales. Was a
Camouflage Officer during the War, and
then taught drawing at the Royal College of
Art until 1948. Afterwards worked largely
on archaeological reconstructions, in Britain
and abroad, for publishers and for the
Ministry of works.

222 *Llantwit Major*
Watercolour 1949
36 × 30 91.5 × 76.2
National Museum of Wales, Cardiff

223

225 *The Giant's Causeway*
Photograph–silver print 1946
13¼ × 11⅜ 33.5 × 28.8
Victoria and Albert Museum, London

Edward Burra 1905–1976

Son of a solicitor. Even as a child suffered
from anaemia and rheumatic fever. Went to
Chelsea School of Art from 1921–3, and to
the Royal College, 1923–4, before returning
to his father's house at Rye, where he lived
quite reclusively apart from trips abroad: to
France with Paul Nash in 1930, to Mexico
and New York in 1934, and to Spain in
1935 and during the Civil War. Exhibited
at the Leicester Galleries in 1929 and 1932,
and twice at the Redfern in 1942. Became a
member of Unit One in 1933. Included in
the International Surrealist Exhibition of
1936. Designed ballets: *Rio Grande*
(Ashton/Lambert), 1931, *Barabau* 1938 and
The Miracle in the Gorbals (Helpmann), 1944.
Favoured urban or theatrical scenes, but in
the late '20s and early '30s painted lush
tropical backgrounds which gave the look of
Rousseau scenery; his landscape style of the
late '30s was his own interpretation of neo-
romanticism with sinister and menacing
undertones.

226 *South West Wind*
COLOUR PLATE XVIII
Gouache on board *c*.1932
21⅝ × 29¾ 55 × 75.5
Portsmouth City Museum and Art Gallery

Robin Tanner b.1904

Began to etch at Goldsmiths' School of Art
in 1927 where he was instructed by Stanley
Anderson. Inspired by the example of the
Samuel Palmer exhibition at the Victoria
and Albert Museum in the autumn of 1926.
Inspired too by the technical excellence of
F. L. M. Griggs. Did a number of
distinguished etchings of Wiltshire subjects
up to 1930, when the print market began to
fade under the impact of the Depression. In
1939 he contributed a number of
distinguished illustrations to Heather
Tanner's *Wiltshire Village*, an account of
Kington Borel, an epitome of a village in
North West Wiltshire: 'To call back
yesterday would be foolish even were it
possible; but in order that what was noble
in yesterday that still lingers might not pass
unhonoured and unlamented this book has
been made ...' (from Heather Tanner's
introduction).

223 *Martin's Hovel*
Etching 1928
8¼ × 6¼ 21 × 16
University of London,
Goldsmiths' College Gallery

Bill Brandt b.1905

As a young man spent four years in a Swiss
sanatorium. In 1929 went to Paris to work
as a studio assistant for Man Ray, and spent
four years there. His principal photographic
books are *The English at Home* (1936), *A
Night in London* (1938), *Camera in London*
(1948) and *Literary Britain* (1951). During
the 1930s most of his work was reportage,
with surrealist undertones. In 1937, though,
he visited the North of England and
reported on grim conditions in Jarrow,
Sheffield, the Potteries, Halifax and
Newcastle. In 1941 produced documentary
pictures of architecture for the National
Buildings Record–comparable to John
Piper's contemporary views of England as a
land of romantic ruins. John Hayward,
author of *Literary Britain* wrote thus of
Brandt's sites: '... each hallowed in one way
or another ... each one a focus of
innumerable associations ... "where'er we
tread is haunted ground".'

224 *Maiden Castle*
Photograph–silver print 1945
12⅞ × 11⅜ 32.8 × 28.8
Victoria and Albert Museum, London

148

227

Rowland Hilder b.1905

Born at Great Neck, Long Island, U.S.A. In
1915 travelled to England on the *Lusitania*.
His family settled at New Cross, South
London. In 1921 entered Goldsmiths'
School of Art where he studied etching
under Alfred Bentley and Malcolm Osborne
and drawing under Edmund Sullivan.
Influenced by Muirhead Bone and Frank
Brangwyn, who was recommended to him
by Graham Sutherland. Was interested in
becoming a marine painter and in following
the example of W. L. Wyllie. In 1924 won a
Cadbury Bournville travelling scholarship
and visited the Low Countries. During 1924
worked two days a week in a printers' office.

In 1925 began to illustrate books for
Blackie's and Cape's. Also illustrated books
by John Masefield, whom he knew.
Illustrated Mary Webb's *Precious Bane* in
1929 and *Treasure Island* for the Oxford
University Press, and in the same year was
introduced to and began to work for Jack
Beddington at Shell Mex. Also designed
Christmas cards and drew for *The Sphere*. In
1935 moved to Blackheath; by now he was
becoming well-known for his drawings and
paintings of the Kentish landscape. In 1939
designed National Savings posters. In 1941
he was a Camouflage Officer and illustrated
the *Army Manual on Camouflage*. In 1945 he
painted pictures for Whitbread's
advertising. Set up the successful Heron

Press. In 1955 he worked with his wife
Edith and with Geoffrey Grigson on *The
Shell Guide to Flowers of the Countryside*. In
1958 painted the *Shell Guide to Kent*, the first
of the county guide pictures. In 1960 joined
the printing and publishing firm of Royle,
and increasingly devoted his time to
painting.

227 *The Garden of England*
Watercolour and pencil 1945–50
$19\frac{1}{2} \times 29\frac{1}{2}$ 49.5 × 74.9
Rowland Hilder

229

231

Tristram Hillier b.1905

Born in Peking. Studied at Downside and Christ's College, Cambridge, then at the Slade and Westminster School of Art, later in Paris under André Lhôte and at the Atelier Colarossi. Lived for a period at Cassis and painted with the decorative lyricism of the Bloomsbury painters, enjoying a romantic lifestyle, celebrated in his autobiography, *Leda and the Swan*. In 1932 was impelled by economic pressures to return to England and began to paint surrealist landscapes, seascapes and interiors. Developed an illusionistic style of uncanny accuracy which he has pursued ever since. In 1933 he became a member of Unit One after Frances Hodgkins dropped out. Between 1940–44 he served in the Royal Naval Volunteer Reserve. He settled in Somerset, painted abroad in Spain and Portugal and was elected a Royal Academician in 1967.

228 *Ecole Communale*
Oil on board 1932
$32\frac{1}{4} \times 31\frac{1}{8}$ 82×79
Kettering Borough Council

Rex John Whistler 1905–1944

A brilliant and prolific illustrator. Studied at the Slade and then in Rome. In 1927 his mural *The Pursuit of Rare Meats* was unveiled in the Tate Gallery restaurant. Decorated Plas Newydd for Sir Philip Sassoon, in 1936–38. Designed costumes and scenery for the theatre, e.g. *The Tempest* at Stratford-on-Avon, 1934. Illustrated, or decorated, many books, including Walter de la Mare's *Desert Islands*, 1930, Faber and Faber. Country scenes appear in Beverley Nichols' enormously popular reports on country life: *Down the Garden Path* (1932), *A Thatched Roof* (1933) and *A Village in a Valley* (1934), all published by Jonathan Cape. Also designed posters for the London Passenger Transport Board as well as Shell. *The Vale of Aylesbury* was published as a poster by Shell. His style was fantastic and witty, in the best manner of the Rococo. Killed in action, serving with the Welsh Guards in the Normandy landings.

229 *The Vale of Aylesbury*
Oil on canvas 1933
$39 \times 21\frac{1}{2}$ 99×54.6
Shell UK, Ltd.

Stanley Roy Badmin b.1906

Born in London and studied at Camberwell School of Art and at the Royal College of Art under Schwabe, Millard and Tristram; received his diploma in 1928. A watercolourist, lithographer and engraver, with a special interest in the English countryside, and in portraying English village life and architecture. In the early 1930s his work was reproduced in *Fine Prints of the Year*, and included such subjects as *Potato Clamps* and *Priory Pond, Stroud*. He lived in London and showed at the Twenty-One Gallery. In 1939 he illustrated *Highways and Byways in Essex* with F. L. M. Griggs for MacMillan and Co; Griggs, who had illustrated most of the books in that distinguished series, concentrated mainly on landscape, and Badmin mainly on building. In the 1940s he illustrated such Puffin Picture Books as *Village and Town* and *Trees in Britain*. Illustrated the *Shell Guide to Trees and Shrubs* as well as completing county paintings for that company. Became an associate of the Royal Watercolour Society in 1932 and a full member in 1939. Lives in Sussex.

230 *Shropshire*
Painting commissioned as artwork for Shell advertising
Gouache 13×17 33×43.1
Shell UK, Ltd.

Evelyn Dunbar 1906–1960

Born at Reading; studied at Rochester and Chelsea Schools of Art and the Royal College of Art from 1929–33. Executed murals at Brockley County School, Kent, 1933–36, and at the Training College, Bletchley, Buckinghamshire, 1958–60. Illustrated *Gardener's Choice* with Cyril Mahoney in 1937. Official War Artist in 1940; married Flying Officer Roger Folley in 1942. Exhibited with the New English Art Club and acted as a visiting teacher at the Ruskin School, Oxford, from 1950. Moved to Kent in 1952 and started to paint mostly portraits. Of *Winter Garden*, the artist wrote: 'Begun before I came to London as a student, and finished later, about 1937. It was painted in the garden of my parents' home at Strood, Rochester, Kent.' (Quoted in the Tate Gallery catalogue, *Modern British Paintings, Drawings and Sculpture*, Vol. I, 1964, p. 159.)

231 *Winter Garden*
Oil on canvas *c*.1929–37
12×26 30.5×66
The Trustees of the Tate Gallery, London

Clifford and Rosemary Ellis C.E. b.1907, R.E. b.1910; married 1931

They collaborated during the 1930s as designers. They produced over 20 posters and bills for the London Passenger Transport Board – posters for Shell-Mex including *Whipsnade Zoo* in 1932 and *Antiquaries Prefer Shell* which initiated the *Professions* series in 1934; for the Empire Marketing Board they designed two sets of five bills in 1931 and 1932; for the G.P.O., two bills in 1935. They worked on a number of mosaics and mural paintings which were shown at the Royal Academy exhibition of British Art in Industry in 1935; the entrance to the British Pavilion in the Paris International Exhibition of 1937; the entrance to the *Britain Can Make It* exhibition at the Victoria & Albert Museum in 1946. In 1945 Collins began the publication of the New Naturalist series with, for some years, related monographs, and by 1982 Clifford and Rosemary Ellis had designed nearly 100 jackets for these titles. For some time it had seemed to Clifford Ellis that Freudian-released

interests in primitive art and child art might for a time bring together the paths of artists and those of teachers of children. During a few years of optimism at the end of the war there were opportunities for experiment, and in 1946 Bath Academy of Art, for the education of art teachers, was started at Corsham Court. It occupied Clifford and Rosemary Ellis for the next twenty years.

232 *Pier with Seagulls*
Watercolour 1946
$25\frac{3}{4} \times 30\frac{3}{8}$ 64.1 × 77.2
William Scott

233 *Antiquaries Prefer Shell*
Original art work for the poster commissioned and published by Shell UK, Ltd.
Gouache on paper 1934
$22\frac{5}{16} \times 38\frac{3}{16}$ 56.6 × 97
Clifford and Rosemary Ellis

234 *Trees, Woods and Man*
Original art work for H. L. Edlin's Trees, Woods and Man, 1954, commissioned and published by Collins in 1956
Gouache on paper 1954
$9\frac{3}{8} \times 7\frac{7}{8}$ 23.8 × 20
Clifford and Rosemary Ellis

234

235

James McIntosh Patrick b.1907

Both his father and elder brother were well-known Dundee architects. He himself has lived in Dundee all his life except during 1924–28 when he studied at Glasgow School of Art and during 1939–45 when he undertook war service in North Africa and Italy. Has enjoyed a life-long fascination with the Angus countryside which he paints out of doors in all weather, in freezing conditions using a stove to keep his paints malleable. Won immediate acclaim in the 1930's with his detailed, almost Pre-Raphaelite descriptions of landscape in which telegraph poles and other manifestations of the twentieth century are usually absent. Asserts his right to select and reject. 'But it is not really that I paint what I see. Rather it is that I see what I paint.' In 1949 elected associate of the Royal Scottish Academy, and also a member of the Royal Institute of Oil Painters.

235 *Autumn, Kinnordy*
COVER (detail)
Oil on canvas 1936
$30\frac{1}{4} \times 40\frac{1}{4}$ 76.8×102.2
Dundee Museums and Art Galleries

Claude Rogers 1907–1979

Went to St Paul's School and then to the Slade, 1925–28. In 1927 he visited Paris, and in 1937 was a founder-member of the Euston Road Group at 316 Euston Road. His colleagues were William Coldstream and Victor Pasmore. In 1937 he painted at Aldeburgh and in 1939 at Mont Ste. Victoire. His early paintings are quite tightly organized, in the Cézanne tradition. More romantic subjects appear in the mid-'40s: *Snowfall* (1945), *The Harvest Moon* (1946), *Clover Fields* (1947) and *Burning Stubble Fields* in the 1950s. Taught at Camberwell School of Art and at the Slade.

236 *Figures on Aldeburgh Beach*
Oil on canvas 1937
$16\frac{1}{4} \times 24$ 41.3×61
Ipswich Museums and Galleries

236

Victor Pasmore b.1908

Born in Chelsham, Surrey. Due to death of his father went straight into employment on leaving school, as clerk in the head office of the London County Council. Painted in his spare time and studied the Impressionists, Cotman and Turner, among others, in the national collections. In 1932 was elected to the London Artists' Association and in 1934 to the London Group. Experimentation with Fauvism gave way to the quiet realism of the Euston Road School which he helped found in 1937, having been freed to paint full time by financial assistance from Kenneth Clark. In 1942 moved with his wife to Chiswick Mall where he painted river scenes partly indebted to Turner and Whistler. His post-war garden and park scenes are less romantic and reveal an austere search for an underlying geometry. In 1948, the year after he painted *The Park*, turned to pure abstraction. Became a major figure in the 1950s as the leader of English Constructivism. Regarded his reliefs as the logical development of his attempt to create an art no longer dependent on nature. Occupied various teaching posts, at Camberwell School of Art, the Central School of Art and King's College, Durham University where he taught a Basic Form course with the help of Richard Hamilton. In 1966 bought a house and studio in Malta. During the 'sixties returned to painting, still in an abstract style but using forms that evoke associations with nature.

237 *The Park*
Oil on canvas 1947
43 × 31 109.3 × 78.7
Adrian Heath (on loan to Sheffield City Art Galleries)

237

238

Carel Weight b.1908

Studied at Hammersmith School of Art and at Goldsmiths' College. First showed at the Royal Academy in 1931 and has stayed loyal to that institution. Was made a War Artist during the 1939–45 war and afterwards joined the painting staff at the Royal College, first under Gilbert Spencer, then Rodrigo Moynihan. Became Head of Painting in 1957 and resigned from this position in 1973. Influenced by Edward Munch and Stanley Spencer, Weight often paints literary or religious subjects, having learnt from Spencer how to deploy narrative across the entire canvas. However, his pictures, if the product of memory or imagination, are grounded in fact and usually set in South London, among terraced streets, ouside railway stations, in parks or back gardens. The suburban landscape is used as a setting for some human or spiritual drama. Even when his figures merely walk along the street, Weight leaves the impression that this is a world on edge. He has written of *The Moment*: 'You pass the spot each day. You know and love every brick and tree. Suddenly, in a moment, everything is changed and the friendly things around can't help you.') 'Carel Weight, ARA', *The Artist's Portfolios: Contemporary Academicians*, No. I, 1958.)

238 *The Moment*
Oil on hardboard 1955
24 × 72 61 × 183
Castle Museum, Nottingham

Graham Bell 1910–1943

Born in the Transvaal, and worked in a bank and on a farm before studying at Durban School of Art. In 1931 came to England. In 1934 exhibited with the Objective Abstractionists at the Zwemmer Gallery, London. 1934–7, wrote art criticism for the *New Statesman*, and in 1939 the Hogarth Press published his pamphlet *The Artist and His Public*. In 1937, associated with the Euston Road School and then with Mass Observation. He was a documentary painter interested in plain views of contemporary subjects. Enlisted with the R.A.F. and killed on a training flight.

239 *Four Courts, Dublin*
Oil on canvas
16 × 20 40.6 × 50.8
Private Collection

Brian Cook b.1910

Born Gerrards Cross, Buckinghamshire. Studied painting at Repton under Arthur Morris and in 1928 at the Central School of Arts and Crafts under John Farleigh and Noel Rooke. Employed by the family firm of Batsford, publishers, from 1928. Throughout the 1930s contributed pen and ink illustrations to their *English Heritage Series*, and designed over 200 book jackets, principally for Batsford but also for other British and American publishers. Specialised in the use of the *Jean Berté* printing process using hand-cut rubber plates and watercolour inks. The brilliance of colour achieved became widely familiar as the trademark of the Batsford *Books on Britain*. Cook was elected a Member of the Society of Graphic Art in 1933; he received a Diploma at the Paris Exhibition in 1935, and was elected a Member of the Society of Industrial Artists in 1936. He became a fellow of the Society of Industrial Artists in 1970. He designed posters for the London and North Eastern Railway, Thomas Cook (no relation) and the British Tourist Board. His work in publishing was not confined to book jackets but included the complete lay-out of both text and illustrations. In this way he collaborated with Oliver Messel, and with Cecil Beaton in the production of all his earlier books. After the war he assumed his mother's maiden name and since then, as Brian Batsford, in the few interludes of a Parliamentary career, has served as Chairman of The Royal Society of Arts, on the Post Office Stamp Advisory Committee, and held one-man shows of his paintings in London and Cornwall.

240 *Bookcover design for 'The Landscape of England'*
Gouache on board 1933
9⅞ × 14¾ 25 × 37.5
Sir Brian Batsford

241 *Chiltern Country*
Gouache on board 1939
8½ × 12¾ 21.5 × 32.5
Sir Brian Batsford

Edward Brian Seago 1910–1974

Born in Norwich, he was trained by the naturalist painter Bertram Priestman. By 1929 he was exhibiting and selling equestrian paintings in Bond Street, and had been impressed by a Munnings show in Norwich. Munnings advised him: 'Begin to be a serious student, and let all the business of *young* Seago and young genius go, and during the years to come you'll probably make a hit'. During 1930–33, travelled around Britain and the Continent with circuses, and published *Circus Company* in 1933, with an introduction by John Masefield, with whom he often worked. His *Sons of Sawdust* appeared in 1934, and *Caravan* in 1937. In a memoir of 1947, *A Canvas to Cover*, he wrote of his 'elation of returning to the cool greens and greys of East Anglia' after the bright colours of Brittany, Cornwall and Northern Italy. Mainly a landscape painter, with a special interest in East Anglia. Instructed that one third of his surviving work should be destroyed on his death.

242 *Evening Haze, Thurne Dyke*
Oil on canvas board pre-1952
$8\frac{1}{2} \times 10\frac{1}{2}$ 21.6 × 26.7
Norfolk Museums Services,
Castle Museum, Norwich

242

243

Josef Herman b.1911

Born in Warsaw, the son of a Jewish shoemaker. Originally trained as a typesetter but in 1930 entered the Warsaw School of Art and Decoration. In 1935 helped found a group of Polish artists called 'The Phrygian Cap' who drew their subjects from the workers, and in the summer went on expeditions to the Carpathian mountains. In 1938 Herman left Poland for Brussels (where he met Constant Permeke), and then France. Finally arrived in Britain, settling in 1940 in Glasgow for the next three years, enjoying the friendship of his compatriot Jankel Adler and befriending the young Joan Eardley. Spent a year in London, where he shared an exhibition with L. S. Lowry, and in 1944 moved to the mining village of Ystradgynlais in South Wales where he set up a studio in the Pen-y-Bont inn, later converting a small nearby factory. Lived in Wales for eleven years, afterwards moving to Hampstead, then Suffolk and in 1972 returning to London. Claimed particular affinity with autumn and twilight. In Wales he favoured that time of day when the glowing sky reddened the walls of the cottages and the outlines of the stark trees. Was also struck by his first sight of the miners walking home, their figures creating black silhouettes against the sun: 'This image of the miners on the bridge against that glowing sky mystified me for years with its mixture of sadness and grandeur, and it became the source of my work for years to come.' (Josef Herman, *Related Twilights: Notes from an Artist's Diary – Places and Artists*, 1975, p. 91.)

243 *Autumn*
Watercolour 1946
19¾ × 24¾ 50.2 × 62.8
The Roland Collection

Roger Hilton 1911–1975

Born in Northwood, Middlesex. From 1929–31 studied at the Slade, and afterwards at the Académie Ranson in Paris under Roger Bissière. In 1936 he had a show at the Bloomsbury Gallery, London, and was represented in Agnew's Coronation exhibition of 1937, chosen by Duncan Grant and Vanessa Bell. Joined the army, and was captured at Dieppe in 1942.

244

Taught for a while on his release, and emerged in the 1950s as a leading abstract painter: 'I have moved away from the sort of so-called non-figurative painting where lines and colours are flying about in an illusory space; from pictures which still had depth, or from pictures which had space in them; from spatial pictures in short, to space-creating pictures. The effect is to be felt outside rather than inside the picture; the picture is to be not primarily an image, but a space-creating mechanism' – he wrote in 1954. In 1957, worked in Cornwall.

244 *November 1964*
Oil on canvas 1964
30 × 36¼ 76 × 92
Aberdeen Art Gallery and Museums

Edwin Smith 1912–1971

Trained as an architect, but worked mainly as a photographer of landscape and architecture. In 1952 produced *English Parish Churches* with Graham Hutton, and in 1954, *English Cottages and Farmhouses* with Olive Cook (to whom he was married). Further publications were *Scotland* in 1955 with G. S. Fraser, *England* in 1957 with Geoffrey Grigson, *The English Garden* in 1964 with Edward Hyams, *The English House through seven centuries* in 1968 with Olive Cook, and *England* in 1971 with Angus Wilson and Olive Cook. With Bill Brandt, Smith was the leading recorder of British landscape in the 1950s and 1960s.

245 *Uffington Berkshire*
Photograph 1950
8 × 10 20.3 × 25.4
Mrs Olive Smith

246 *Arbor Low*
Photograph 1953
10 × 8 25.4 × 20.3
Mrs Olive Smith

Keith Vaughan 1912-1977

Born at Selsey Bill, in Sussex. His father had
been a civil engineer on the Gold Coast.
Moved to North London, but attended
school near Horsham, and was affected by
the landscape of that area with its ochres
and off-whites. In 1931 joined the
advertising agency of Unilever, where Felix
Kelly was a colleague. At this time read
Clive Bell and Roger Fry, looked at
Cézanne, Ben Nicholson, Matisse and
Picasso, listened to music and attended the
opera. In 1939 did studies of figures by the
sea, based on photographs; spent that year
painting in the country at Shere, in Surrey.
Spent the war in the Pioneer Corps, road
building on Salisbury Plain and in the Wye
Valley. His paintings were bought by the
War Artists Advisory Committee. Met
Sutherland, MacBryde, Colquhoun,
Prunella Clough and John Craxton. John
Minton introduced him to the Lefevre
Gallery. In 1948 visited Suffolk, and
continued to do so in the 1950s. In 1949
went to Brittany and in 1950, Italy.

247 *September*
Oil on canvas 1956
$46 \times 59\frac{7}{8}$ 117×152
Arts Council of Great Britain

Robert Colquhoun 1914-1962

Grew up at Kilmarnock in Ayrshire.
Attended Glasgow School of Art where he
met Robert MacBryde from whom he
became inseparable. On a travel bursary,
left Glasgow in 1938 for a prolonged tour of
France and Italy, returning to Ayrshire on
the outbreak of war where he painted
mainly landscapes. Admired the incise,
stylized draughtsmanship of Wyndham
Lewis, the work of the French Post-
Impressionists, Picasso and Braque. In 1940
was called up and served in the Royal Army
Medical Corps until February 1941 when
he collapsed and was discharged. With
MacBryde, moved to London where they
shared a studio with John Minton.
Colquhoun joined the Civil Defence,
driving by day and painting at night.
Under the influence of the Polish artist
Jankel Adler, whom he had first met in

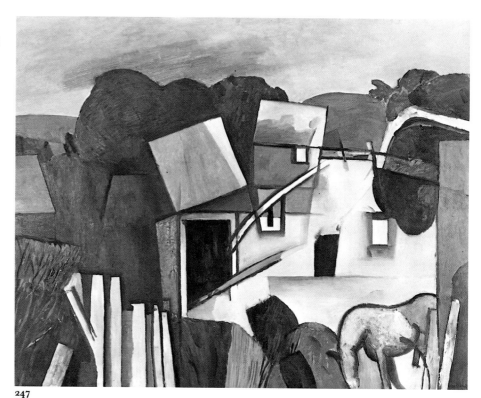

247

248

Glasgow in 1940, he developed a schematized figurative style, employing sinewy design and rich but sombre colour harmonies. Like MacBryde, was deeply impressed by the 1945 Picasso exhibition shown at the Victoria and Albert Museum. During the 1950s his health, life and art gradually deteriorated; suffered financial hardship, engaged in fighting bouts with MacBryde and excessive drinking; haunted Soho pubs and clubs. A Colquhoun Memorial Art Gallery opened in Kilmarnock in 1972.

248 *The Lock Gate*
Oil on canvas 1942
$15\frac{3}{8} \times 23$ 39×58.4
Glasgow Art Gallery and Museum

Terry Frost b.1915

Born in Leamington Spa, Warwickshire. From 1930–39 he worked in a cycle repair shop, a radio factory, an aircraft factory and in an electrical components firm. Joined the Territorial Army, and from 1939 was in the Commandos, in France, Palestine, and then in Crete where he was captured. Imprisoned in Salonika, Poland and Hohenfels, Bavaria; met Adrian Heath, and began to paint in these years. After the war attended evening classes at Birmingham College of Art. Spent 1946–7 in Cornwall, on Adrian Heath's recommendation, at the St Ives School of Painting, Back Road West, where he met Peter Lanyon, Harry Rowntree and others. In 1947 entered Camberwell School of Arts and Crafts at the second attempt; met Anthony Fry and corresponded with Ben Nicholson. In 1951 met Roger Hilton. From 1952–4 taught at Bath Academy of Art, the school run by Clifford Ellis. In 1954 was made a Gregory Fellow in Leeds, where he continued to teach for some time. Lived in London and in St Ives.

249 *Movement: Green, Black and White*
Oil on canvas 1951–2
44×34 111.8×86.3
Scottish National Gallery of Modern Art, Edinburgh

249

Bryan Wynter 1915-1975

Born in London. From 1938–40 studied at the Slade School. From 1947–56 taught at the Bath Academy of Art. Lived at Zennor in Cornwall. 'The landscape I live among is bare of houses, trees, people; is dominated by winds, by swift changes of weather, by the moods of the sea; sometimes it is devastated and blackened by fire. These elemental forces enter the paintings and lend their qualities without becoming motifs'–he wrote in 1962. Associated at St Ives with Peter Lanyon, Patrick Heron and Trevor Bell: all these painters have been interested in fusing gestural abstraction with experience of place.

250 *Landscape with Mines*
Gouache 1946
$8\frac{3}{4} \times 11\frac{3}{4}$ 22.2 × 29.8
Victoria and Albert Museum, London

John Elwyn b.1916

Born in Cardiganshire, and studied at the Carmarthen School of Art, Bristol College of Art and at the Royal College of Art, where he was taught by Carel Weight at the beginning of his career as a teacher. A landscape painter throughout, concentrating on the West Coast of Wales, Cardiganshire in particular, although with some commissioned painting of Hampshire subjects. Has illustrated the poems of Dylan Thomas. In the mid 1950s was commissioned by Kenneth Rowntree, then art director for Shell, to work on several county paintings, of which the *Glamorgan* picture is one; it was subsequently used in a number of different formats. Taught at the Winchester College of Art and in Portsmouth. His works are held by a large number of public collections and he has been commissioned by the G.P.O., Glaxo Laboratories, the Midland Bank as well as by Shell. Awarded the National Eisteddfod Gold Medal in 1956.

251 *Glamorgan*
Painting commissioned as artwork for Shell advertising
Gouache $12\frac{1}{2} \times 17$ 31.7 × 43.1
Shell UK, Ltd

253

John Minton 1917-1957

Trained at the St John's Wood Art Schools
1935-8 under P. F. Millard. Initially
influenced by de Chirico. In 1938-9 spent
eight months in Paris and at Les Baux in
Provence with Michael Ayrton and Michael
Middleton. Became interested in the work
of the French neo-romantics and adopted
certain of their emotive devices. In 1940
registered as a conscientious objector but
later withdrew from this position and
entered the Pioneer Corps in the autumn of
1941. Was released from the army in 1943
and for the next three years shared a studio
with Robert Colquhoun and Robert
MacBryde, adopting their sonorous if
slightly acidic palette. Taught, first at
Camberwell, then at the Central School of
Art and finally the Royal College of Art.
Executed designs for the theatre and for
book illustration. Also travelled widely, in
1947 visiting Corsica with Alan Ross,
illustrating Ross's account of this trip, *Time
was Away*. His drawing style, inspired by
Palmer and Sutherland, took neo-
romanticism to a nervous pitch that can be
associated with war-time anxiety. He also
spent much time wandering through
London's docks, apprehending certain
aspects of the urban romantic. Suffered a
drink problem and died by his own hand at
the age of forty.

252 *Rocks by the Coast*
Oil on canvas 1945
13 × 20 33 × 50.8
Harrogate Art Gallery,
Harrogate Borough Council

253 *A Kent Garden*
Pencil and watercolour 1948
15 × 11⅛ 38.2 × 28.4
Sheffield City Art Galleries

254

Sir Lawrence Gowing b.1918

Born in Stamford Hill. Began to paint as a
boy at school, after encouragement from
Maurice Feild. At the age of eighteen,
became a pupil of William Coldstream at
the Euston Road School. In 1942, held his
first one-man exhibition at the Leicester
Galleries, London. From 1948-52 was
Professor of Fine Art at Kings College,
Newcastle upon Tyne, and Principal of the
Chelsea School of Art, 1958-65. From
1965-67 he was Keeper of British Painting
at the Tate Gallery, and from 1967-75,
Professor of Fine Art at Leeds University.
Since 1975 he has been Slade Professor of
Fine Art at University College, London. He
was made an associate of the Royal
Academy in 1978, and was awarded the
C.B.E. in 1952, a D.Litt from Heriot Watt
University in 1980 and a knighthood in
1982. He has published a wide range of
books on artists, beginning with *Vermeer* in

1952, *Cézanne* in 1954, *Turner* in 1966,
Hogarth in 1971, *Matisse* in 1979, and most
recently, *Lucian Freud* in 1982.

254 *Briar and Hawthorn at
Savernake*
Oil on canvas 1952
20⅛ × 26 51.1 × 66
Laing Art Gallery, Newcastle upon Tyne

257

Kyffin Williams b.1918

Born in Llangefni, Anglesey. Worked as a land agent in Pwllheli between 1936 and 1939, gaining a detailed knowledge of the topography. Was advised to paint in order to help cure poor health, which had obliged him to leave the army. Attended the Slade School of Art 1941–44 and afterwards became an art master at Highgate School where a fellow-teacher was Allan Gwynne-Jones. Though some of his earliest oils were of views of North London, he remained conscious of his roots in North Wales and always made this his proper subject. Held his first one-artist show at Colnaghi's, London, in 1948, titled 'Welsh Landscape Paintings'. Though John Piper had worked there in 1946 and 1947, he was the first native artist to paint Snowdonia. He recorded not only the landscape but also the local farmers and landowners in whose houses his paintings hang. Often used a wide canvas for panoramic effect and made popular views of isolated Caernarvonshire mountainside cottages. Uses thick paint, close tones and a palette knife technique.

258 *Snowdon*
Oil on canvas
10¾ × 30¼ 27.3 × 76.8
Glynn Vivian Art Gallery and Museum, Swansea

Peter Lanyon 1918–1964

Born at St Ives, and took lessons from the painter Borlase Smart before attending Penzance Art School in 1936. In 1937, he was discovered by Adrian Stokes and advised to go to the Euston Road School, which he did for four months. In 1938 spent the summer in Aix-en-Provence, at a time when he was very interested in Cézanne: 'When I began to paint, the cliff edge and winter storms put more pressure on me than I could absorb. My pictures became so wild, messy and dispersed that I was driven indoors and I settled for experiments in the technical probems of painting.' In 1939 Adrian Stokes introduced him to Ben Nicholson and Naum Gabo, and under Nicholson's instruction worked on relief constructions. From 1940–45 served in the R.A.F. in North Africa, Palestine and Italy as an aero-engine specialist. In 1945 he returned to Cornwall. From the early '50s onward taught at the Bath Academy of Art (Corsham Court) and began to travel widely in Europe and in the U.S.A. 1957–60 he established an art school at St Peter's Loft in St Ives, with Terry Frost and W. Redgrave. Referred often to 'immersion in landscape'. Killed in a gliding accident.

255 *The Yellow Runner*
Oil on board 1946
18½ × 24 47 × 61
Guy Howard

256 *Prelude*
Oil on canvas 1947
24 × 38 61 × 96.5
Andrew Lanyon

257 *Ground Sea*
Gouache on paper 1961
22 × 30½ 56 × 77.5
Towner Art Gallery, Eastbourne

Prunella Clough b.1919

Born in London. From 1938–9 studied at Chelsea School of Art, where she returned to teach in the 1950s. In 1940–45 worked at various clerical and draughtsman's jobs. In 1946–9 lived in London and visited East Anglia, where she painted fishing scenes at Lowestoft; thereafter painted mainly in London, and mainly scenes from working and industrial life. In 1961 Michael Middleton, introducing an Arts Council exhibition of her paintings, described her thus: 'She is an urban painter of the mid-century. The signs and winking lights of the by-pass, the dark debris of the industrial wasteland, the structures of mysterious purpose that provoke no twist of the head from the uncurious: these are the sort of things that she turns to her own purposes.' Her comment in 1961, 'I like paintings that say a small thing rather edgily'.

259 *Fishermen in a Boat*
Oil on canvas 1949
55 × 30 139.7 × 76.2
The Roland Collection

260

Michael Ayrton 1921–1975

Long periods of illness broke into his formal schooling. Travelled extensively studying art and briefly attended various art schools, including Heatherley's School of Art. In the autumn of 1938 settled in Paris with John Minton where both studied under Eugéne Berman, Ayrton also occasionally working in de Chirico's studio. With Michael Middleton, Ayrton and Minton travelled to Les Baux where they spent the summer. Returned to London soon after war was declared and entered the R.A.F. Was invalided out in 1942 and obtained a post teaching life drawing and theatre design at Camberwell. During the mid 1940s executed a series of landscapes in a neo-romantic vein. Spent the summers of 1945–46 in Pembrokeshire where he was in contact with Graham Sutherland. Ayrton's fascination with tangled roots and gnarled tree trunks semi-transmogrified into human forms owed something to Paul Nash and his *Monster Field*. Had a diverse career as art critic, art historian, novelist, broadcaster, theatrical designer and film director, as well as painter, sculptor and etcher.

260 *Winter Stream*
Oil on canvas 1945
$22\frac{1}{2} \times 32\frac{3}{4}$ 57.2 × 83.2
Aberdeen Art Gallery and Museums

Joan Eardley 1921–1963

Born in Sussex, into a middle-class family. After her father's death, her family moved to Scotland where she attended the Glasgow School of Art, also studying under James Cowie at the Patrick Allan-Fraser Summer School of Fine Art. Won a travelling scholarship and spent a year in Italy and France, returning home laden with canvases and rolls of drawings, many of them Van Gogh-like studies of peasants. Settled permanently in Scotland and was drawn towards the Glasgow slums where she lived, producing many pictures of children. In 1956 acquired a house and studio in the fishing hamlet Catterline, on the north-east coast and would return there whenever the weather reports predicted a storm. Her almost abstract seascapes established her reputation. Though she also painted nearby meadows in the summer at Catterline, her tumultuous seas under leaden skies are thought to be more characteristic.

261 *Breaking Wave*
COLOUR PLATE VIII
Oil on canvas
48 × 55 122 × 139.5
Kirkcaldy Museums and Art Gallery

Alan Lowndes 1921–1979

Born in Stockport, Cheshire, fifth child of a railway clerk. Left school at fourteen, and apprenticed as a decorator. Went to night classes at Stockport Technical School: 'We learned chiefly lettering, graining, and heraldry ... but quite a bit more about paint, pigments and so on.' From 1939–45 was a private in the Cheshire Regiment and then in a map-making unit as a draughtsman; during this period saw paintings in Italy. In 1945 resumed work as a decorator, then became a textile designer, and attended evening life classes at Stockport School of Art. Turned to painting full-time in the early 1950s: 'The army and the war had taught me that it's better to try to do what you want in life, because so far as I could see, you don't get another chance'. In 1950, began to exhibit at the Calman Gallery in Manchester. Painted in St Ives in the 1950s and eventually settled in Gloucestershire, but the majority of his pictures refer back to Stockport street life.

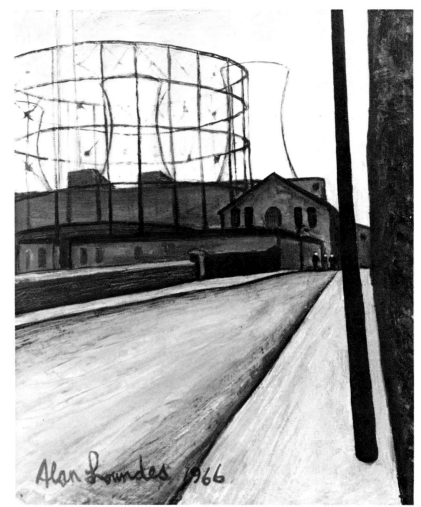

263

His work has been astutely discussed by John Willett and Keith Waterhouse. Willett concludes that he is 'a painter of the environment, above all in its essential impact on people'.

262 *Stockport*
Oil on canvas 1953
36 × 24 76.2 × 63.5
Arts Council of Great Britain

263 *Hazy Morning, Huddersfield*
Oil on canvas 1966
24 × 20 61 × 50.8
Huddersfield Art Gallery

264

Edward Middleditch b.1923

Born at Chelmsford in Essex, and brought
up in Nottinghamshire. Studied at the
Regent Street Polytechnic and at the Royal
College of Art. Exhibited at the Beaux Arts
Gallery through the 1950s. In 1958 Douglas
Cooper introduced him as a looker at a
nature which is 'miraculous and mysterious
in itself, so imbued with lyrical and
dramatic effects, that he has no need to
impose upon it a poetical or emotional
interpretation of his own'.

264 *Sheffield Weir*
Oil on hardboard 1950
$48\frac{1}{8} \times 59\frac{7}{8}$ 122.2 × 152
City of Manchester Art Galleries

Alan Reynolds b.1926

Born in Newmarket, Suffolk; his father was a stableman in racing stables. Left school at fourteen and became a fitter in the REME. In Germany at the end of the war he took teachers' training courses and became an education sergeant. Painted in the afternoons. Spent his leaves in the Harz Mountains and saw paintings by the Blue Rider Group and by Klee. From 1948–52 was a full-time student at Woolwich Polytechnic; taught by Heber Matthews, Victor Tempest and Paul Bullard. In 1952 began to exhibit at the Redfern Gallery. Gradually turned towards abstraction and construction: 'I admire Gainsborough for his quiet excellence and his natural spontaneity. I love the little sketches of Constable; there is more definition in them than in Turner, but it is not a constructive art and less in keeping with our time than Nash and Sutherland. . . . The English watercolourists in general are too extrovert, too much dependent on outside, too topographical. It is an English way but does not therefore become a national art,' he wrote in 1962. (Quote from J. P. Hodin's book on Reynolds in the Redfern Artists Series, 1964.)

265 *Summer: Young September's Cornfield*
Oil on board 1954
40½ × 61 102.9 × 155
The Trustees of the Tate Gallery, London

265

Ken Bennetts b.1933

Born in New Zealand. Worked his passage to Britain in 1957. Took a variety of jobs in order to be able to continue painting part-time. Held his first one-man exhibition at Walkers Gallery in Bond Street in 1959, which he followed with a second exhibition at the same gallery the following year.

266 *Londonderry*
Oil on canvas 1962
43 × 33 109.2 × 83.8
Shell UK, Ltd

Bibliographic Note

by Frances Spalding

Most books written on this period deal with movements and the work of individual artists rather than landscape painting in itself. Two exceptions are Michael Rosenthal's *British Landscape Painting* (Phaidon, 1982) and Allen Staley's *The Pre-Raphaelite Landscape* (Clarendon Press, 1973) which contain detailed information on a wide range of Pre-Raphaelite-inspired landscapes. A chapter on this subject can also be found in Christopher Wood's *The Pre-Raphaelites* (Weidenfeld and Nicolson, 1981). Articles of particular interest that I have found useful include Rosemary Treble's 'The Victorian Picture of the Country' in G. E. Mingay's *The Victorian Countryside* (Routledge and Kegan Paul, 1981); Anna Greutzner's 'Great Britain and Ireland' in *Post-Impressionism* (Royal Academy of Arts, 1979–80); Howard D. Rodee's 'The "Dreary Landscape" as a Background for Scenes of Rural Poverty in Victorian Paintings', *College of Art Journal*, Vol. xxxvi, No. 4, Summer 1977, pp. 307–13; Marcia Poynton's 'The Representation of Time in Painting: A Study of William Dyce's "Pegwell Bay: A Recollection of October 5th, 1858"', *Art History*, Vol. i, No. 2, March 1978, pp. 99–103; Kenneth McConkey's 'The Bouguereau of the Naturalists: Bastien-Lepage and British Art', *Art History*, Vol. i, No. 3, September 1978, pp. 372–82.

Among the general books on this period those that are an invaluable source of reference are Martin Hardie's *Water-colour Painting in Britain III. The Victorian Period* (B. T. Batsford, 1968); David and Francina Irwin's *Scottish Painters. At Home and Abroad 1700–1900* (Faber and Faber, 1975); William Hardie's *Scottish Painting 1837–1939* (Studio Vista, 1976); Anne Crookshank's and The Knight of Glin's *The Painters of Ireland c.1660–1920* (Barrie and Jenkins, 1978); Richard Shone's *A Century of Change. British Painting since 1900* (Phaidon, 1977); Dennis Farr's *English Art 1870–1940* (Oxford University Press, 1979); Charles Harrison's *English Art and Modernism 1900–1939* (Allen Lane, 1981).

Important information about landscape painting can also be found in T. J. Honeyman's *Three Scottish Colourists* (Thomas Nelson and Sons, 1950) and Wendy Baron's *The Camden Town Group* (Scolar Press, 1979), as well as in certain key monographs, such as Alfred T. Story on John Linnell (1892), Marcia Poynton on William Dyce (1979), Sir James L. Caw on William McTaggart (1917), Paul H. Walton on Ruskin's drawings (1972), Hilary Taylor on Whistler (1978), Stanley Cursiter on S. J. Peploe (1947), Bruce Laughton on Wilson Steer (1971), Lillian Browse on William Nicholson (1956), Herbert Read on Ben Nicholson (1948), Andrew Causey on Paul Nash (1980) and on Peter Lanyon (1971), Douglas Cooper (1961) and John Hayes (1980) on Graham Sutherland, Alan Bowness on Ivon Hitchens (1973). A number of artists' autobiographies were written during this period of which the most outstanding is Paul Nash's *Outline: An Autobiography and Other Writings* (Faber and Faber, 1949). The above list merely offers a guide to further reading and is not intended to be exhaustive.

Artists Index in Alphabetical Order

Bold numbers refer to catalogue numbers

Acknowledgements

The selectors would like to thank the following for their valuable assistance in the preparation of this exhibition:

Patricia Andrew
Gaynor Andrews
Annette Armstrong
Sir Brian Batsford
Dr Mary Beal
Mark Haworth Booth
John Boyden
David Brown
Les Buckingham
Bob Castle
Michael Clarke
Andrew Cumming
Elizabeth Cummings
Patrick Connor
Clifford and Rosemary Ellis
Lindsay Errington
Kate Eustace
The Fine Art Society, London
Christopher Gibb
Catherine di Giulio
Ian Guthrie
Rosalinda Hardiman
Nigel Herring
Rowland Hilder
Lilian Hogg
James Holloway
Martin Hopkinson
Richard Jefferies
David Fraser Jenkins
Pamela Johnson
Sean Kelly
Andrea Kerr
John Kirby
Charles Knight
Jill Knight
Sheila Lanyon
Paul Lawson
John Lowerson
Jeremy Maas
Margaret Mackay
Sandra Martin
David Mellor
Rosemary Miles
Corinne Miller
Richard Morphet
Guy Morrison

Joanna Mundy
Christopher Newall
Elizabeth Ogborn
Andrew McIntosh Patrick
John Pemble
David Phillips
Marjorie Pringle
Pamela Reekie
Stephen Sartin
Ted Shepherd
Sheena Smith
Rosemary Somerville
Andrew Spencer
Peter Steele
Timothy Stevens
Miranda Strickland-Constable
Margaret Timmers
Rosemary Treble
Julian Treuherz
Norma Watt
Louise West
Tim Wilcox
Peter Wilson
Christopher Wood
Stephen Woodward
Clara Young

Photographic Credits

Carlton Fox
Prudence Cuming Associates Ltd
G. W. Harvey
Eldon Johnson
Peter Lowry
Godfrey New Photographics Ltd